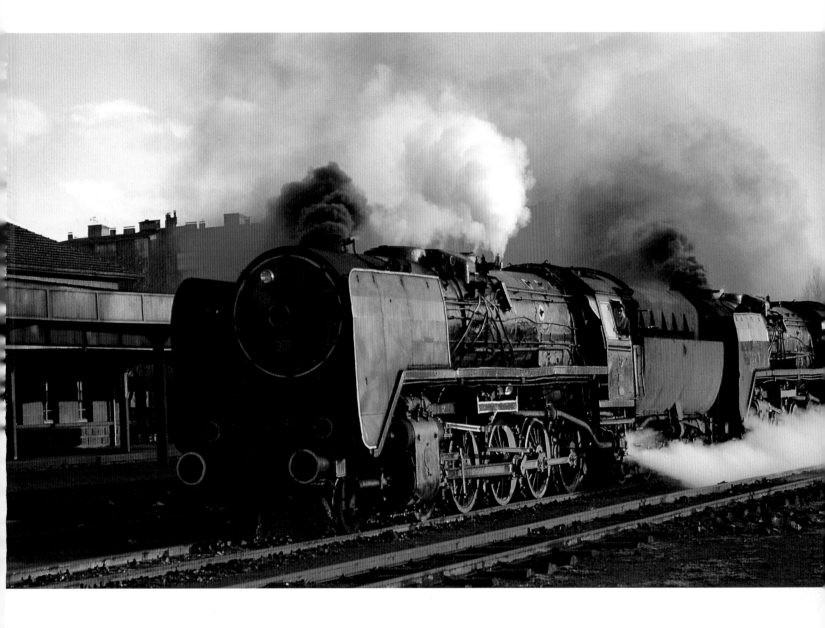

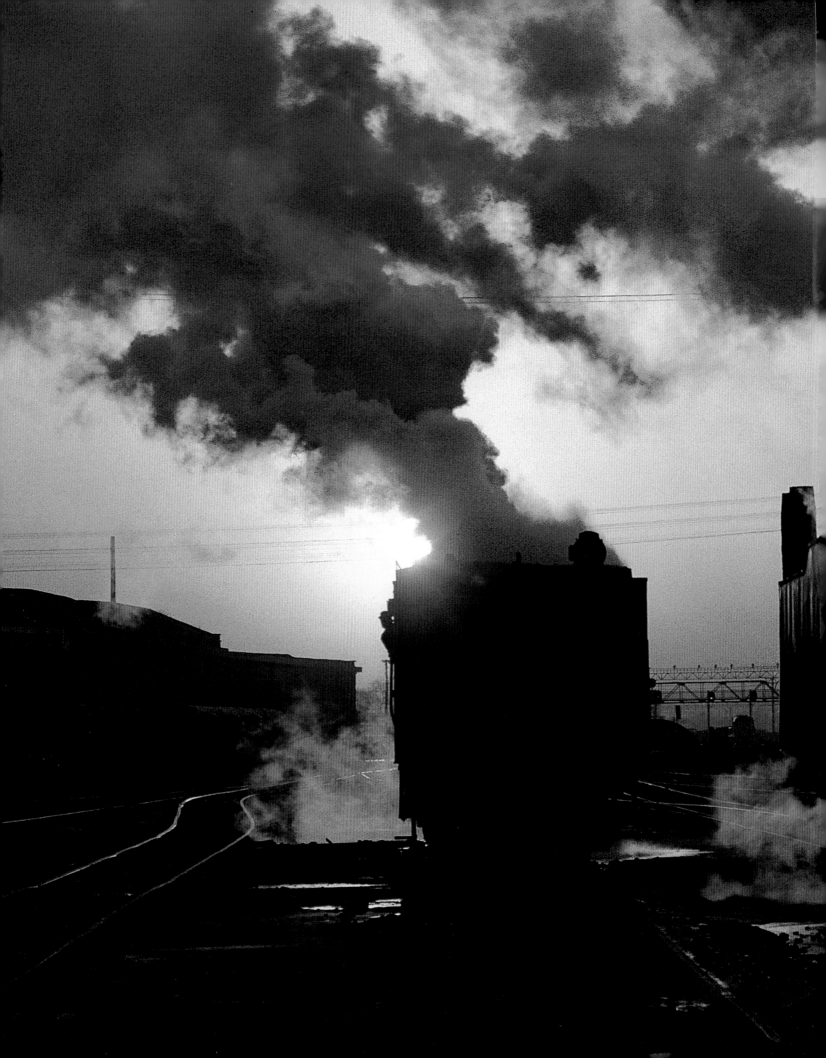

VANISHING STEAM

A PHOTOGRAPHER'S ODYSSEY AROUND THE WORLD

Eric Langhammer

HARRY N. ABRAMS, INC., PUBLISHERS

EDITOR: Richard Slovak
DESIGNER: Susi Oberhelman
PRODUCTION COORDINATOR: Maria Pia Gramaglia

Library of Congress Cataloging-in-Publication Data

Langhammer, Eric.
 Vanishing steam : a photographer's odyssey around the
 world / by Eric Langhammer.
 p. cm.
 ISBN 0-8109-3482-5
 1. Railroads—Pictorial works. 2. Railroads—History.
3. Photography of railroads. 4. Langhammer, Eric. I. Title.
TF149 .L34 2002
385'.361'0222—dc21 2002005267

Printed and bound in Hong Kong
10 9 8 7 6 5 4 3 2 1

Harry N. Abrams, Inc.
100 Fifth Avenue
New York, N.Y. 10011
www.abramsbooks.com

Abrams is a subsidiary of

LA MARTINIÈRE
G R O U P E

HALF-TITLE: A pair of Standard 2-10-0s are caught double-heading an evening freight from Erzincan into Erzurum in northeastern Turkey. (May 1984); TITLE: The setting sun backlights a pair of QJs in the loco shed yard in Jiamusi, China. (Feb. 1996); OPPOSITE: A bracing early-morning climb at Lutan, near Nancha, China, results in excellent elevation over a QJ with a Jiamusi–Wuyiling passenger train. (Feb. 7, 1996); CONTENTS: A WP pacific discharges a flush of water at the loco shed in Bhusawal, India, as the setting sun spangles off its frame. (Oct. 1984)

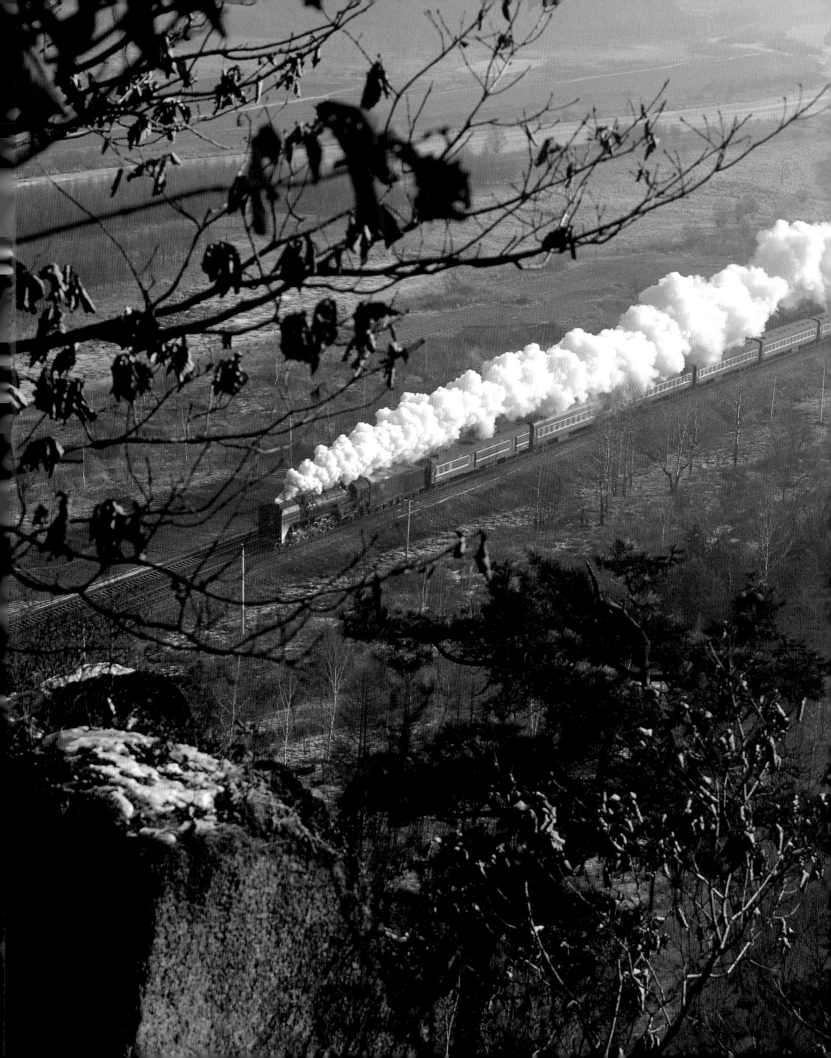

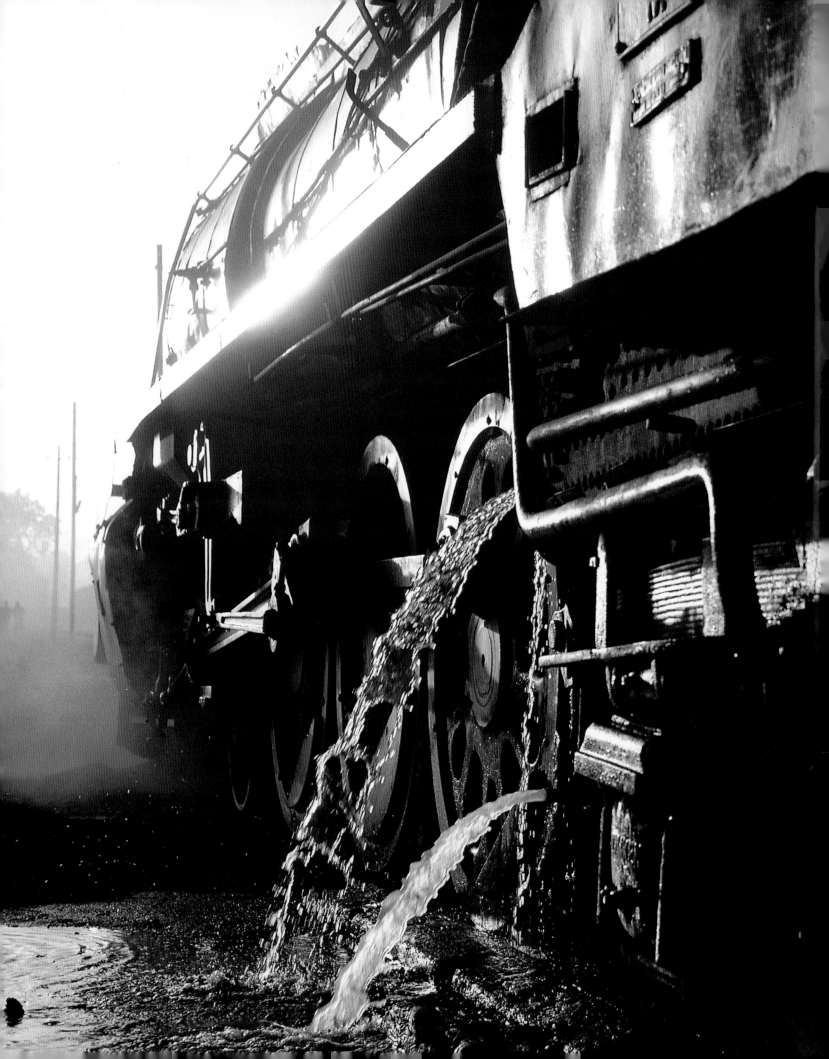

Contents

Introduction

FOR SOME FIFTY YEARS, THE STEAM locomotive has been in terminal decline. It was phased out in the United States during the 1950s and in Western Europe between the 1960s and 1970s, while lingering on in Eastern Europe until the late 1980s and in scattered other parts of the world to the present. No form of technology, however, has generated such emotion at its passing. In the West, steam continues to exercise a romantic appeal to laypeople as well as aficionados—particularly in Great Britain, where hundreds of privately restored engines in pristine, museum-quality condition can be found trundling up and down preserved branch lines on weekends, or out on the main lines for special rail tours.

While heartening that so much of the Steam Age has survived, to the committed photographer of the subject these inevitably somewhat artificial re-creations of an increasingly distant reality—regular steam operations having ceased in the United States and Canada as far back as 1960, and in Britain in 1968—can in no way compare to the thrill of authentic, workaday steam. The desire to see steam locomotives at work in a natural, everyday environment spawned one of the oddest latter-day tourism phenomena: extensive overseas itineraries undertaken for the exclusive purpose of photographing steam in action. During the last thirty years, thousands of people have traveled abroad to pursue this particular agenda.

Such, moreover, is the spell cast by steam that hard-core vapor addicts will go literally anywhere, no matter how remote, primitive, or nonexistent the local tourism infrastructure, or repressive prevailing police attitudes toward photography. They will put up with grueling climatic extremes, with often grim hotel and travel conditions—with virtually anything, in fact, just to get another fix of the steam drug.

I myself am a self-confessed incurable case, having spent some three years altogether backpacking around the world in pursuit of steam since my first trip to West Germany as a teenager in 1974, including a marathon yearlong stint in India, Pakistan, and Turkey in 1984–85 and a nine-month tour of China in 1995–96. In common with many other people, the photographic pursuit of the world's last working steam locomotives has become a major leitmotif of my life.

Ever since my first overseas trip, I have spent innumerable happy hours poring over atlases with eager anticipation, planning future itineraries. Over the years, the steam locomotive has become inextricably associated with adventure and the lure of exotic, faraway places. Amid life's many vicissitudes, the constant changes undergone while progressing through the dream of time, this at least has been one firm, familiar fixture: the imperative to travel for steam.

Although it covers much ground, this book is not intended to be a comprehensive, country-by-country, historical overview of world steam in its twilight years. Instead, it simply presents one particular photographer's vision of a spectacularly animated machine in those places that he has managed to visit. Pursuit of the last steam locomotives must rate as one of the most cash-intensive life interests, and regrettably there are omissions I would rather have included—South Africa and what was then East Germany, for example, two top spots that I did not get to in time.

This, too, is part of the wider story of chasing steam. For with so many places to go in so little time, only the very luckiest during the past three decades have been able to comprehensively cover the eclipse of this superlatively photogenic machine in all the countries in which it could still be found in operation.

► In this view, taken at Ucea, Romania, on the Sibiu–Braşov line, farmworkers and a pair of white horses provide the perfect foreground for Prussian P8 4-6-0 230-224, passing by on an enthusiasts' special. (Oct. 1997)

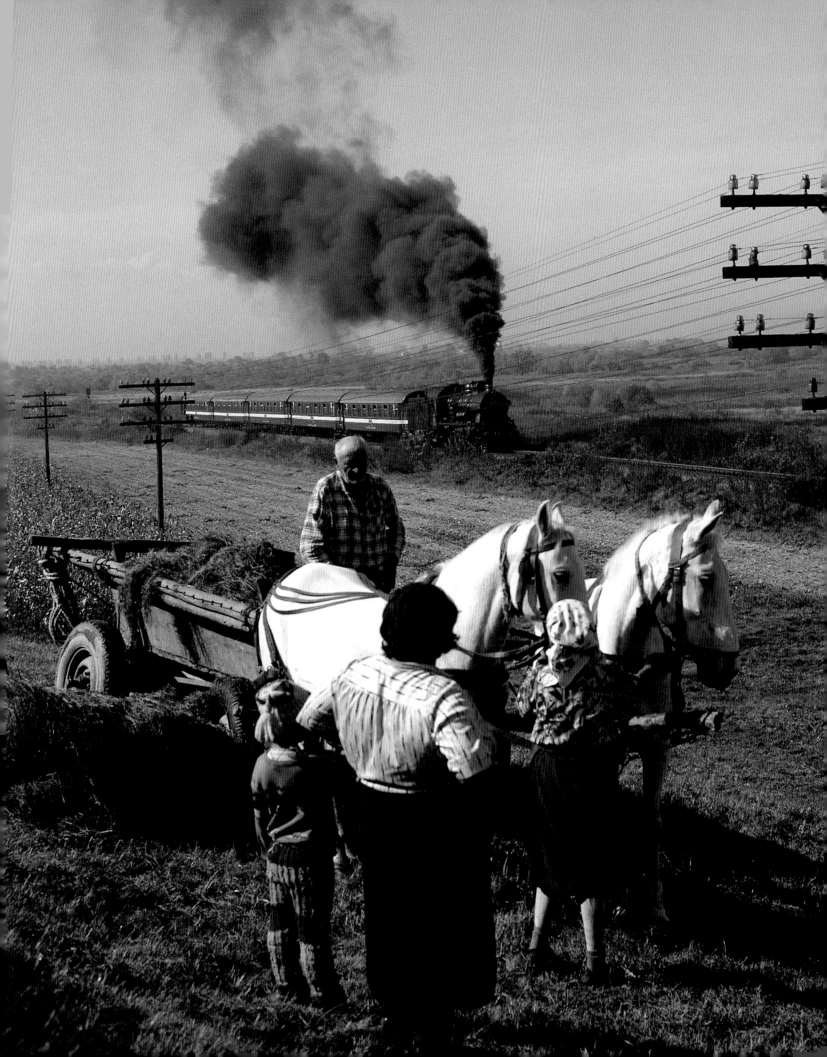

1 | The Allure of Steam

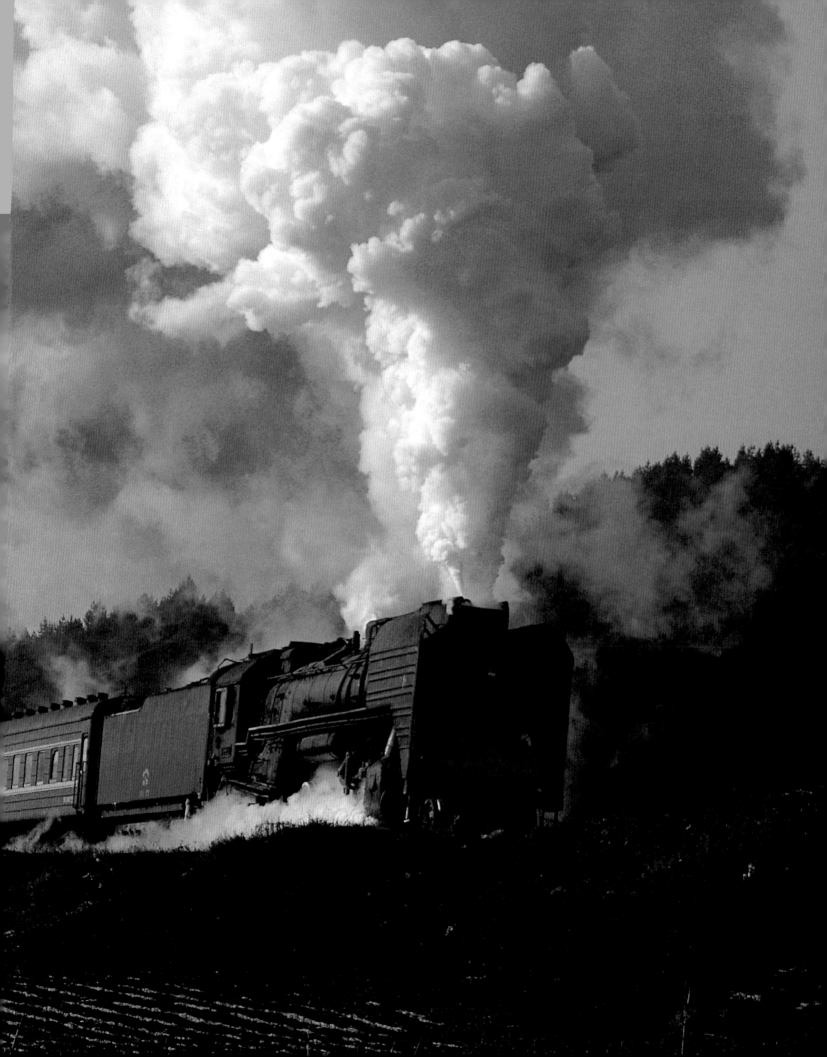

A Machine Apart

WHAT, THE LAYMAN MIGHT WELL WONDER, could possibly motivate any sound-minded person to set off again and again to some of the world's least salubrious spots simply to photograph old steam locomotives in action? What—to take but one of so many innumerable days I have devoted to doing precisely just that—could induce my traveling companion Torsten and myself to even contemplate quitting a warm hotel at dawn to venture out onto the streets of Nancha, where the prevailing temperature is something in the region of twenty degrees below zero?

Nancha—a bleak industrial town of some 160,000 inhabitants in China's far northeastern province of Heilongjiang—is situated just south of Siberia, and features winter weather conditions every bit as severe. As we mingle with citizens making their way to work, the crunching of boots on ice resonates crisply over the subzero air, even acoustics seeming amplified in the extreme cold. Ahead of us, the sun is rising in a bloody red ball, its flaming iridescence only serving to more starkly highlight the frigid desolation of the scene it is illuminating. Fleeting vapor clouds form ahead of pedestrians as they exhale, with passing cyclists clapping a hand to their ears for a quick rub every so often to ameliorate the bitter subzero bite. Practically everything, whether static or moving, is shrouded in a fine rime of ice. Most locals wouldn't dream of lingering about in such extremes for any longer than necessary, yet here we are, setting off with the intention of remaining out-of-doors for the entire day. If like us, however, you're men with a mission, your perspective on just what makes

sense is different perhaps. And while there's no doubt that these are daunting conditions to be out and about in, as so often when setting off on happy-hunting steam-photography expeditions, I have that familiar bounce to my step, galvanized by the possibility that today might just be the one to yield *that* sequence, *the* shot. . . .

We stop at a dingy roadside shack to buy some sugared breadsticks and cans of lemonade. These will have to suffice by way of sustenance till a break in the steam action permits us to address the secondary concern of filling our bellies with something more substantial. On intersecting the railroad at a level crossing, we take a left turn, then start walking down the tracks, veering sharply left again some fifteen minutes later at the point where the Wuyiling branch splits from the main line to Jiamusi. Our intended photo location today is the legendary Nancha bank.

At this late stage in the worldwide endgame of the steam locomotive, it's safe enough to say that there's nowhere comparable now in terms of providing a showcase for the superlative powers of expression of this maybe moribund, yet still no less magnificent, machine. Just out of town, one severe grade (with a maximum gradient of 27 percent) heading north leads straight onto another, even steeper (20 percent) climb coming south. What this equates to from a steam-photography point of view is that within a relatively short distance, trains working both into and out of Nancha are guaranteed to be spectacular in the extreme. Most freights require the assistance of a banker, or bank engine, pushing from behind, and some of the south-

▲ A QJ at the head of an early-morning Jiamusi–Wuyiling passenger train (with another QJ providing banking assistance behind) takes on one of the severe grades just outside Nancha, China—which produced truly awesome locomotive performances. (Jan. 31, 1996)

bound freights (mostly block loads of logs felled in the forests extending between here and Wuyiling, some 160 miles north) will even need three locomotives, two double-heading up front, with another banking behind.

To any steam lover, this all sounds like highly enticing stuff, no doubt, but does *anything,* even hard-core vapor aficionados such as myself have on occasion been forced to wonder, really justify being out in such extremes? Just one glance at Torsten is enough to remind me how far we are from home. A fine layer of frost has settled over his protective felt face mask, with a coating of powdery white ice crystals likewise in situ on his eyelashes. Is all this hardship really necessary? Would a spring or summer visit not suffice instead? To the dedicated steam photographer intent on optimum image quality, though, this is to miss the point. For while a visit to Nancha at any other time of year would certainly prove an easier option for creature comforts, it could never offer anything remotely like the marvelous photo potential we're hoping to exploit to the full today: the brilliant blue, uncannily cloudless skies; the spectacular steam effects resulting from the interaction between steam exhaust and the subzero air—all in all, the incomparable atmosphere that this same at times barely endurable freeze can lend to a shot.

A bracing twenty-minute walk up the grade brings us to the summit, where we discover that we aren't the only ones out braving the elements this morning in pursuit of a steam-photography agenda. Spread out alongside the line, about a dozen English photographers wadded up in multi-ple layers of winter wear are already eagerly anticipating some oncoming steam action. They're traveling on a more

organized basis, having been ferried out on location in the relative comfort of a CITS (China International Travel Service) minibus. Later, as prearranged, their Chinese guides will drive back to the hotel to pick up hot food and bring it out to the line, thus sparing them from missing out on any steam action by having to adjourn for lunch elsewhere.

We exchange trade talk, lamenting the unwelcome developments that have recently taken place here. Whereas only last year (1995) all freights on the Wuyiling branch had been steam-hauled and steam-banked, now diesels have been drafted in to cover some of the banking duties. Even if a freight is steam-hauled, if it is diesel-banked the drama factor is de facto reduced by half. Only some 50 percent of freights now remain both steam-hauled and -banked. To those of us who have been to Nancha before, the consensus is that it simply isn't the same place. But then again, this is the context in which we steam lovers have always pursued our passion. Counterbalancing any regrets as to what's gone is an awareness, too, of being lucky enough at least to see what's left while it's still around. For most of us agree that such steam workings as remain to be seen here for the mean-time will all too soon be gone for good as well.

Before long, the roar of a northbound freight storming the base of the bank reaches us from down in the valley below. It is standard practice for Nancha crews to race northbounds out of town so that they hit the grade with maximum momentum. Just around the corner a little farther down the line, it really makes for quite some spec-tacle to actually be able to see the locomotives palpably slow by the second as they hit a long, sweeping S curve and absorb the shock of the grade. Clouds of prettily backlit

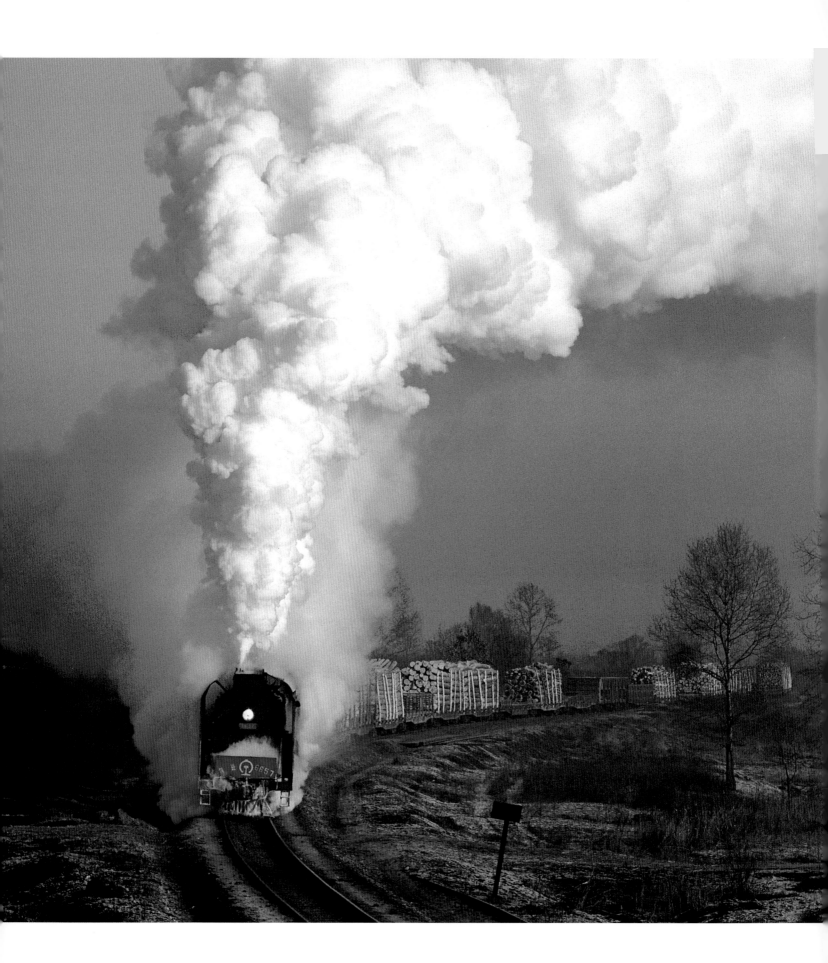

smoke rising over the treetops precede the appearance of one of the ubiquitous QJ-class 2-10-2s around the sharp curve, its exhaust intersected at a right angle by that of the banker billowing up from behind as it sets into tackling the long straight stretch on the final approach to the summit. It's a long train, the lead QJ almost level with our position toward the top of the bank before the banker appears around the curve too. As is similarly standard operating practice at Nancha, the QJ at the rear of the train is lending its banking assistance tender first so that when it drops off at the small wayside station of Liushu, several miles up the line, it will be positioned right way around to couple on the next southbound freight to double-head it back toward Nancha. The two engines cut a stirring sight as they strain to keep their load on the move upgrade, no complaints to be heard about the bitter cold now as we delight instead in how the subzero conditions enhance our shots, the photogenic rime of ice on the coupling rods of the lead QJ providing the perfect atmospheric touch. It's a good start to the day, but little do we know there's better still to come. . . .

With the next train more likely to be a southbound, we take the short walk over to the other side of the summit, where we find ourselves facing another grade, except coming from the opposite direction now as the line goes curving off to the right. Presently a feathery wisp of steam can be discerned off in the distance, drifting into Liushu to join the plume already rising from the banking locomotive that has been sitting there since detaching from the preceding northbound. Once it has coupled up to the QJ just arrived in on the latest timber consignment from the northern forests, another train will be on its way. I lend Torsten a hand as he hoists himself up into a tree to gain some dramatic elevation for his intended video sequence, then look for a position myself, all the others

◄ A picture that epitomizes the dramatic appeal of the steam locomotive: the thermometer is down to twenty degrees below zero as two China Rail QJ-class 2-10-2s pound up to the summit at Nancha on an early-morning log freight from Wuyiling. A 2-10-2 is a locomotive with two lead wheels (before the cylinder), ten driving wheels, and two trailing wheels on the main locomotive frame. Europeans classify by the number of *axles,* rather than *wheels,* so a 2-10-2 would be a 1-5-1 in Europe. (Jan. 31, 1996)

likewise seeking out a spot. To its practitioners, it's all part of the appeal of this particular photographic genre that you can never really tell what kind of photo possibilities will present themselves until actually out on location. Each day unravels as an unpredictable adventure, with no way of knowing where you might end up when, or what kind of lighting conditions might prevail at any specific point. Like so many others, this latest shot will just have to be improvised according to whatever happens to be at hand.

Long years of practice, though, have probably finely honed the inner eye's instinctive editorial abilities with regard to scanning the folds of a landscape for some kind of shape to use as a compositional frame. Apprising the possibilities presented by what is a much narrower field of photographic fire than the northbound bank, I deliberate on whether to remain where I am with the sun behind my shoulder and go for a traditional three-quarters approach shot, or cross to shoot from the other side of the tracks, an option (easily enough overlooked from this side) that doesn't necessarily entail being on the wrong side for light. For, what with the train's angle of approach to the curve, the sun will be lighting it up from there too, before it swings around. In the end, this is what I opt for, hoping to achieve some dramatic tension by emphasizing the shape of the curve with an 85mm lens. And so, the vital decision on where to stand taken and out of the way, I try not to distract myself thinking too much about other edited-out alternatives that might very well have produced equally impressive results.

By now it's about 8:30, and prevailing photo conditions are practically as perfect as perfect can be. The sky is a stunning sheer azure shade, with the sun's crisp white rays shredding the pearly swathe of mist-suspended static above the fields (this more than any other detail rendering the subzero freeze even visually palpable) to lend the landscape toward Liushu an exquisitely ethereal look. As a series of chime whistles suddenly splits the silence, then profuse mushroom-shaped clouds of white smoke erupt off in the distance, the dull, muffled beat of our quarry can be discerned getting under way. It's always a compelling contrast how the incursion of a hardworking steam train into a landscape so radically transforms its mood, as the previously prevailing stillness cedes to an onslaught of animation. For almost as soon as the southbound has gotten under way (just a double-header this time, as we can tell even at a distance from the smoke trails, with no banker on behind), in terms of both sound and vision, it completely dominates the countryside for miles around. As the pounding beat of the two laboring locomotives slaps back off the hills to come echoing eerily down the valley ahead of the train, two tall white steam trails slinking from left to right convey the impression of a slow-motion tornado on the move. For a full fifteen minutes now, the two locomotives will face a dogged upgrade slog with their 2,500-ton load before passing the point where we are gathered in wait.

Distracting myself briefly from the drama unfurling off in the distance, I contemplate the motley crew spread out alongside the line, for all the world like some devotional sect congregated out in the wilderness. No one is speaking, everyone's attention fixated on the same focal point, eyes glazed with the characteristic expression of those in the world perhaps, but not entirely of it. For undeniably, there is something otherworldly about this steam

fascination. That, at any rate, is the effect that exposure to the stimulus of the steam locomotive induces subjectively in those susceptible to its charms—of seeming to transport to some enchanted other dimension. While most members of the public probably perceive railroads as little more than a functional means of conveyance, to those like ourselves the steam-worked railroad is a world in itself, one charged with drama, magic, and mystery, able to offer a whole array of wonderful, soul-stirring sights and sounds. Although each of us has come to this enthusiasm from different points of departure, the roots tend to be deep. For most of us, our ongoing fascination with the steam locomotive bears the indelible impress of earliest childhood experiences. I daresay I'm not the only one here today for whom the fascination extends so far into the primal murk of way back when that I can't say for sure just precisely how or when these hissing, panting, super-animated behemoths were first fixated upon as an object of fascination. What I do know definitely, though, is that ever since, it's been well-nigh impossible to shake the spell. A love for the steam locomotive is rarely a casual short-term affair, but more commonly a grand lifelong passion, something in the blood almost, the machine's myriad moods and expressions seeming to resonate right down in the deepest, most primitive layers of psyche. The appetite of hard-core vapor fiends for steam, too, tends to be more or less insatiable. For no matter how many great steam experiences each of us may have had in the past, it is in the nature of the fascination—or, perhaps more accurately put, addiction—that it demands to be experienced again and again in the palpable present-tense reality of another new now.

And while there may be much in life that can pall with repetition, so far as stirring steam experiences are concerned, each time can still seem like the first time. No matter how frequently witnessed before, the sight and sound of a hardworking steam locomotive at loose within a landscape can still somehow unfailingly provoke those original feelings of wonder and awe, undiminished in intensity. These days, moreover, each such experience is lent additional emotional resonance—knowing time has all but closed in to finally eclipse this little world we love so well—by being treated as if it might be the last.

So just what is it about these old engines that inspires such dogged devotion that those smitten by their charms will follow them—as we are doing right now—quite literally to the ends of the earth? Even to myself, I cannot properly explain just why the steam locomotive exercises such a potent allure. I could say that it had something to do with its visual appeal, with the way these QJs, for example, are cutting such a fabulously phantom-like sight as they come looming out of the milky morning-mist haze, put it down to the hypnotic effect of the relentless drumming beat, or cite some other aspect of its spellbinding animism. In the end, though, I would still be no closer to fathoming how a mere machine can get under the skin to strike such a profound emotional chord within. Perhaps this is one of the reasons photography is our means of response to its enigma, as if we might once and for all encapsulate in tangible, time-trapped form with one of our photographic efforts the essence of its elusive, intangible allure.

But now the time to attempt to do just that is once more almost upon us, for in just another few moments,

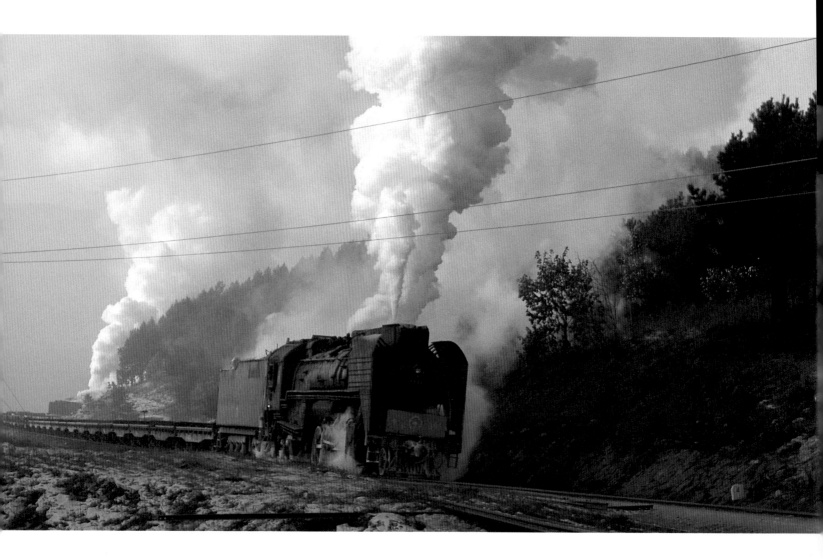

the stars of the show we've been so eagerly awaiting will break cover from behind the last few trees obscuring them from view to strut their stuff on the little photographic cat-walk extending out ahead of us. Undertaking the familiar last-minute ritual, I try to think myself several steps ahead of my subject matter, anticipating at which points, for example, a horizontal- or vertical-format shot might be more appropriate. Yet even while performing these abstract projections, I know they will be dispatched to the wind according to what—as ever before—will simply have to be improvised on the spur of the moment. For such a thing of the moment is steam-locomotive photography that right up to the very last, it is still impossible to predict just what kind of pictures an action sequence like this will produce.

As the two QJs come within range of our lenses, still no letup to the barely believable smoke display they've been spewing skyward ever since leaving Liushu, the picture they present is so breathtaking that my initial reaction is a kind of mild panic lest unsteady, overexcited hands botch such a marvelous opportunity. Once I've taken the first shot in a sequence, however, something else seems to take over as I switch to autopilot. By this stage, much like the others likewise busily snapping away around me, I imagine, I don't have any conscious overview of what I'm doing while I'm doing it, being too much in the midst of doing it to work out just how. Critical calculations regarding composition are executed instinctively within the merest blink of an eye, as indeed the situation dictates they must, given that a con-stantly moving subject is never going to stand still.

Each time the shutter snaps, an afterimage of the exposure seems to sear for a split second into the back of the brain, only to evaporate into the instant irrelevance of

an already unrepeatable past as the next possibility presents itself in the viewfinder to invite a potential response. There's little like it for coalescing creative energies when you have to perform within such a limited time frame, your way of being in time itself so acute that it's down to trying to interpose your inner-eye vision between a series of exposures at 1/250th of a second. There's little like it, either, for inducing a state of super-sharp alertness, for only lightning-flash reactions will be capable of catching photo possibilities disappearing almost as soon as they've appeared. Nothing else exists, only the super-magnified now, reality contracted right down to the tiny world-within-a-world framed in the viewfinder. And despite the pressure of being put on the spot, from the photographer's point of view, the feeling subjectively engendered by such intense immersion within an activity is one of acute existential *thereness,* so inside the moment you seem outside of time.

By now on the final approach to the summit, the presence of the two lumbering, smoke-spewing leviathans is simply awesome, all the more so now that they're right up close. The acoustics level is little short of an all-out sonic assault, with even the very ground pulsating by now from the vibrations of their ongoing efforts. As their coupling rods grind inexorably around, the disparate exhausts of the two QJs cut into the air with such crisp rasping ferocity that it almost seems they might split the sky apart. Every nut and bolt of the engines seem to quake with the strain of their struggle, their smoke deflectors oddly evoking flapping elephant ears as they quiver with reverberation to each successive exhaust beat blasting up their chimneys. Initially irritated by how the second QJ has been obscured by shrouds

of steam thrown up by the lead locomotive, I'm almost about to put the camera down, about to lose the light anyhow in a second or so as the engines arc around the curve. Then, seeing how the lead locomotive's headlight offers an entirely new dramatic focal point, suddenly seeming so much more luminous as it bears head-on down toward the lens, in automatic reflex I snap the shot that, among all the others in the sequence—whether due to the headlight detail, or dynamic shape of the train and accompanying smoke trail on the neck of the curve—turns out to be the one, arguably *the* one. Only moments later, as the locomotives crest the summit, shut off, then begin to drift sharply downhill, the show is over, the only trace of their spirited upgrade assault now a giant steam trail hanging ethereally in the subzero atmosphere (where it will remain visible for another half hour while slowly turning to ice crystals). The beatific expressions on the faces all around is choice. If any of us had forgotten just why we go to such extremes to see these moribund old machines, this latest demonstration of their superlative powers of expression has served as a potent reminder.

For all their sleek efficiency, the diesel engines that have now effectively eclipsed the steam locomotive worldwide could never produce anything even remotely comparable to this kind of drama. With its explosive vitality and overwhelming combination of sight, sound, and smell— of billowing smoke, mesmerizing rhythm, and intoxicating

◀ With QJ-class 2-10-2s leading and banking behind, an early-morning northbound freight of empty flatcars struggles up the long, straight section of the Nancha bank, watched by a couple of English steam photographers. The flatcars will later return to Nancha loaded with logs. (Jan. 31, 1996)

aroma—it is easy to see why the steam locomotive exercised such a hold on the imagination of so many down through the generations for the 150-odd years it ruled supreme on the rails. Its mysterious spell is hard to define. On the one hand, yes, it is a functional machine; on the other, it seems imbued with "otherness," to be something else besides. With its repertoire of soulful sounds—gasps, wails, shrieks, and roars—the steam locomotive so often seems to have a life of its own, in full flight to be like some wild thing exulting in its own existence. There is something elemental about its appeal, combining as it does the elements of fire and water to produce steam. To the world-renowned violinist Yehudi Menuhin, there was no more haunting sound than that of a steam locomotive's whistle piercing the still of the night. The nineteenth-century writer and naturalist Henry David Thoreau was another who saw it in such terms, as a machine that not only stirred the soul but seemed to have one of its own.

To the unimpressed layman, ascribing such poetic qualities to a mere machine may seem far-fetched. To those bewitched by it, however, the steam locomotive is appreciably more than a machine: a spellbinding object of enchantment and sheer dynamo of audiovisual expressivity. Certainly no machine has such animistic presence, or can create such atmosphere around it. Even when stationary, it hisses and pants like a living, breathing thing. On the

move, it can be poetry in motion. To witness a steam locomotive in full cry, struggling upgrade with a heavy load, is to experience a sublime assault on the senses, a high-drama showstopper in sound and vision. Even early on in its development, the enigmatic charisma of the steam locomotive exercised a hold on the imaginations of artists such as J. M. W. Turner and Claude Monet, who endeavored to render their own particular perception of it. As any drummer would appreciate, the steam locomotive is also hypnotically percussive. The French composer Arthur Honegger tried to convey his fascination for the steam locomotive in his tone poem *Pacific 231*. Antonín Dvořák, the Czech composer, was another famous steam aficionado, equally appreciative of the machine's powers of musical expression.

Moving on to the rock 'n' roll era, there was Chuck Berry's celebrated character Johnny B. Goode, who learned to play guitar down by the railroad tracks, "strumming to the rhythm that the drivers made." Ever since the disappearance of steam from most of the world, trains just do not make that kind of rhythm, and the railroads themselves have lost much of their romantic allure. For if the railroad was a stage, back in the Steam Age at any rate, there was little doubt who had the main starring role.

▶ Dawn at the loco shed in Kurduvadi, India, with a narrow-gauge G-class 4-6-4 in the foreground and a broad-gauge WG 2-8-2 behind, its fireman silhouetted by the rising sun. (Jan. 4, 1985)

▼ Immaculately turned-out engines are always a delight to behold. The SZD (Soviet Railways) P 36 4-8-4s were the most glamorous engines in the former Soviet Union until the 1970s rostered for star express turns such as the Trans-Siberian. Because of the prevailing circumstances during the Cold War, it was virtually impossible to photograph the P 36s when they were in normal service. Since the collapse of Communism, however, enthusiasts have had ample opportunity to photograph the P 36s on special rail tours. Here, P 36 0050 crosses the Sluch River at Novohrad Volyns'kyy, Ukraine, on a special run between Korosten and Shepetivka. (June 2, 1993)

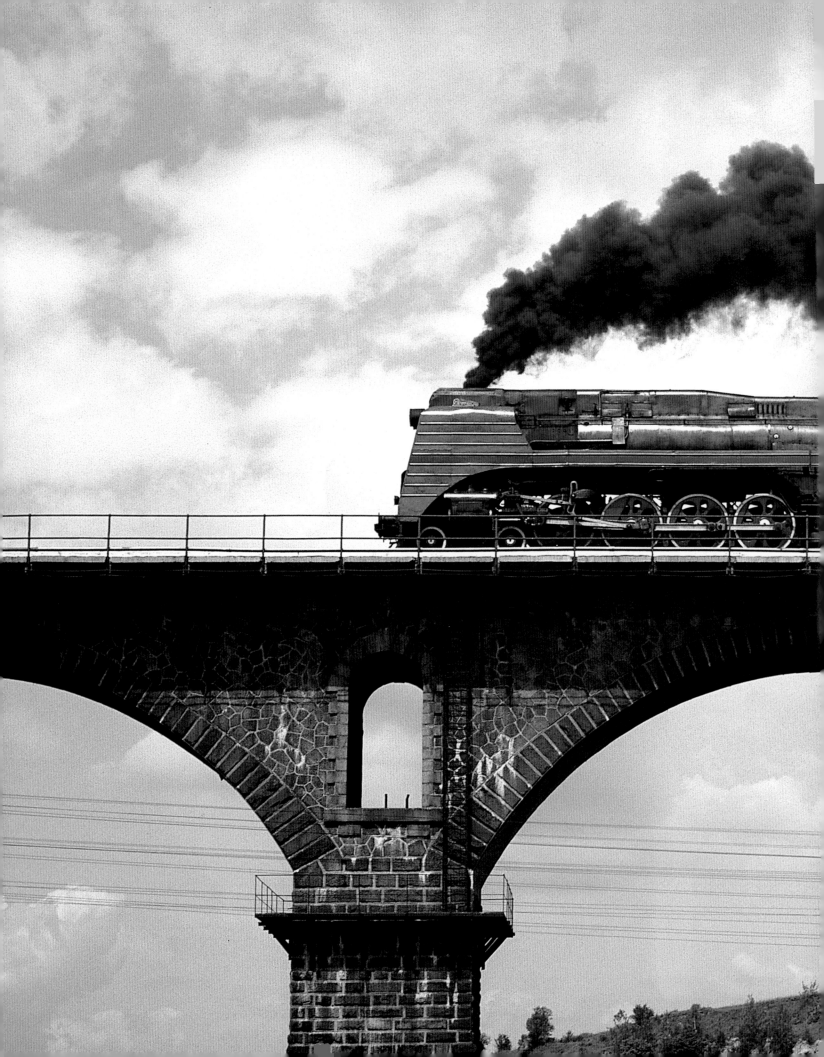

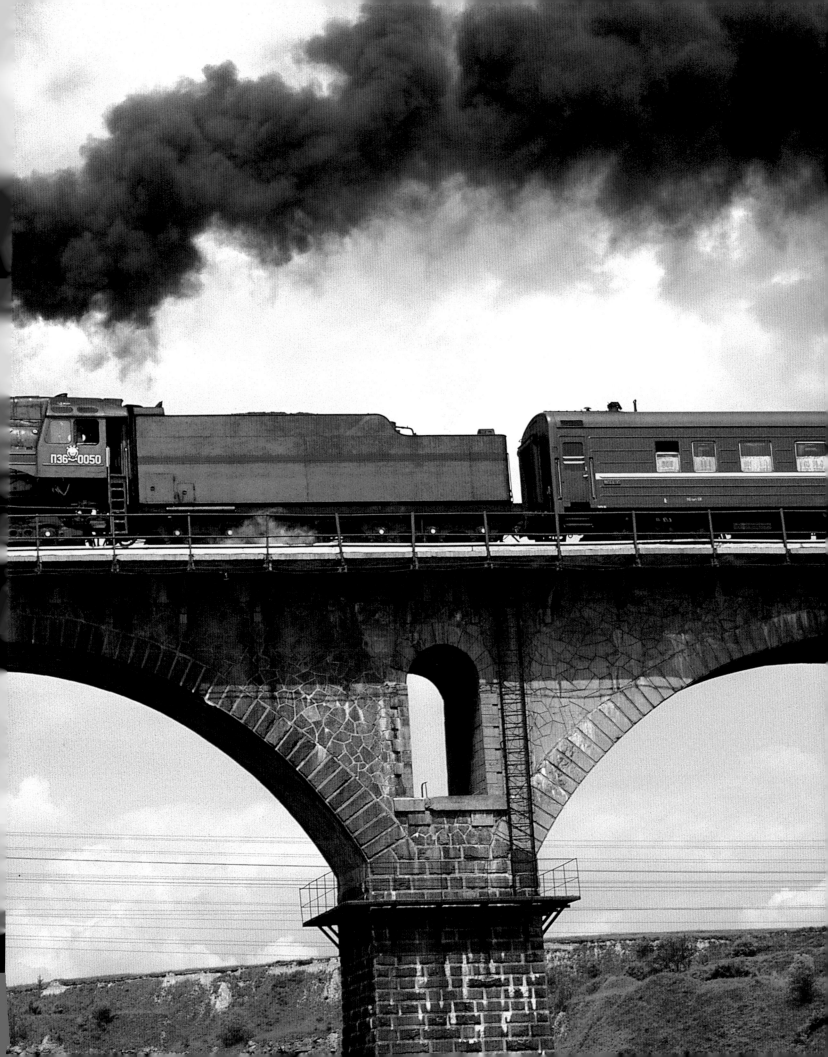

A Doomed Technology

THE STEAM LOCOMOTIVE HAS BEEN DYING for a half century. Until World War II it was the predominant, as yet not seriously contested, form of traction on railroads worldwide—one synonymous, indeed, with the railroads themselves. Even before the war, however, moves were afoot to challenge its hegemony. As far back as 1932, the first high-speed diesel train, the Flying Hamburgher, had been inaugurated between Hamburg and Berlin, followed in 1934 by the first diesel-electric streamlined train, the Burlington Zephyr of the Chicago, Burlington & Quincy Railroad.

The spirit in which these early experiments were made was tentative, however, and in terms of its own technology, steam locomotion enjoyed a golden age in the 1930s, with many bold innovations. In Germany, the United States, and the United Kingdom, streamlined express passenger locomotives appeared, sporting futuristic profiles quite unlike any steam design hitherto seen. On July 3, 1938, an English A4-class streamlined pacific, no. 4468 Mallard, hit a new high for steam, setting a still-unsurpassed world speed record for steam engines of 126 miles per hour.

The technology of steam was still being pushed almost everywhere, with bigger and more powerful engines rolling off production lines worldwide, featuring state-of-the-art innovations such as double chimneys, Kylchap exhaust systems, and smoke deflectors. The famous designers of the day, such as Chapelon in France and Gresley in England, were constantly excelling over previous efforts. As the shadows of war closed in on the world, it seemed inconceivable that the steam locomotive, the main moving force of the railroads ever since they had begun some 100 years earlier, would be largely vanishing from the scene within a generation.

In 1939, however, tests conducted in the United States on the Electro Motive no. 103, a four-unit, 5,400-horsepower General Motors freight locomotive, determined that its performance with heavy trains was conclusively superior to steam locomotives in virtually every respect. Had it not been for wartime exigencies and the need to play it safe in time of emergency, dieselization might have occurred even sooner than it did in the United States, the country that was to serve as the decisive trendsetter for the displacement of steam engines worldwide.

Soon after the war ended, despite further wartime advances in steam technology (including the production by Alco of the 4-8-8-4 Big Boys, the world's largest-ever steam locomotives, for Union Pacific in 1941–42), the lessons that had been learned were rapidly put into effect. In 1945, there were still some 38,850 steam locomotives in service on American railroads. By 1950, the last main-line steam engine for indigenous use had been built, and throughout the 1950s, steam locomotives were dispatched to the scrapyard by the thousands.

By the mid-1950s, it had become impossible for other countries to ignore the radical transition taking place on American railroads. All of a sudden, the issue of steam versus diesel was on the agenda of almost every railroad management board worldwide. In 1955, British Railways, then midway through a major steam construction program of some 1,000 new engines, published a modernization plan in which it announced its long-term intention to replace its steam fleet with diesel and electric, and to bring fresh steam-engine construction to an end. In 1956, following a review, the Soviet Union brought a substantial steam

construction program to an abrupt halt and switched its engine production lines over to diesel. Within just a few years in virtually every country in the world, steam went from a technology that was still being developed as a force for the future to one that was perceived as irrevocably doomed, a dinosaur from another age. By the time steam power in the United States finally ended in 1960, several smaller countries, such as Cuba, Israel, and the Netherlands, had already fully dieselized their state railroad systems.

The reasons for the rapid, pervasive triumph of diesel traction over steam were relatively straightforward. Compared to diesel, the steam locomotive was a thermally inefficient and labor-intensive machine that expended more energy to pull less. All that wonderfully photogenic smoke belching out of the chimney was an all-too-visible indication of how much potential energy was going to waste. In terms of servicing ease and traffic availability, the diesel conclusively came out on top as well. Whereas a diesel could be conveniently switched on and off at will, the steam locomotive required a painstakingly slow coaxing to life, making it fit to work a train only long hours after having been first lit up. Because of the accumulation of scale (a hard incrustation on the inside of the boiler), the availability of a steam locomotive for service was further hampered by its need to undergo regular boiler washouts. On arriving at a locomotive shed after a run, a steam engine had to undergo various time-consuming and labor-intensive servicing rituals, including coaling, watering, motion oiling, and disposing of ash, before it finally could be left to simmer. In addition, the steam locomotive had to be turned around at the end of

its journey, whereas diesels—with a cab at each end—were equipped for bidirectional running.

Concerns about job losses aside, railroad operating staff generally welcomed the change. What locomotive fireman, for instance, would not gladly exchange the back-breaking toil of being obliged to shovel ton after ton of coal into a seemingly insatiable firebox for the relative comfort of sitting as second man aboard a diesel? What 1990s Chinese locomotive crew—still stuck with steam a generation after it had been displaced in the West—given the choice of making their journey through prevailing temperatures of twenty degrees below zero in the clean, cozy cab of a diesel, insulated from the elements, or on the drafty footplate of a rough-riding steam locomotive, from which they will have to periodically dismount into the freezing cold to clamber about while replenishing with water, would not likewise opt for the technology offering the edge in terms of creature-comfort considerations?

In each country that undertook it, the changeover from steam to diesel entailed a quantum shift in railroad operating practices. A set of skills finely honed over generations had to be abandoned and a new set embarked upon, necessitating extensive staff-retraining programs to familiarize fitters and crews with the new technology. The switch from steam to diesel had an inevitable effect on other industries as well, such as coal and engineering—the coal industry's loss, most obviously, being the oil industry's gain. Heavy-engineering firms that had hitherto been able to rely upon the railroads for new steam-engine orders had to adapt to the new technology and start building diesels, or face being driven economically to the wall.

The railroads themselves also began to look different, as superfluous steam-engine maintenance infrastructure was demolished; engine sheds, water cranes, turntables, and water and coaling towers disappeared as staple accessories of the railroad scene. Urban skies cleared a little, with no more telltale smoke smudges hanging heavily in the air to pinpoint the whereabouts of the local steam shed. If the general public noticed the transformation at all, it was liable to be in terms of the disappearance of a familiar set of acoustics from the sound track of everyday life: no more haunting whistles piercing the quiet of the night or raucous rhythms pounding out from the bowels of a city as another steam engine struggled to keep a heavy load on the move.

There were many, certainly, who regarded the passing of the steam locomotive with regret, suddenly, now that it was under threat—such a flamboyant and poetically inspired machine in contrast to the prosaic diesels whose dull, growling purr and strident, blaring horns increasingly dominated the soundscape of both city and countryside. Along with regret at the passing of the steam locomotive in particular, there was possibly a more general hankering for one era fast passing into another. More strikingly perhaps than anything else, the passing of the steam locomotive symbolized that of a whole familiar wider world. For exiting from the stage of history along with it was an entire period of historical development: the age of heavy industry, giant coal mines and steel plants, smoking factories, busy production lines, and a time when wealth was generated by the manufacture of solid, tangible objects. Now, as the service sector began to account for an increasingly large portion of modern economies and the heavy manufacturing sector correspondingly less, the West was entering a new, more uncertain, and somehow less tangible period, the so-called Post-Industrial Age.

▶ By the late 1950s, the steam locomotive was almost universally perceived as a doomed and moribund form of technology, largely because of the proven superiority of the diesel in tractive power and thermal efficiency, but also because of the comparative ease of servicing diesels. Here, a China Rail QJ-class 2-10-2 has its ashpan raked out at the loco shed in Jiamusi after arrival with a freight from Nancha. Following ash disposal, the locomotive must undergo more time-consuming, labor-intensive servicing rituals—turning, coaling, and watering—before it can finally be left to simmer. (Feb. 2, 1996)

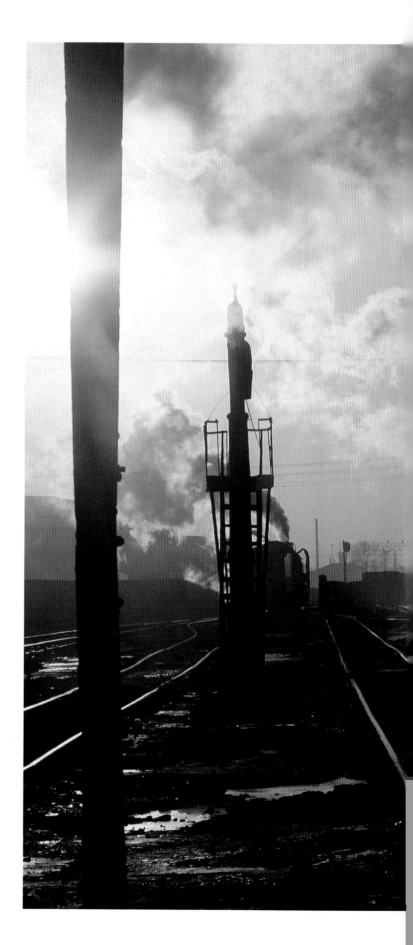

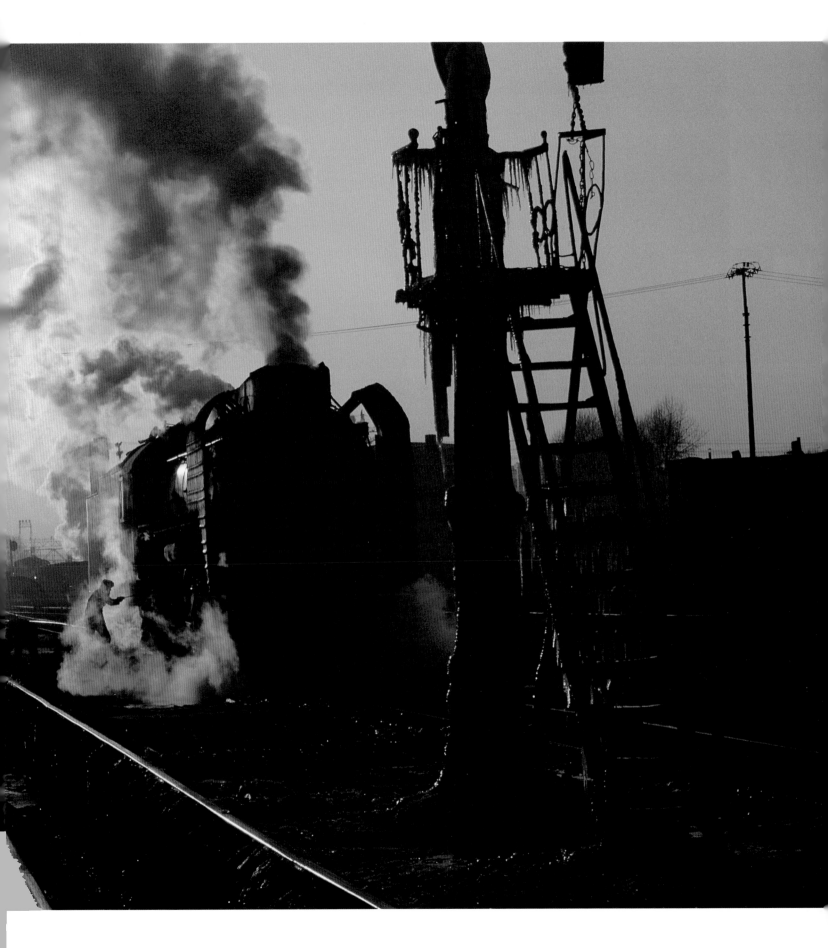

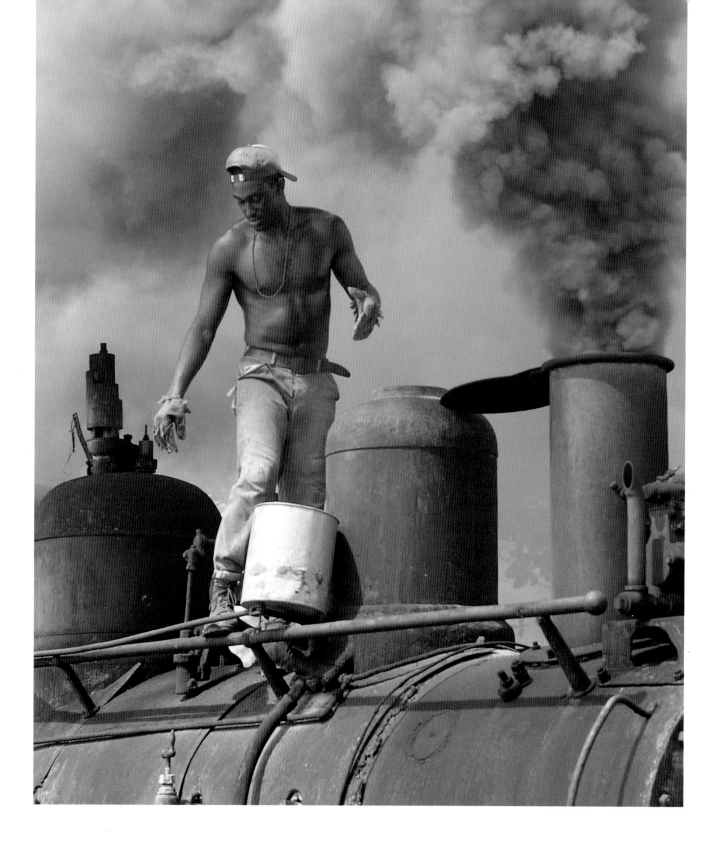

By the late 1950s, aside from a few notable exceptions such as India and China, almost every railroad in the world had decided on diesel as the motive power for the future and was bringing fresh steam construction to an end. Even once any given country had made the decision to switch to diesel, it still often had many thousands of steam locomotives with which it would have to decide what to do: whether to let them run out a normal course of service (which in the case of those just constructed would in normal circumstances mean another twenty to twenty-five years) and undergo a relatively long interim phase during which the two technologies—along with

electric, a more expensive but even more impressive traction form than diesel—would coexist, or do as the Americans had and dieselize wholesale, fast.

In some countries, such as West Germany, steam was more gradually and rationally phased out, with high maintenance standards retained right to the end; in others, such as the United Kingdom, it was eradicated in a kind of irrational frenzy, as a technological pariah that had to be swept into the dustbin of history as fast as possible. In this latter method of steam displacement, locomotive maintenance standards were typically allowed to deteriorate drastically and engine cleaning was all but abandoned. It was almost as if the railroad management wanted to create a self-fulfilling prophecy, so that the public, too, would perceive the thousands of steam locomotives that were still inconveniently in stock as dirty, decrepit, hopeless has-beens requiring elimination posthaste to make way for the beloved sleek new diesels—and not demur about the massive squandering of state assets that the scrapping of practically new steam locomotives represented, not to mention the vast expenditure required to purchase new diesels.

Besides the many rational reasons there may have been for replacing steam in the long term, other considerations contributed to its being eradicated far sooner than made any sound economic sense. In the West, the displacement of steam coincided with a time when the railroads themselves were coming under threat, increasing affluence having brought private vehicle ownership within the means of the many as opposed to relatively few. With more and more people opting to travel privately by car rather than public transport, proceeds from passenger rail traffic plummeted, forcing closure of many unremunerative rural routes. Total rail route mileage in the United Kingdom, for example, was radically reduced—by almost half—between 1960 and 1970. Quite apart from the heyday of the steam locomotive being over, that of the railroads themselves clearly was too, for now, all of a sudden, they found themselves in a new era: the age of the jet engine and the car.

If anything, the mounting competition from the roads—and increasingly from the air too—in the postwar period only exacerbated railroad management's perception of the puffing, hissing, solid cast-iron steam locomotive as an anachronism in an age in which everything of the age was seemingly so much more lightweight and oil-borne. Put on the defensive by increasing competition—and with the postwar proliferation of the long-distance truck, their cut of freight traffic was fast decreasing too—the railroads were keen to fight back and refashion their image in accordance with the new age. In this respect, the steam locomotive was perceived as a public-relations disaster, tainted almost overnight with the stigma of backwardness. However spurious such considerations may seem compared to the premature decommissioning of perfectly good modern (as the steam locomotives of the 1950s then were) industrial assets costing countless millions, they still contributed greatly to the rapid decline of the steam locomotive without any real debate as to how to phase it out over a more rational timescale.

◄ Generally speaking, railroad operating staff welcomed the changeover from steam to diesel; most probably, so too will the worker pictured here, atop the boiler of a narrow-gauge 2-8-0 at the Obdulio Morales sugar mill in Cuba, when diesels eventually displace steam. (March 9, 1998)

Endgame for the Steam Locomotive

WESTERN EUROPE

It is an odd irony that Britain, birthplace of the steam locomotive, would not only be one of the first Western European countries to eliminate steam, but do so with absurd, near-fanatic profligacy. In 1955, British Railways had almost 18,000 steam locomotives in service, a tally that had fallen to 13,271 by 1960, after which the steam replacement program radically accelerated, leaving just 2,550 steam engines by 1965. To British vapor aficionados, the speed of steam's displacement was truly shocking. Few could have conceived that it would vanish so quickly. After all, steam locomotives had still been built in considerable quantities as recently as the late 1950s, with the very last one, 9F 2-10-0 92200 Evening Star, making its appearance in 1960.

To a modern, image-besotted railroad management, however, it became an obsessive imperative to eradicate steam at any cost, as indeed it did, dispatching expensive engines—sometimes scarcely more than five years old—to the scrap heap. Photographers set themselves to the task of capturing a whole world that was fast vanishing before their eyes, but hardly had they fully begun to appreciate what was going than it had already all but gone, and by August 1968 it was all over.

At the close of the 1960s, steam engines could still be found working in several Western European countries: Italy, Portugal, Finland, Spain, Austria, France, and, above all, West Germany, the last bastion of really large-scale steam operations in the West. In 1969, some 2,000 steam engines were still in service on the Deutsche Bundesbahn. Although this represented a drastic reduction from the 10,000 in operation ten years before, it nonetheless compared favorably to steam stock in other Western European countries at the same time (for example, 920 in Italy, 640 in France, and 430 in Austria). In the early 1970s, there was still much to be seen—pacifics performing on expresses out of Hamburg, Hof, and Rheine; Prussian veterans in the Black Forest; smart 2-6-2s from the 1950s on intensive suburban workings in the Saarland; and, wherever steam remained in operation, Third Reich–era Kriegsloks galore on freight.

The Rheine–Emden line, a route carrying enormously heavy ore traffic from the docks at Emden, was steam's last major stomping ground in the West. Rheine–Emden became such a mecca that more steam photographers were frequently to be found on the platforms at Rheine station than bona fide fare-paying passengers. Everywhere else in Western Europe, however, steam was disappearing with alarming rapidity—from France in 1974, Finland and Spain in 1975, and from the Portuguese broad-gauge lines in 1977. In Austria, the standard-gauge steam stock dwindled from 411 in January 1969 to only 188 in 1974, and by 1978 even relatively low-key steam operations on the standard gauge had effectively come to an end.

In West Germany as well, the decline proceeded apace. Its 1969 stock of 2,000 steam locomotives was down

Typically Alpine verdure characterized the Austrian Vordernberg rack system. Here, a veteran Gölsdorf-designed 097-class 0-6-2T nears a level crossing on its way out of Vordernberg with an early-afternoon train bound over the mountain to Eisenerz; ahead is a ruling gradient at times as severe as 7 percent. (Aug. 24, 1976)

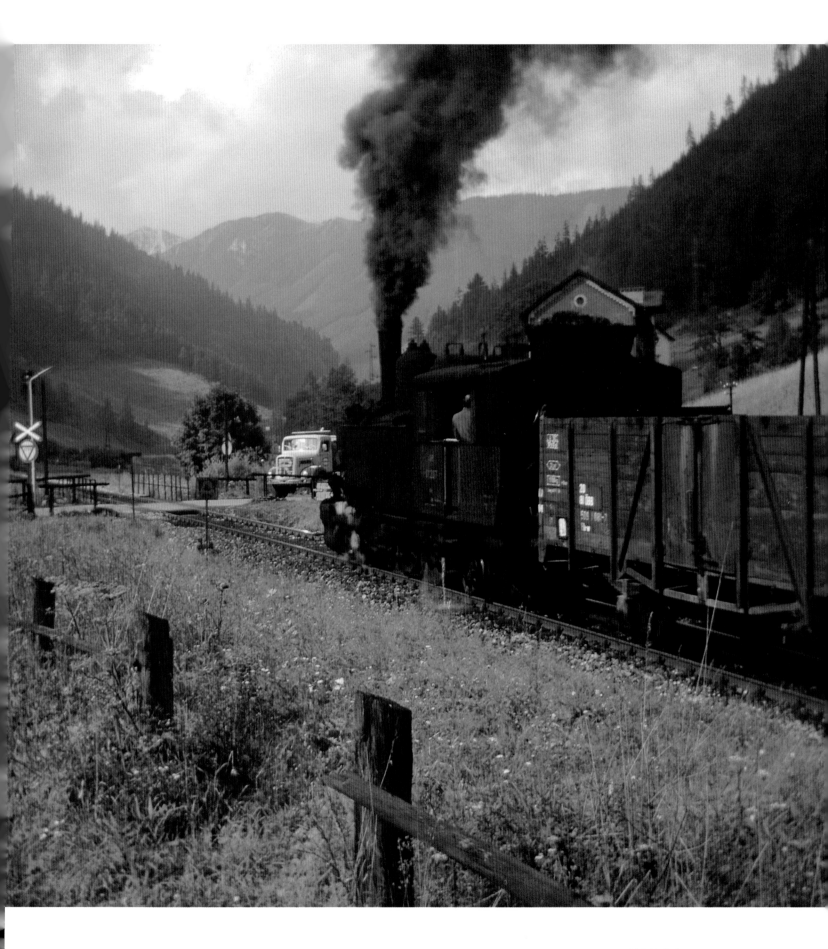

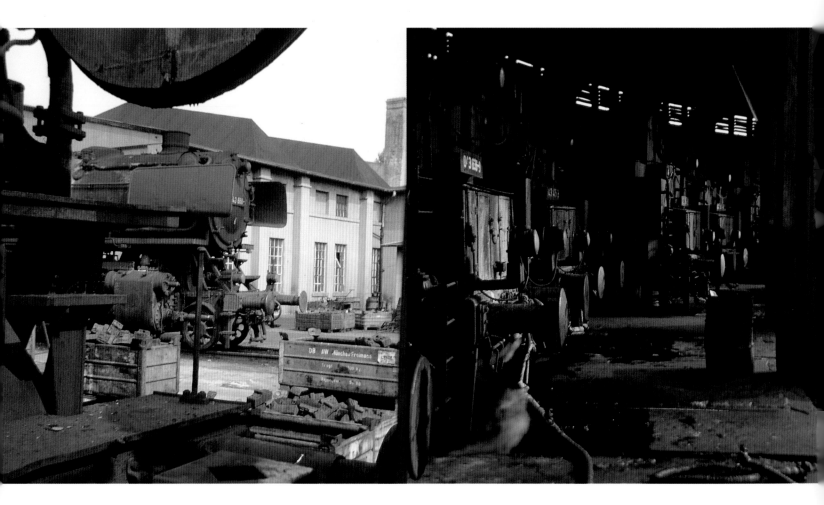

to 615 at the beginning of 1975 and just 277 by the beginning of 1976. Even the Rheine–Emden line was doomed; the very last main-line steam-engine operation in West Germany—and anywhere in Western Europe—took place there in October 1977.

EASTERN EUROPE

Although dieselization was well under way in Eastern Europe too, steam survived both in quantity and quality appreciably longer than in the West. In Eastern Europe, where the Soviet-style planned economy prevailed, rail (and likewise

heavy industry) still reigned supreme, with road transport offering scant competition. At the beginning of the 1970s, Eastern Europe was still a highly steamy region, with some 3,000 steam locomotives in service in the erstwhile German Democratic Republic and 2,500 in Czechoslovakia. Exact stock figures are not available for Poland, but it was far and away the steamiest country in the region.

Many exotic delights abounded, such as the exquisite 142-class 2-8-4s and 231 pacifics in Romania; a wonderful variety of different designs in Yugoslavia, from Hapsburg-era veterans to pre–World War II pacifics; and, in Czechoslovakia, the world's most advanced (and, many would argue, best-

▲ Steam's last big stomping ground in the West was the Rheine–Emden line in northwestern Germany. Here, an 043-class 2-10-0 in the Rheine loco shed yard is framed by the rusty smokebox of a withdrawn classmate. The 043s—an oil-burning version of the coal-fired 044s—continued in service until the end of steam at Rheine. Only modest post–World War II steam construction took place in West Germany, and the 043s, like most surviving locomotives, dated from the era of the Third Reich. (Summer 1976)

▲ The Rheine–Emden line featured the last high-speed steam-hauled expresses in Western Europe, worked by the 012 pacifics. Even after the 012s had been withdrawn from these turns in May 1975, enthusiasts continued to flock to the line to witness the heavy steam-hauled freight traffic, until it ended in October 1977. Here, an array of tenders' backs face out from the Rheine roundhouse. (Aug. 1976)

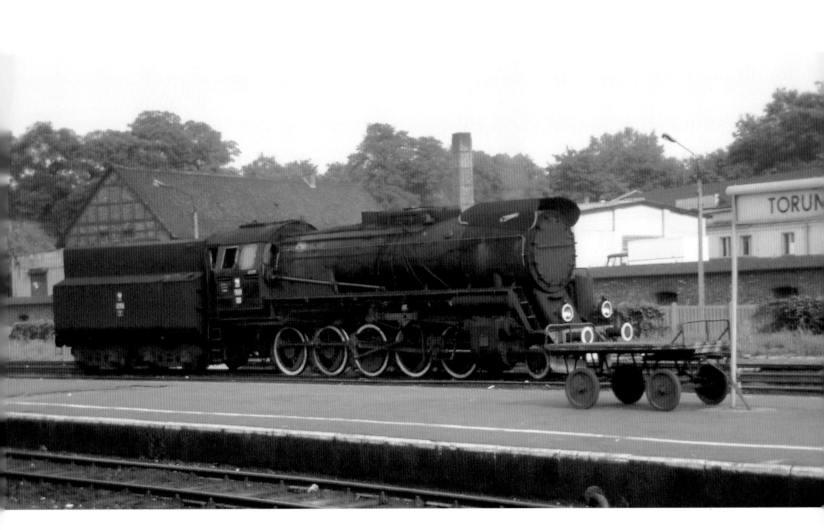

looking) steam locomotives, among them the super-sleek 477-class 4-8-4Ts, which seemed to hint at the direction in which steam design might have been headed had its further development not been arrested by the advent of the diesel.

Despite the many idiosyncratic types particular to each country within the region, overall a distinctly German feel pervaded the railroads of Eastern Europe. The German school of locomotive design was represented not only by steam engines bought from German manufacturers before World War II (such as the numerous old Prussian

P8 4-6-0s and G 10 0-10-0s to be found in Romania), and by those left behind during the Nazi retreat from the Red Army (particularly the Kriegslok, the standard Third Reich war engine, found throughout Eastern Europe but especially in Poland), but also in terms of lingering influence, with indigenous postwar designs (such as the Polish Pt47 2-8-2s and Ty45 2-10-0s) often looking distinctly German.

Poland, a country rich in coal reserves, was the major outpost for steam operations in Eastern Europe, with more steam locomotives still in service in the late 1970s than the rest of Europe combined. Just through the steam engines at a big junction such as Toruń, it was possible to see the country's history parade past in microcosm: aged Prussian veterans, Kriegsloks left behind by the retreating Nazis, postwar American locomotives donated through the United Nations Relief and Rehabilitation Administration (UNRRA) aid program, and passenger trains powered by indigenous designs built in the 1950s.

▲ Poland was *the* country for steam in Eastern Europe, featuring an enormous quantity and—until the late 1970s, at any rate—excellent quality too. Normally, photography at big junctions was all but impossible, but by some sheer fluke or miracle, the author managed to secure permission for an afternoon photography session at Toruń, a steam lover's paradise at this time, where 2-10-0 Ty51-35 is pictured. The Ty51 was Poland's last steam design, introduced in 1951, with 232 engines built until 1958. Originally intended for heavy freight work, the Ty51s were early casualties of dieselization. (Aug. 1977)

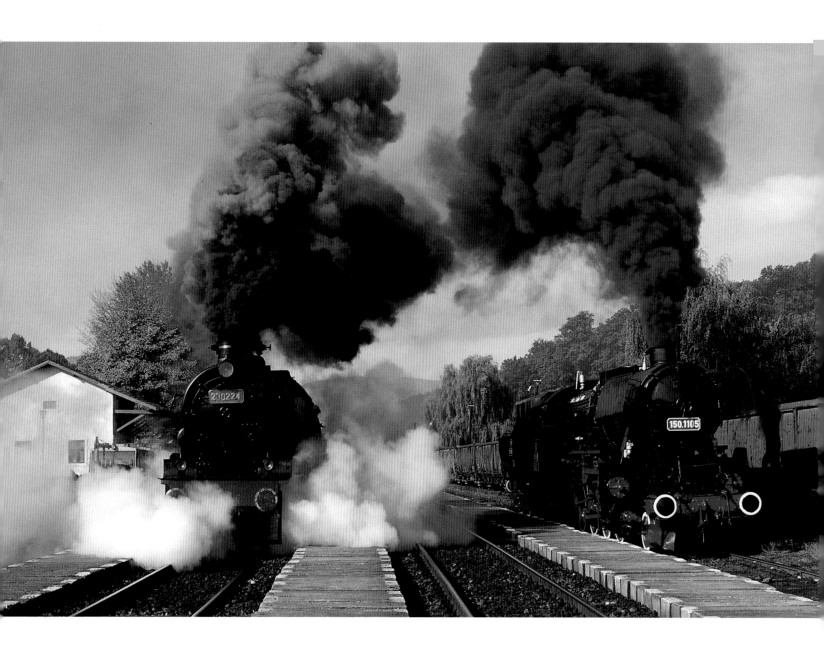

In theory, Eastern Europe during the 1970s should have been a steam lover's paradise, offering a wealth of attractions: Austrian veterans trundling down Slovenian branch lines, giant freight-marshaling yards in Silesia packed with pre- and postwar 2-10-0s, and modern steam superpower in the form of 498 4-8-2s and 556 2-10-0s from the 1950s thundering along Czech lines. In reality, however, because of the political nature of the times, much of what was in operation remained inaccessible to those eager to witness it. To a much greater extent than in the West, the Cold War was palpable all over Eastern Europe—the whole region was still seemingly stuck in the early 1950s.

Railroad stations were frequently filled with young conscripts in transit. Cult-of-personality portraits of the leading lights of the day, such as Nicolae Ceauşescu of Romania, Erich Honecker of East Germany, and Gustav Husák of Czechoslovakia, were a ubiquitous presence, alongside clichéd depictions of flinty-faced Worker-Heroes staring earnestly into foundry furnaces, accompanied by exhortations to meet the latest Five-Year Plan targets. Even the steam locomotives were dragooned into an agitprop role, their smokeboxes adorned with Red Stars (significantly, removed in Czechoslovakia during the attempted liberalization of Alexander Dubček's Prague Spring in

1968—and, just as significantly, reinstated following the reimposition of full-fledged Stalinism). Each station had its own generous complement of militia, almost invariably exuding paranoid hostility toward any foreigners dawdling about on railroad property. There was little understanding of railroad enthusiasm as such, and scant sense of the special nature of the historic steam locomotives eking out their twilight. Instead, any interest in the railroads was generally misconstrued as having ulterior motives of espionage.

Only in East Germany, where an indigenous culture of railroad enthusiasm already existed, did photography rarely pose a problem. Here aficionados were able to freely avail themselves of the many attractions on view—pacifics performing on high-speed turns out of Berlin, charming narrow-gauge lines in the Harz Mountains, and the inevitable Kriegsloks hauling freight up and down the countryside. Elsewhere in Eastern Europe, however, a considerably more stringent and suspicious Cold War mentality prevailed. The agenda of steam buffs traveling within Warsaw Pact countries was apt to feature such delights as arbitrary arrest, interrogation, confiscation of film, surveillance by the secret police, and even occasional expulsion from the country. Photographers often had to conduct a battle of wits against the authorities to return home with any film at all. For all that was on offer, therefore, Eastern Europe sometimes might as well have been on the moon—a great pity, given what was still available yet, even there, going all too fast.

Gradually, official attitudes eased somewhat, but ironically, by the time Communism collapsed in 1989—bringing all previous restrictions on photography to an end—there was scarcely anything left to photograph. Steam finished in Czechoslovakia in 1980, in Romania around the same year, in Hungary in 1986, and on the standard gauge in the German Democratic Republic in 1988. In Poland, regular steam service lingered on until 1992. With private car ownership proliferating under deregulation, and with governments no longer prepared to underwrite unprofitable enterprises, the railroads in Eastern Europe underwent much the same changes as those in the West had a generation earlier. In Poland and Romania especially, much track mileage was closed in the immediate post-Communist period.

THE REST OF THE WORLD

Turkey, straddling Europe and Asia, was the most convenient Asian country for European steam fans to see ongoing operations. At the beginning of 1981, Turkey still had 681 steam locomotives in stock (compared with 320 diesels and 48 electric locomotives), its fleet comprising a magnificent array of British-, German-, French-, American-, and Czech-built locomotives. South Africa, with some 1,819 steam locomotives still in service at the beginning of 1976, was another perennially popular destination, offering the unusual attraction of really big main-line steam locomotives working on just a three-foot-six-inch gauge, which continued right up until the late 1980s. Pakistan, renowned for its veteran British-built locomotives, still had 423 steam engines in stock in January 1984. The steam situation there had remained

◄ Romania's steam fleet was heavily dominated by German designs, such as the Prussian P8 4-6-0 and Kriegslok 2-10-0 seen side by side here at Podu Olt. Due to the repressive realities of the Ceauşescu regime, however, it was extremely difficult to practice railroad photography in Romania during the waning days of steam. (Oct. 1997)

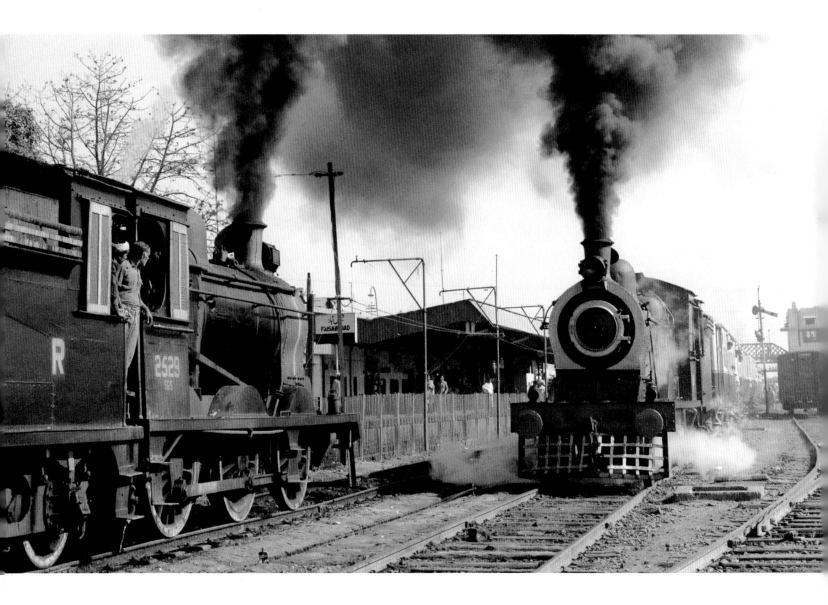

remarkably stable for a considerable amount of time, with little deterioration occurring after the main trunk routes had been dieselized. From 1987 onward, however, a more determined steam-displacement program got under way.

China and India were the two countries making the most intensive use of steam traction in the latter days of the Steam Age, with some 10,000 and 8,000 steam locomotives, respectively, still in service at the beginning of the 1980s. Factors favoring the retention of steam engines in both countries included abundant coal reserves and the

▲ In Pakistan, venerable British-built veterans soldiered gamely on into the 1990s. Pakistan Railways SPS 4-4-0 3008 puts on an excellent smoke display as it pulls out of Faisalabad on the 9:35 A.M. to Shorkot, passing SGS 2529 on station pilot duties at left. (March 1985)

availability of cheap labor. Due to the lumbering inertia of a centralized Five-Year Plan economy, steam construction in China continued even beyond the time when it logically ought to have stopped. As late as 1986, the Datong Locomotive Works was producing steam locomotives for which there was no longer any work. By then, however, railroad management in each country was well aware that the rest of the world had long voted for diesel. Even if overwhelming arguments still existed in favor of prolonging the use of steam, management there would still probably have become determined to eradicate it, if only to shake the stigma of backwardness attached to its continuation.

Throughout the 1980s, steam's star inexorably waned. By 1990, the Steam Age was over in Turkey and had

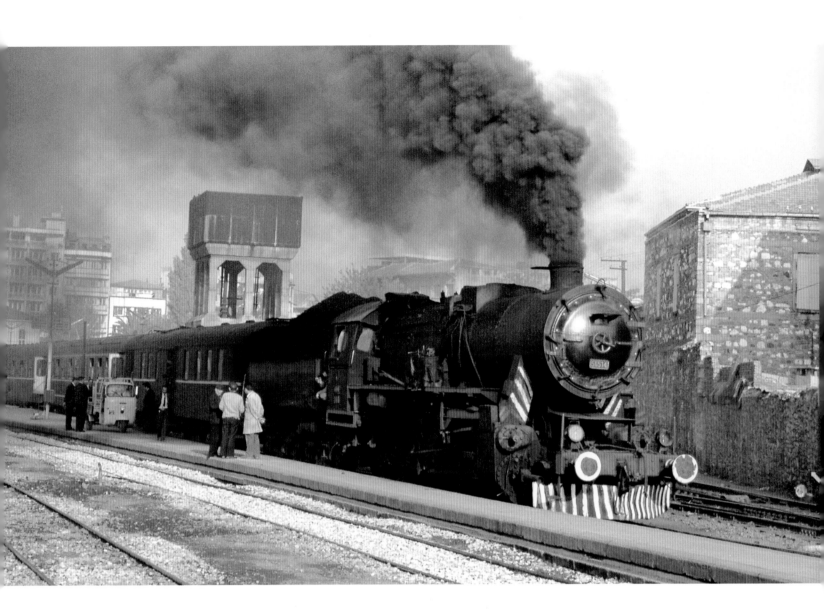

all but ended in South Africa. As the new decade got under way, only India, China, Pakistan, and Zimbabwe offered main-line steam operations in any quantity. Zimbabwe had passed a massive vote of confidence in steam at the outset of the 1980s, abandoning an intended dieselization program to instead undertake an extensive refurbishment of its steam fleet. In May 1993, however, it dieselized its main-line steam workings virtually overnight. By 2000, with steam on the Indian broad gauge having already ended in 1995 and just one isolated pocket—the Mirpur Khas meter-gauge system—left in Pakistan, only China remained as a relatively major steam outpost, along with much-smaller-scale operations to be seen only seasonally in Cuba. Even in China, steam operations were phased out

rapidly between 1996 and 2000, with what steam survived, as it entered the twenty-first century, employed mostly on minor shunting duties within industries.

▲ The German Kriegslok (literally "war locomotive"), mass-produced to a quantity of some 8,000, was one of the most successful steam-engine types ever and seemingly omnipresent in the latter years of steam in Europe, often outliving more modern designs built in the 1950s. Germany supplied some 53 Kriegsloks to Turkey in 1943–44, this at a time of military setbacks when Germany was particularly eager for Turkey to maintain its neutral stance during World War II. Some forty years later, 56514 is seen brewing up in the early-morning sunshine at İzmir (Basmane) at the head of the 8:15 A.M. Mixed (both freight and passengers) to Afyon. Featuring excellent scenery, friendly locals, and a wide variety of steam-engine classes, Turkey was a popular country on the overseas steam-chasing circuit, with steam holding out until 1990. (April 26, 1985)

Chasing the Steam Trail

IF RAILROAD MANAGEMENTS HAVE OFTEN been fanatic in their determination to displace steam, more than equal to their fanaticism is that of the thousands of steam aficionados who have devoted themselves to recording on film the endgame of their heroes. Never has a disappearing form of technology been documented with such zeal, and the obsessiveness with which the steam locomotive has been followed indicates just how much it is loved. There must exist literally millions of images of steam locomotives within the private collections of the countless numbers of people who have made inordinate efforts to ensure that even if steam was doomed to oblivion, something of its beauty would endure. Inextricable, indeed, from the wider story of steam's endgame is this particular dimension, the quixotic chase after vanishing vapor.

Over the past few decades around the world, railroad employees and officials were brought into contact with this strange Western fascination—some simply bemused, but others (as was the case in Communist countries during the Cold War) not at all amused. Crews generally got used to the intent-looking individuals to be found awaiting their passage in the strangest places, whether perched precariously up a mountain face in eastern Turkey or patiently suffering subzero temperatures on the steppes of northeastern China, while railroad police kept an eye out for these shifty-eyed characters—similarly on the lookout for *them*—who persisted in trying to slip into restricted, off-limits areas such as loco sheds.

When the cult of steam chasing got under way seriously in the late 1960s (with Germans and British tending to be the most strongly represented among many nationalities, including Australians, Swiss, South Africans, and Japanese), the biggest problem was obtaining good-quality information on where the best available steam action might be found. Enthusiasts might have been dimly aware that steam operations existed in, say, Hungary or Turkey without knowing specifically where to go. Soon an infrastructure came into being to serve the burgeoning number of aficionados, in the form of specialized magazines such as *World Steam* and *Continental Railway Journal* in England and *Dampf und Reise* (Steam and Travel) in Germany. The contents of such publications were effectively provided by readers, who sent magazine editors reports of their most recent steam-chasing trips, detailing the latest particulars—which lines were still steam-powered, which had gone diesel, and where the last members of rare classes could be found, along with maps giving directions to particularly scenic lineside photographic positions.

This pooling of information on often obscure parts of the world about which little or no tourist literature existed has undoubtedly been one of the most impressive achievements of the steam-chasing culture. Whatever was available, whether Prussian veterans at work in the backcountry of Turkey or densely trafficked steam routes through the lush landscape of West Bengal in India, the international steam-chasing fraternity somehow or other got to hear about it. So effective was this information system that even in giant countries such as India and China, the steam situation was comprehensively charted, with precious few gaps left to be filled in.

It was a happy accident of fate that the twilight of the Steam Age coincided with the dawn of a new trans-

portation era, that of international air travel. Whereas prospective travelers to far-off destinations such as Africa or Asia formerly had to embark on long voyages by ship, by the late 1960s affordable long-haul flights were becoming available for the first time. For the many steam enthusiasts who could take full advantage of this new age of travel, there was no question that global distance did indeed radically contract as the business of reaching far-away lineside locations, whether in South Africa, India, or Brazil, suddenly became simplicity itself, just a question of hopping aboard a 747 and, a mere matter of hours later, being halfway around the world.

Enthusiasts arriving at some of the unlikeliest backwaters, whether in Poland, India, or Pakistan, often knew in advance precisely which trains were steam, where best to photograph them, where the nearest hotel was situated, and so forth. The mere appearance of foreigners in some farther-flung spots, however, frequently created a minor local sensation, with visiting enthusiasts being regarded almost as extraterrestrials—often, indeed, becoming something of a tourist attraction themselves. In parts of India especially, many steam chasers experienced the Pied Piper of Hamelin syndrome firsthand, pulling huge crowds that could shadow them right across town in tireless amazement.

Chasing the steam trail could be a tough undertaking and, in some countries, definitely a labor of love. The average overseas steam trip might be immensely rewarding but could scarcely be considered a vacation in the traditionally conceived sense. In most cases, steam chasing was a Spartan, fanatic lifestyle, pursued at a break-neck pace, with creature comforts rating very much as secondary considerations, and with food and sleep tending to be fitted in and around the steam action as circumstances permitted. Photographers often arose at unearthly hours to drive themselves into forbidding climatic extremes—in China, for example, staggering from warm beds into temperatures well below zero. On the Indian subcontinent, the heat near a rail line could be enervating as early as eight o'clock in the morning, and several hours later, no amount of liquid intake would seem capable of slaking the diabolical, unremitting thirst.

The places where steam locomotives could still be found working were often situated in remote areas with only the most basic—or sometimes nonexistent—tourist infrastructure. Social conditions in certain locations, moreover, were so dire that steam photography could sometimes seem an irrelevant indulgence even to the most ardent aficionado. There were language problems to be surmounted—these were particularly insurmountable in China, where the language was represented in a cryptic script, which made the deciphering of railroad timetables, to figure out onward travel options, a frequently stressful affair. Between locations, there were long journeys on overcrowded trains. More often than I would care to recall, I have found myself squashed and bleary-eyed in a dingy corridor in the wee small hours, wondering what kind of accommodation, if any, might await at journey's end. Some of the overnight lodgings encountered on the steam trail—grim, cockroach-infested hovels—could stretch previous conceptions of just what could be encompassed by the term *hotel* to new limits of understanding.

Many interminable hours could be spent negotiating Kafkaesque labyrinths to secure photographic permission. In certain countries, unpleasant tussles with police were de rigueur, and sometimes many more hours ended up being spent in police custody. In Eastern Europe, even picking a seemingly secluded lineside spot out in the country did not suffice to steer clear of trouble, as suspicious farmhands working in adjacent fields could telephone the police. In such circumstances, one often had to resort to bizarre stratagems. I well recall, for instance, during a 1983 tour of Poland, setting off from Olsztyn at daybreak and tramping some ten miles out of town before turning off into a dense forest adjoining the line, where I remained ensconced the entire day without encountering a soul, breaking cover only when a train appeared, and then moving on to a new spot—a not entirely paranoid precaution, since engine crews also could report the location of lineside photographers to railroad police at the next station down the line. Elsewhere, there was no shortage of hairy situations, my own hairiest being caught up in an anti-Sikh riot at Raipur, India, in the immediate aftermath of Indira Gandhi's assassination in 1984, during which the Sikh-owned hotel in which I was staying was set ablaze by a mob, necessitating a mad dash into the building to salvage six months' worth of (miraculously unscathed) exposed film.

For some, the rigors of independent travel within Third World countries, even to see steam operations, could be too much. For those preferring an easier option or with limited time at hand, an infrastructure conveniently came into being in the form of specialized tour companies, generally run by steam enthusiasts themselves and catering to the particular needs of the steam buff, with itineraries devoted exclusively to the photography of steam locomotives. For those going it alone, however, backpacking on an

◀ As steam declined in Europe, vapor aficionados found themselves traveling ever farther afield to ever more exotic locations. Distinctive hourglass-shaped tea glasses and copies of *Hurriyet* on this shunter's table, set under the shade of trees, provide unmistakable pointers that this shot was taken in Turkey—as does the locomotive, a 45001-class 2-8-0, with this particular example, 45052, supplied by Nohab of Sweden in 1935. The location is Konya, famed hometown of the whirling dervishes. (Aug. 22, 1982)

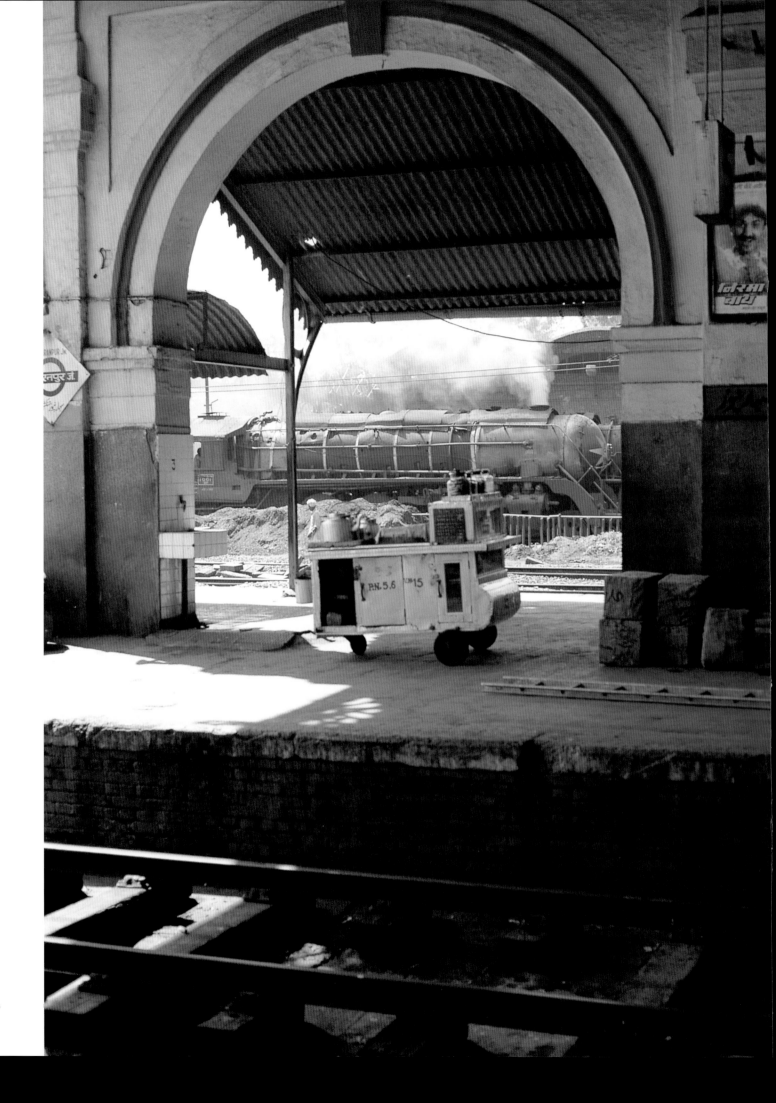

ad hoc, open-ended basis around remote regions, where foreigners had in many instances never previously been seen, could be a real adventure that in fact stretched the traveler in many ways.

Being thrown exclusively upon one's own resources in unfamiliar surroundings, with no one else to depend on to keep the show rolling in terms of getting tickets, finding hotels, hassling for permission to photograph, and so forth, fostered a fine feeling of self-sufficiency. The very nature of the traveling lifestyle, being constantly off-balance with no cozy familiarity to slip into, facilitated a more vital experience of self and world, which back home could all too often be atrophied by the numbing sameness of predictable, quotidian routine. On the road in search of steam, every day was a new point of departure, never the same. In consequence, one seemed to be living on a more essential existential plane—living in the moment, rather than by the clock.

At some more opaque psychological level too, the whole steam-chasing lifestyle could be said to entail something of an atavistic throwback to an erstwhile hunter-collector modus vivendi, a shadow playing out of old species instincts largely stifled by civilization—the primal imperative, to hunt after game. Certainly, to the photographer out there on the spot, it really seemed somehow to have the quality of a hunt, albeit an innocuous one, resulting in no carnage but merely the trapping of images

in time. Like hunters, steam photographers would typically arise before daybreak—in their case, to catch the optimum early-morning light. Out there, somewhere in the day, lay the quarry: the big, ever-elusive master shot, in which all the elements—location, composition, available light, exposure—would come together perfectly to grant a result epitomizing the magic of the machine.

Being outdoors all day in pursuit of this goal, through all kinds of weather, always acted as a keen sharpener of the senses. On location, steam photographers generally functioned in a more primal, nature-related mode, bringing a whole range of blunted sensibilities back into play, always acutely aware of such things as the position of the sun, the subtle nuances of light on landscape, and the topography, as when scaling arduous hillsides to secure the best photographic positions. This connectedness to physical environment—a faculty progressively being lost touch with, it would seem, in our ever more virtual (computer-, video-, and television-) screen-mediated culture of life that is ever further at a remove from life itself—invariably promoted a heightened sense of being alive, of being more vitally present in the here and now.

While the photographic pursuit of steam locomotives may have been a very narrowly focused travel agenda, at the same time it was tremendously horizon-broadening in many ancillary respects. Although steam may have been

◀ As steam progressively declined, locations that might not hitherto have enjoyed special attention stood out as solid steam bastions amid a surrounding flood tide of dieselization. Ten years earlier, Saharanpur would have been only one of many Indian locations at which one could witness the wonderful WP pacifics. By the time this shot was taken, however, it was the last shed with a significant number (twenty-two) of the class allocated. A lazy early-afternoon siesta atmosphere pervades this scene, glimpsed through one of the station arches, of a WP basking in the sunshine at the loco shed, with a vendor's trolley in the foreground. (Sept. 1992)

the main focus, the photographer was always operating within a wider context, and even the most blinkered, vapor-obsessive fanatic could hardly avoid absorbing something of this. Like many others, I have found myself ending up in some of the oddest, most out-of-the-way places, which, were it not for the vital, galvanizing factor of steam, I would hardly have set eyes on: dusty provincial towns on the Hungarian *puszta,* sleepy cross-country junctions on the Polish steppes, remote towns in the heartland of rural India—places that were interesting in themselves, quite apart from the steam, and which conveyed a wider perspective of a country than might have been gleaned from a more conventional style of touring, restricted to big, established tourist centers.

Furthermore, in the course of pursuing their passion, enthusiasts witnessed firsthand not only a fascinating variety of countries, but also at particular historic junctures: Poland in the period of martial law, South Africa during the apartheid era, Romania under Ceaușescu, and India in its year of crisis, 1984. Inevitably, therefore, even if by default, one offshoot of chasing the steam trail was a wider sense of the world itself. On location, steam aficionados

▶ Though only single-tracked, the Yinchuan–Zhongwei route in Ningxia Province, northwestern China, was an extremely busy trunk route. In the background beyond the signalman's cabin, in this shot taken at an intermediate station, no fewer than three QJ-hauled freights are awaiting access onto the main line to continue south to Zhongwei. This scene was soon to vanish. In accordance with China Rail's policy of targeting heavily trafficked main lines for dieselization, the Yinchuan–Zhongwei line (itself part of the Beijing–Baotou–Lanzhou–Ürümqi trunk route, connecting the capital to the far west of the country) was fully dieselized just a year later. (Jan. 1995)

certainly encountered a broad array of people from widely divergent cultures. Language problems notwithstanding, there was much friendly interaction between photographers and locomotive crews, with drivers sometimes offering rides in the cab or entering into the spirit of things by staging smoke displays on cue to facilitate dramatic shots. Working as they did with steam on an everyday basis, the crews were no strangers to the animistic qualities of the machine and could often well appreciate what motivated this obsession to record the endgame of a vanishing beauty that they, too, could perceive.

The general public, however, was less prone to see any sense to the whole endeavor, and there were many hilarious cross-cultural encounters, with locals frequently incredulous at the raptures into which foreigners could be sent by prosaic old steam engines. It was one anomaly of the steam-chasing culture that, with a few exceptions such as South Africa and East Germany, there was no indigenous culture of steam enthusiasm in most countries along the steam-chasing trail, and the passing of this particular historical era, while documented with fervent, flat-out fanaticism by foreigners, was locally all but ignored.

Ultimately, the most vital area in which steam enthusiasts were stretched was in the practice of their art. Most began as mere amateurs who came to photography through a love of steam locomotives, yet often ended up far exceeding earlier efforts to undertake breathtakingly imaginative interpretations of their subjects. For each photographer, the challenge of taking ever-better pictures became a kind of personal odyssey. I am not alone, no doubt, in wishing I could have recorded the scenes I witnessed ear-

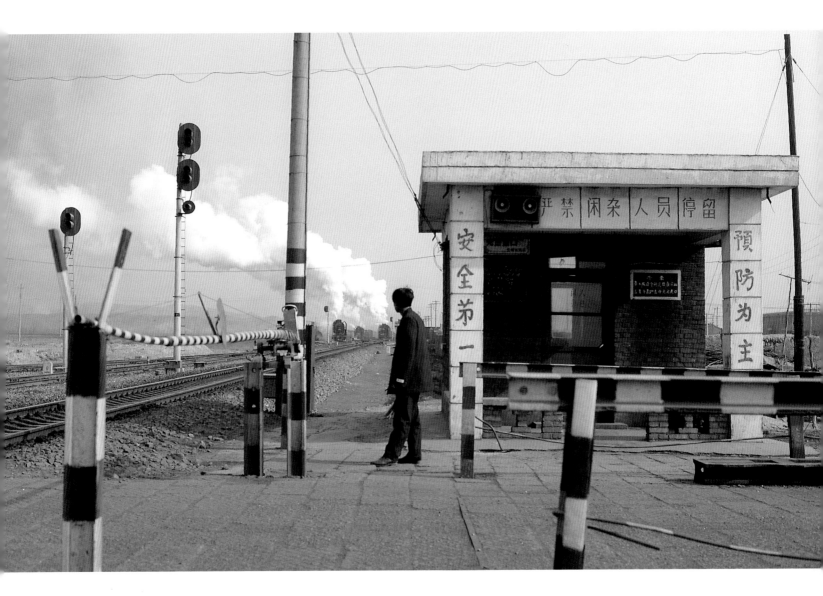

lier, in the 1970s, with the photographic skills and sensibility I have since acquired. For most of us, however, the honing of photographic talent was a process that took time, entailing much trial, error, and patience along the way.

No matter how often the photographer satisfactorily froze images in time, it still somehow never satiated the need to experience yet again the spell of steam in another new circumstance. All the while, of course, galvanizing the practitioners of this particular photographic genre was the acute awareness that theirs was a subject matter that would be around for a limited time only. It was precisely that fact—the dead certainty of witnessing the last throes of something about to vanish forever—which gave the obsession (for *hobby* would be too tame a term, by

far) of photographing the world's last working steam locomotives such a special edge.

For all the losses sustained over the years, there have been gains as well. The two major countries remaining on the steam-chasing trail—China and Cuba—were once largely inaccessible. Cuba only began to open up to steam photographers in the 1980s, while China was until the mid-1980s a forebodingly closed society enforcing stringent restrictions on the free movement of foreigners. By the mid-1990s, most of the country was accessible to independent travelers, a fine and fortunate thing, for it would have been a major calamity if this—the very last outpost of big, mainline steam operations in the world—had remained off-limits to those eager to witness steam's final fling.

Steam Meccas

SUCH WAS THE QUALITY OF STEAM operations at certain locations—whether because of rare locomotive classes, spectacular nature, or the volume of the operations—that they became meccas to visiting enthusiasts, musts on the overseas steam-photography circuit. When the cult of steam chasing first began in the late 1960s, only a shadowy outline existed of what was available around the world. Intrepid explorers quickly displayed a remarkable talent for winkling out the prime steam spots, then reporting their finds back to magazines such as *World Steam,* which published that information for the benefit of others. Little by little, this filled in the picture as to where best to see steam in action.

Towns with no previous significant tradition of tourism—such as Rheine in West Germany, Saalfeld in East Germany, and Kłodzko in Poland—suddenly found themselves swamped by a motley, multinational crew of camera-toting fanatics, solely based on the quality of steam operations. Then, once steam had been displaced there, those towns lapsed back into obscurity equally suddenly. Some of the most incongruous spots in the world became a focus of international attention—few more so than the rural backwater of Malakwal in Pakistani Punjab. Despite being little more than a dust-blown cross-country junction with only the most basic of hotel facilities, Malakwal—to the considerable bewilderment of its inhabitants—drew countless vapor aficionados from all over the world just to see the veteran British-built steam engines working there.

With its vast, uncharted expanse, China presented the biggest challenge for discovering new top spots in steam. Once the country began to open up for independent, unchaperoned travel in the mid-1980s, it was steam photographers more than any other type of traveler who tested the boundaries of what was and was not officially permissible, venturing off into the remoter regions of the country's giant interior, then spreading the word back home among the faithful as to what could be found where. As in all the other countries where steam had fought its losing battle against time, China soon had its meccas too, locations drawing photographers in droves, the common denominator tending to be steep grades that forced locomotives to work flat out and put on a show.

The Tianzhu–Wuwei section of the Yinchuan–Ürümqi trunk route, set in a barren, lunar wasteland, was hardly the kind of destination the Chinese authorities had envisaged foreigners flocking to when they opened up the country to tourism for the purpose of netting valuable hard currency. However, once the international steam-chasing fraternity became aware of what was available there—double-headed steam freights threading through a breathtakingly stark landscape dwarfed by 10,000-foot mountains—there was no stopping the enthusiasts, notwithstanding the frequent altercations with authorities that ensued. In addition to arrest, official escort away from the area, and confiscation of film and occasionally equipment as well, some steam fans even found themselves enmeshed

► The unlikely backwater of Malakwal, Pakistan, midway along the Lala Musa–Sargodha route, drew steam fans for two decades. With its British-built engines—mostly SPS 4-4-0s from 1904–22 and SGS 0-6-0s from 1911–22—and venerable coaching stock, Malakwal seemed little removed from 1920s India. In this view of the high-set signal tower, an SGS 0-6-0 curves in on the 1:50 A.M. Shorkot–Lala Musa passenger run. (March 1985)

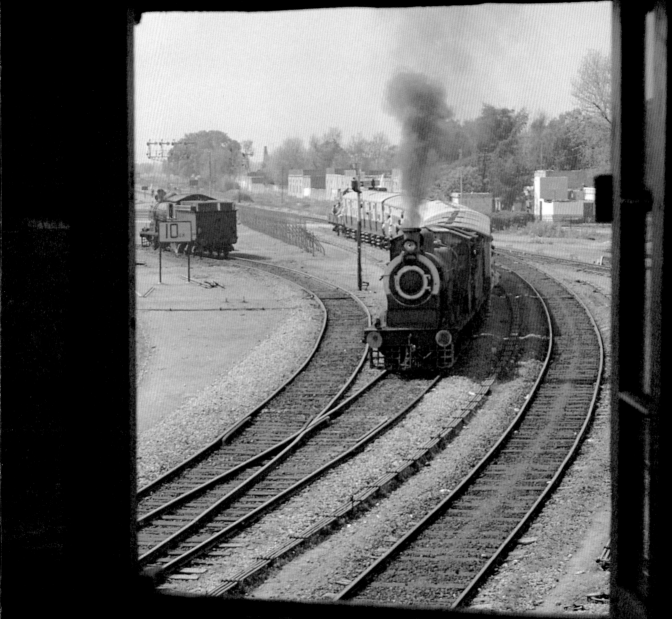

in purely absurdist scenarios—being arraigned before People's Courts, and in classically Communist show-trial style being obliged to write out confessions–cum–self-criticisms for the crime of incursion into a closed area—before being permitted to go on their way.

When Tianzhu went over to diesel in 1992, as with so many other much-loved localities to which they had bade farewell over the years, steam enthusiasts just had to stoically accept the loss and set their sights elsewhere. The Zhongwei–Gantang line on the fringes of the Tengger desert, which featured double-, triple-, and sometimes even quadruple-headed steam freights traversing a similarly stark northwestern Chinese landscape, was another major mecca, until it succumbed to diesel too, in December 1994.

With its impressive collection of temples, the former imperial summer resort of Chengde, about 150 miles northeast of Beijing, may be a prime tourist spot. Steam photographers, however, generally sidestep its more conventional attractions. Instead, since around 1992, they have been making for the western suburbs to take up position on the high hillsides overlooking the Chengde Steelworks branch. Just out of town, westbound freights face a severe climb to a tunnel summit. Three locomotives are required to surmount the grade, generally one up front and two pushing from behind. By the time they reach the top, they will be practically grinding along at walking pace, spewing out giant mushroom clouds of smoke, their disparate exhaust beats ricocheting back off the hillsides in a cacophonous swirl of rhythm.

Nancha, a junction on the Harbin–Jiamusi line, was more typical of the kind of place in which steam

▶ For about a decade, the junction of Nancha on the Harbin–Jiamusi main line in China was one of *the* places on the steam-chasing circuit. The major attraction was the Wuyiling branch, which featured a fabulously dramatic bank just out of town, leading straight into another coming south into Nancha. Both necessitated two- or three-engine combinations per train. Photographers generally concentrated on uphill workings because of the spectacular smoke effects, but here a pleasing result has been managed showing two QJs coasting downhill on a log freight. Diesels began to appear on freight in the winter of 1995–96. By the end of 1997, the reign of steam at this onetime mecca was over. (March 1995)

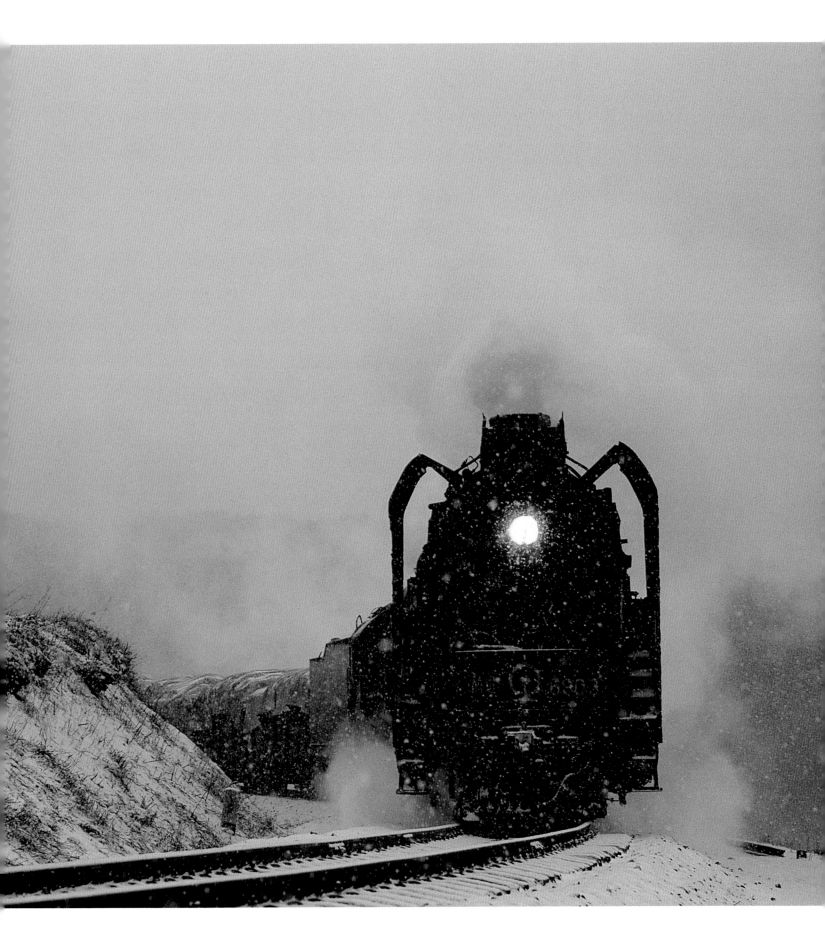

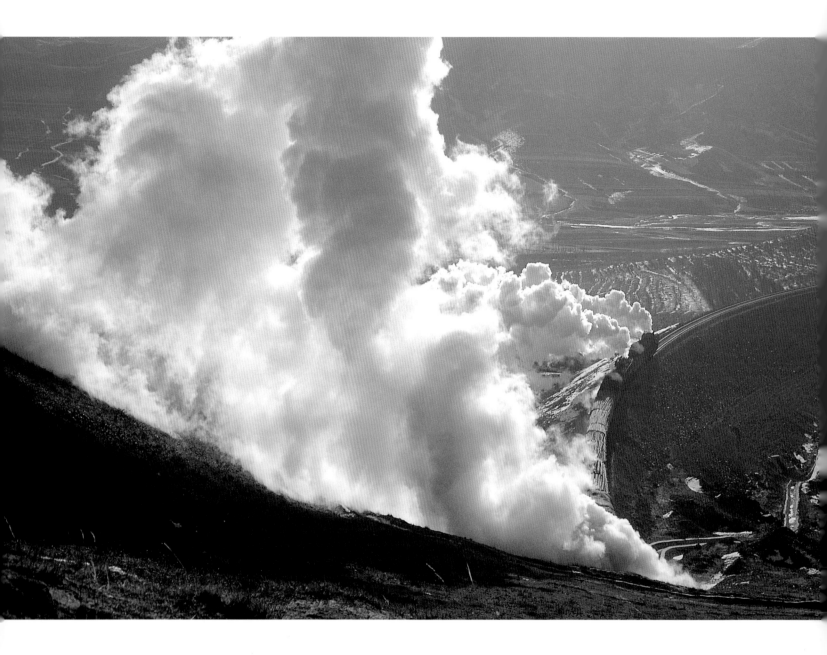

photographers have found themselves ending up: a non-descript backwater with only two run-down hotels, but featuring a fabulously dramatic bank on the branch to Wuyiling, leading straight into another coming south. During its short period of fame between its discovery in the

▲ The extremely scenic Jingpeng Pass in Inner Mongolia went straight to number one, the world's top steam attraction, when the 586-mile Tongliao–Jining Local Government Railway opened for traffic in December 1995. This is a rear three-quarters view of two QJ-class 2-10-2s, with a morning westbound freight, emerging from the tunnel on the ledge overlooking Reshui and curving around to change direction as they continue upgrade toward Liudigou, and thence to the summit at Shangdian. (Jan. 26, 1999)

late 1980s and the end of steam there in 1997, locals became accustomed to the sight of foreigners mooching along the line in the foulest subzero conditions.

Yebaishou, a junction on the Chengde–Shenyang line, was another steam mecca with a short life span, hardly discovered (in 1994) before the diesels were drafted (in 1997) to displace steam there. Following reports of double- and occasionally even triple-headed steam freights over scenic, steeply graded sections on all three routes out of town, the faithful began flocking there too, with business booming as never before at the Jianpeng, the only tourist-standard hotel in town. In common with so many

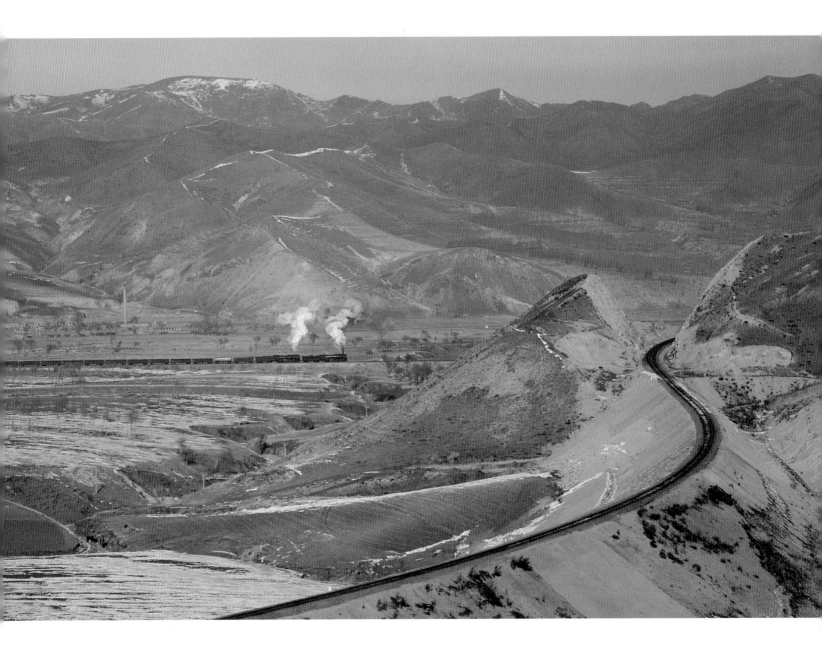

other unlikely places worldwide, now it was the turn of the townspeople of Yebaishou to be both amused and bewildered by the sudden influx of foreigners, especially when they discovered what had drawn these visitors. There too, however, once steam started to dwindle away, so did the short-lived local tourism boom.

Right up to the eleventh hour in China, enthusiasts continued to come upon new steam meccas. Almost as soon as the new 100 percent steam-powered, 586-mile route between Tongliao and Jining opened in December 1995, an intrepid enthusiast reconnoitered the line on the caboose of a freight train to ascertain whether there might

be any worthwhile offerings for steam photography. He was not disappointed, discovering a spectacular section through a mountain pass between Galadesitai and Jingpeng, snaking up to a summit 4,000 feet above sea level via sweeping S curves, the grade reducing the double-headed QJ-class freights to a walking pace. In the familiar fashion, now every self-respecting steam lover wants to make the trek to Jingpeng, the latest "must" not to be missed.

▲ Another view from the Jingpeng Pass, this one taken from Liudigou, and looking down toward a pair of QJs battling upgrade from Reshui. Sometime later, the train will pass before the rails visible in the foreground, except now facing in the opposite direction. (Jan. 24, 1999)

Steam in the Landscape

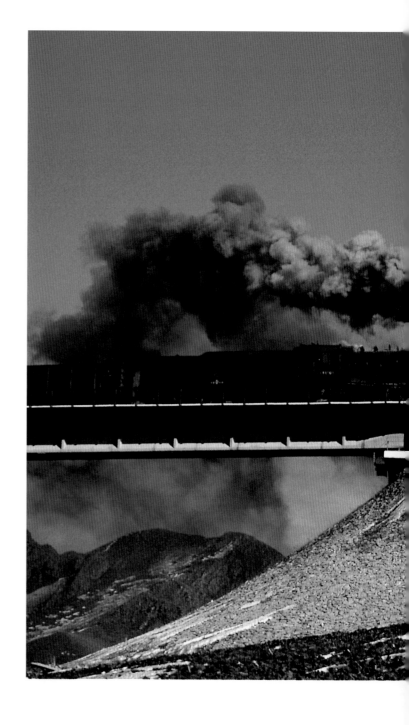

THE MOST POPULARLY PRACTICED TYPE of steam photography has been the depiction of steam locomotives in action within a landscape context, whether linesiding—in which the photographer selects a suitably photogenic spot out in the country and waits for the trains to come—or chasing, in which the train is pursued by car. In countries such as China and India, where densely trafficked steam routes abounded, linesiding was generally the preferred option. This entailed a lot of waiting, relatively speaking, around brief bursts of action. In countries such as Turkey, on the other hand, it made more sense to chase, sometimes even staying with the same train all day.

One appreciation intimately allied to that of steam locomotives is for good scenery, for there is little that more effectively complements the drama of a steam engine than a suitably striking backdrop. In this respect, some of the settings against which steam's last acts were played out were truly superb: the vine-clad valleys of the Douro in Portugal and Mosel in West Germany back in the 1970s, the rugged lunar landscapes of eastern Turkey and Pakistan's North-West Frontier during the 1980s, and the spectacular mountain passes over rocky wastelands in China during the 1990s.

Days spent along the lines, waiting for trains to go by, could pass with idyllic timelessness, with so much else coming into focus besides the steam: the beauty of the surrounding countryside, the ever-changing effects of light

▲ A former Soviet Er-class 0-10-0 heads an enthusiasts' special at Vorokhta, along Ukraine's most scenic line, between Ivano-Frankivs'k and Rakhiv, near the Romanian border. (June 4, 1993)

► In the Jingpeng Pass, China Rail QJs 7137 and 6760 come off the Xiakengzi viaduct with a Daban-bound freight. (March 2, 1999)

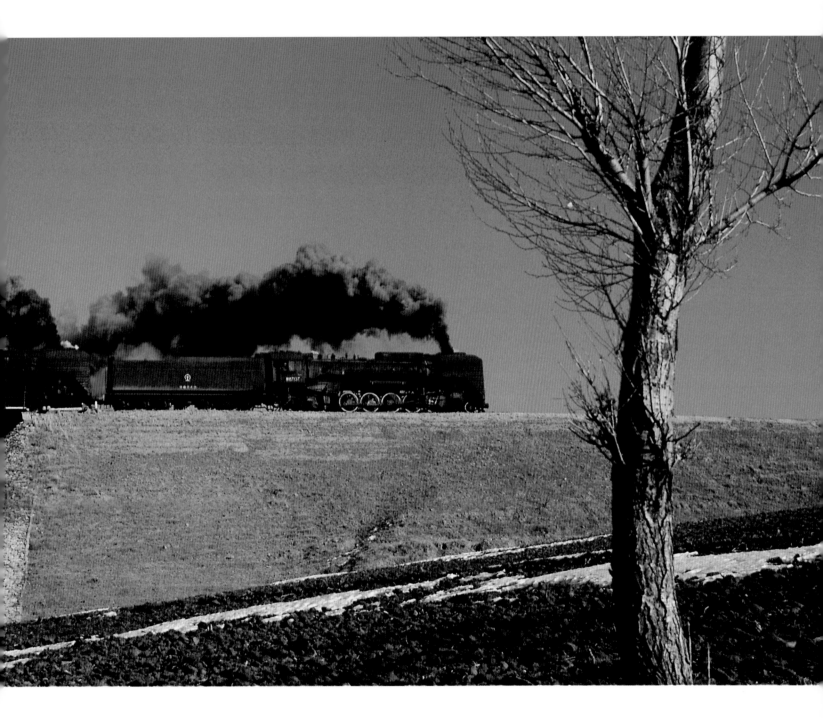

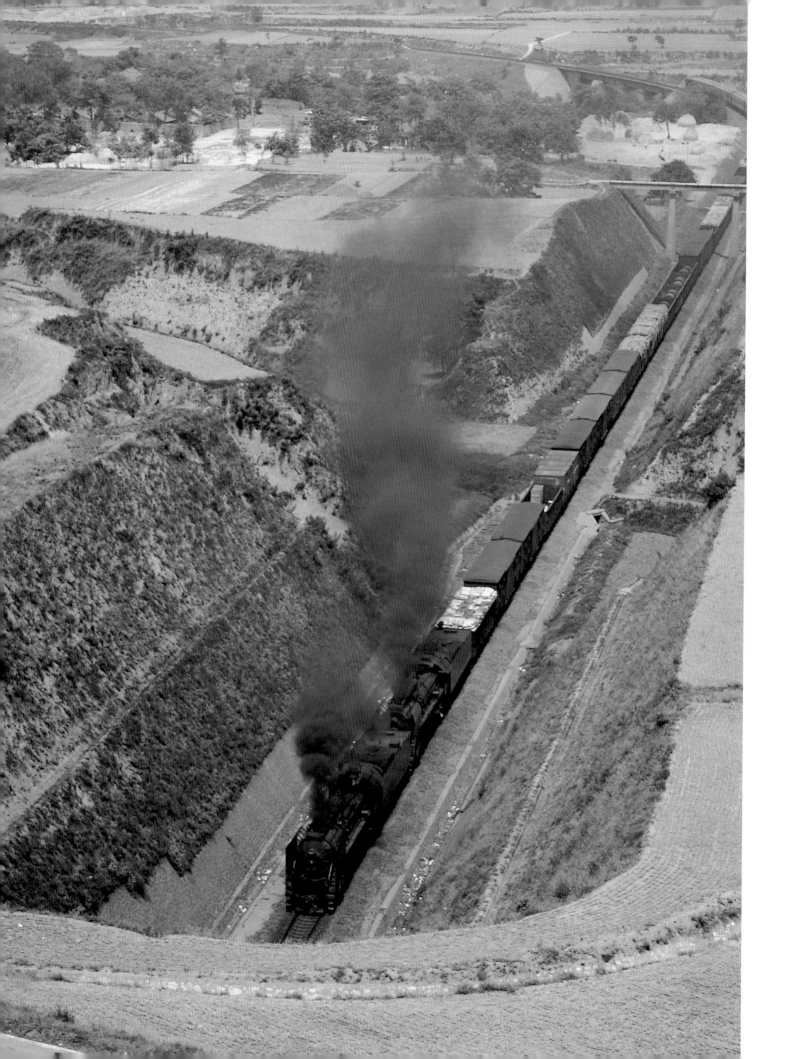

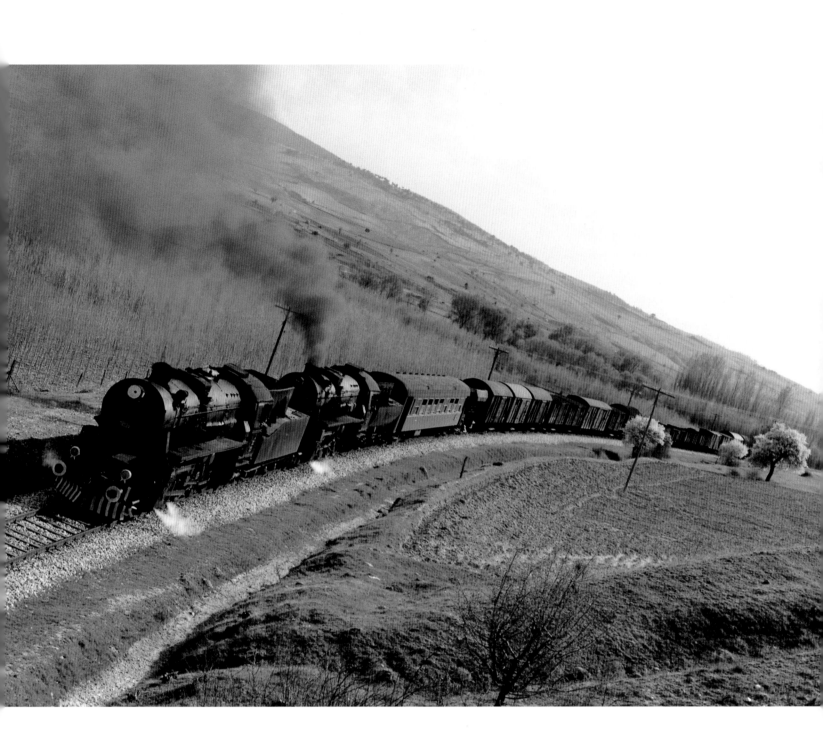

on landscape, the peace and tranquillity—all experienced with the increased sense of aliveness that comes from being out of a familiar context and more keenly attuned to the myriad nuances of the fleeting present.

Even at this late stage, some excellent landscapes remain. In China, there is the fabulously dramatic Jingpeng Pass on the Tongliao–Jining line in Inner Mongolia. In Cuba, the sugarcane fields provide a pretty tropical setting. Since the end of the Cold War, special steam rail-tour groups have also been able to access some superbly scenic yet rarely visited parts of Europe, such as the Carpathians, in both Romania and Ukraine.

A view of the popular Alaşehir–Afyon Mixed—a freight formation with one or two passenger coaches attached—behind Kriegsloks 56522/56547, between İnay and Uşak in western Turkey. (April 19, 1985)

The steeply graded Gangkou–Mengyuan section of the Linfen–Mengyuan route in Shanxi Province, China, traverses a fascinating loess-soil landscape. Here, a pair of QJs grind upgrade during wheat-harvesting season. (June 7, 1995)

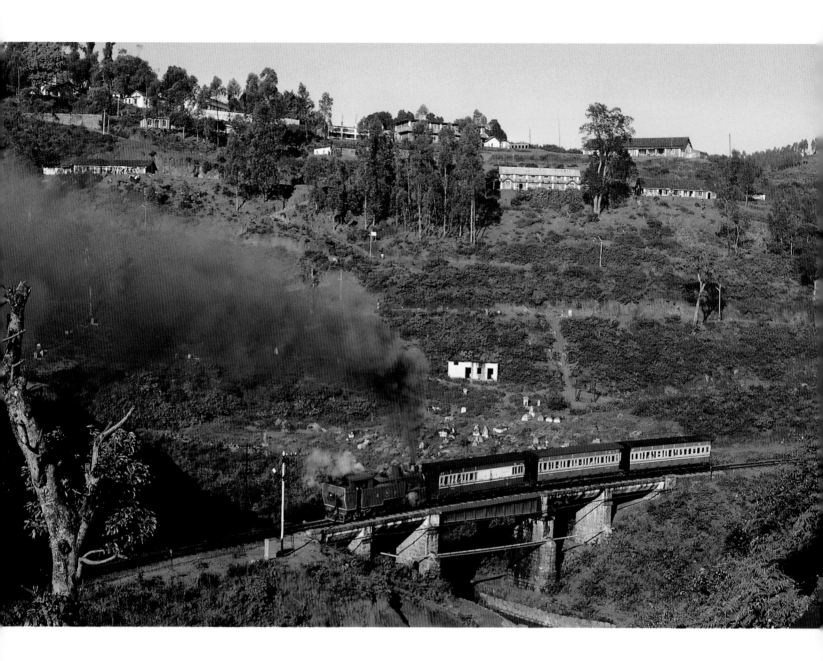

▲ The celebrated meter-gauge Nilgiri Railway, in the southern Indian state of Tamil Nadu, climbs steeply away from Mettuppalaiyam to the former hill station of 'Ooty (Ootacamund), situated 7,440 feet above sea level amid the Nilgiri Hills. The first section of the line is rack-operated, traversing steamy, tropical jungle, but from Coonoor onward it is in a more temperate environment, with tea plantations straddling the hillsides. In this view taken at Wellington, just beyond Coonoor, X-class 0-8-2RT 37384 propels the 8:00 A.M. Coonoor–'Ooty uphill. The line is featured prominently in the film *A Passage to India*. Steam traction remains in use, though restricted these days to the Mettuppalaiyam–Coonoor section. (Dec. 1984)

▶ Generally speaking, India is a flat, dry, and dusty country, not especially noted for good scenic contexts. There were exceptions, however, such as the former Portuguese colony of Goa, which enjoys a lush, tropical setting. In this view taken on New Year's Day, palm trees conveniently frame the meter-gauge YD 2-8-2 30166 nearing Suravali on the 6:15 A.M. Kolamb–Marmagao passenger run. (Jan. 1, 1985)

▼ The waterlogged fields testify to recently fallen monsoon rains at Parsabazar, Bihar State, India, as a farmer herds his pigs ahead of WP pacific 7618 on the 4:00 P.M. Patna–Gaya passenger run. (Aug. 17, 1984)

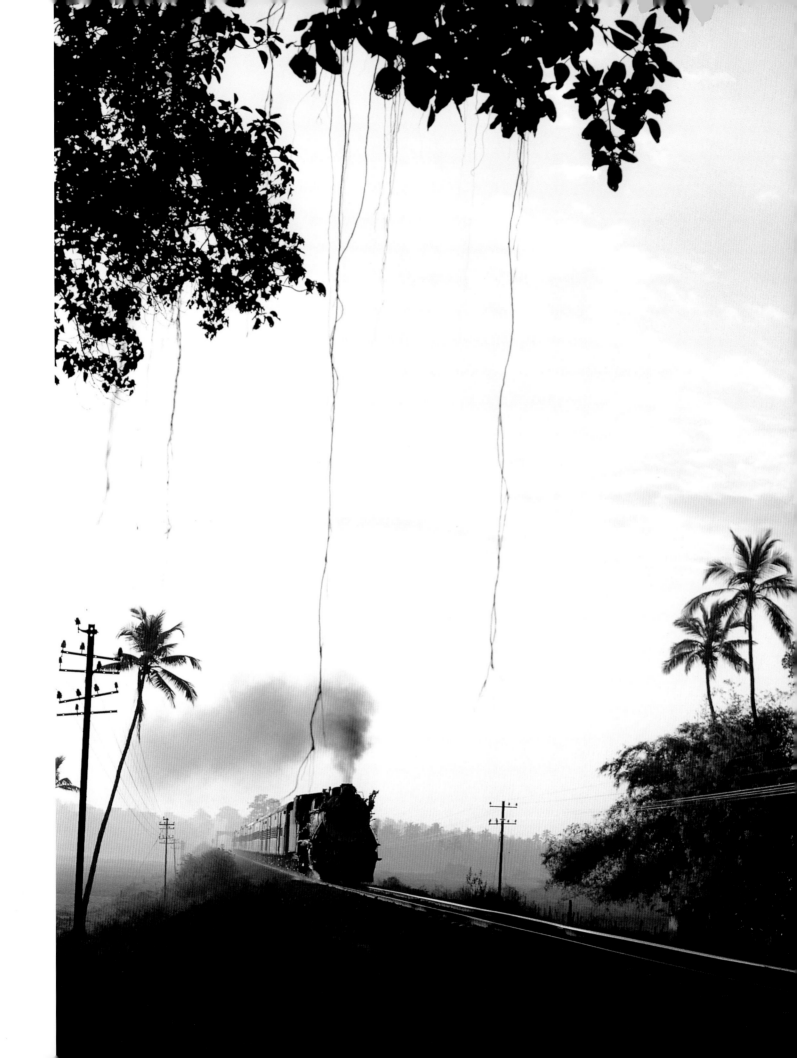

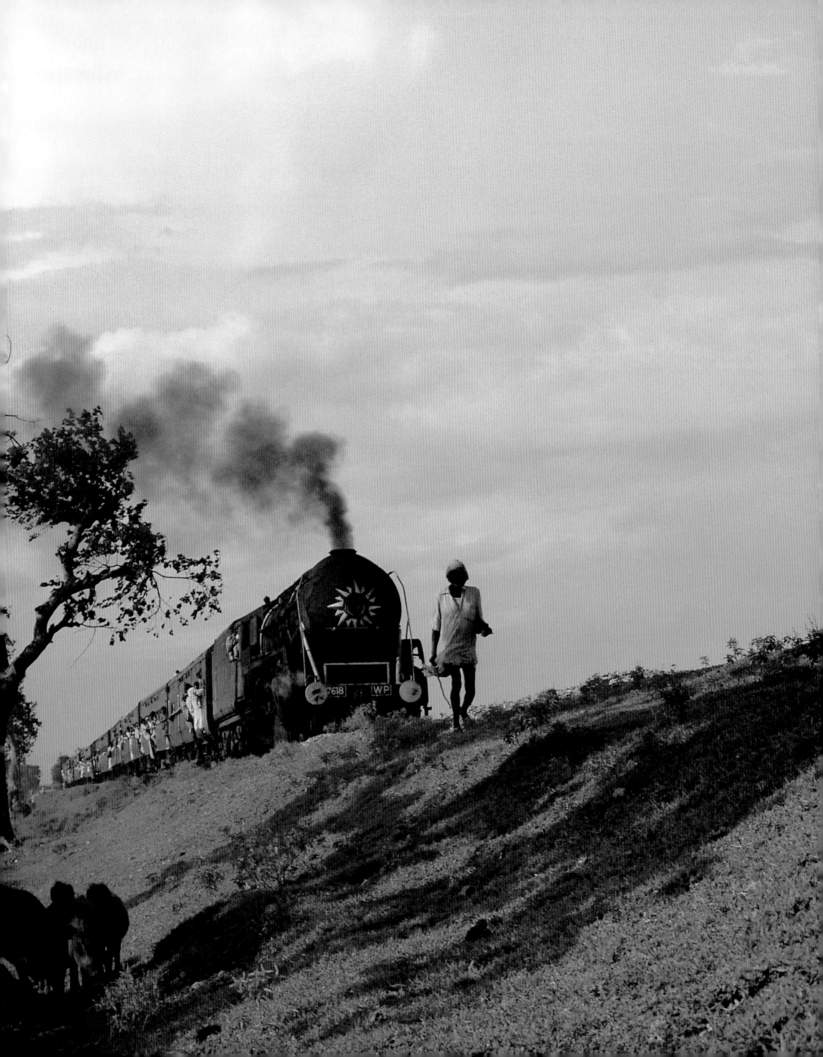

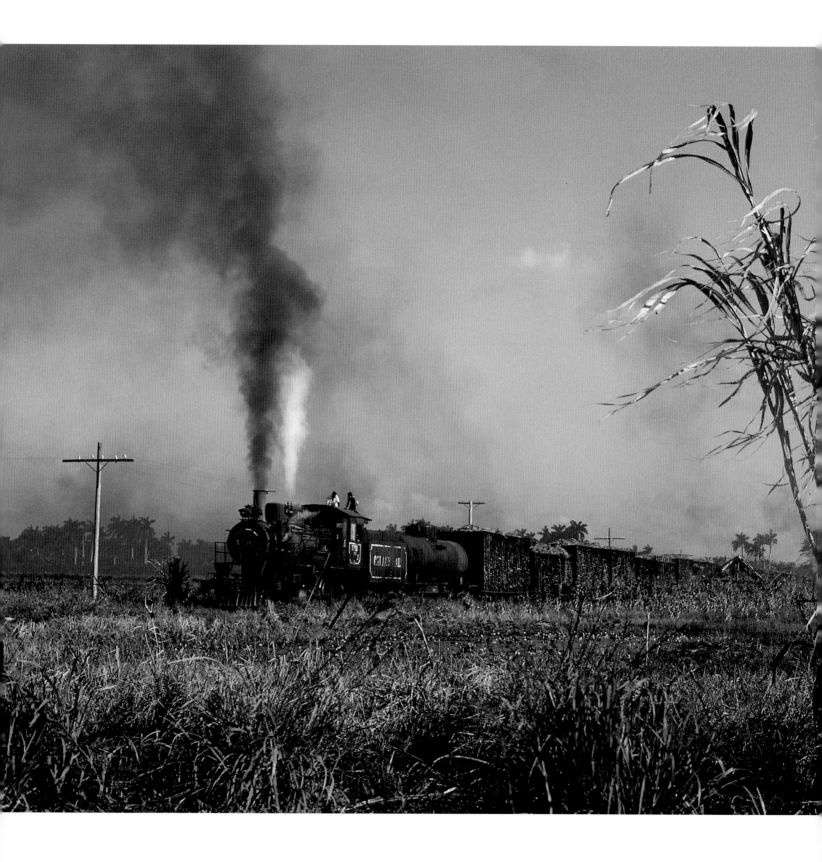

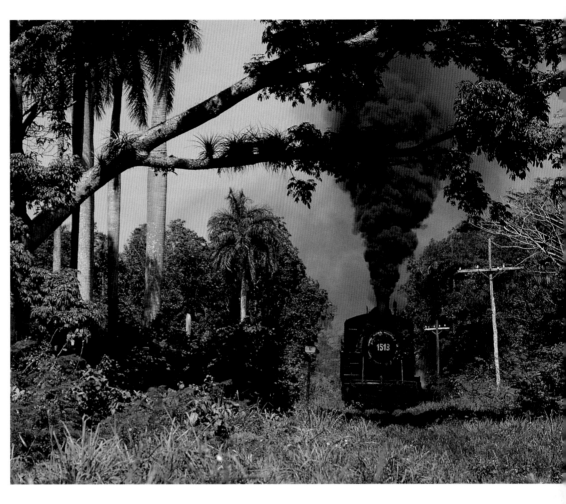

Although the Cuban landscape—flat, by and large—may lack the drama of China's rugged northwestern mountains, it can nonetheless offer some pretty tropical settings. At times, the overgrown rail tracks seem to practically merge with the landscape itself, as in this morning shot on the Australia mill system of Baldwin 2-6-0 1513 advancing with a train of empties along rails so overgrown as to be practically invisible. (March 1998)

One of Cuba's best sugar-mill rail systems is Australia, a long and busy one near Jagüey Grande. Here, 2-6-0 1716 (built by Henschel, Germany, in 1913) heads toward the mill on a cane load, with Baldwin 2-6-0 1607 (out of sight) providing banking assistance behind. Steam photographers and anyone else heading to these lakeside reeds in 2002 faced an unusual hazard: a hurricane in November 2001 struck a nearby crocodile farm—a local tourist attraction—and scattered the animals in the cane fields. (March 1998)

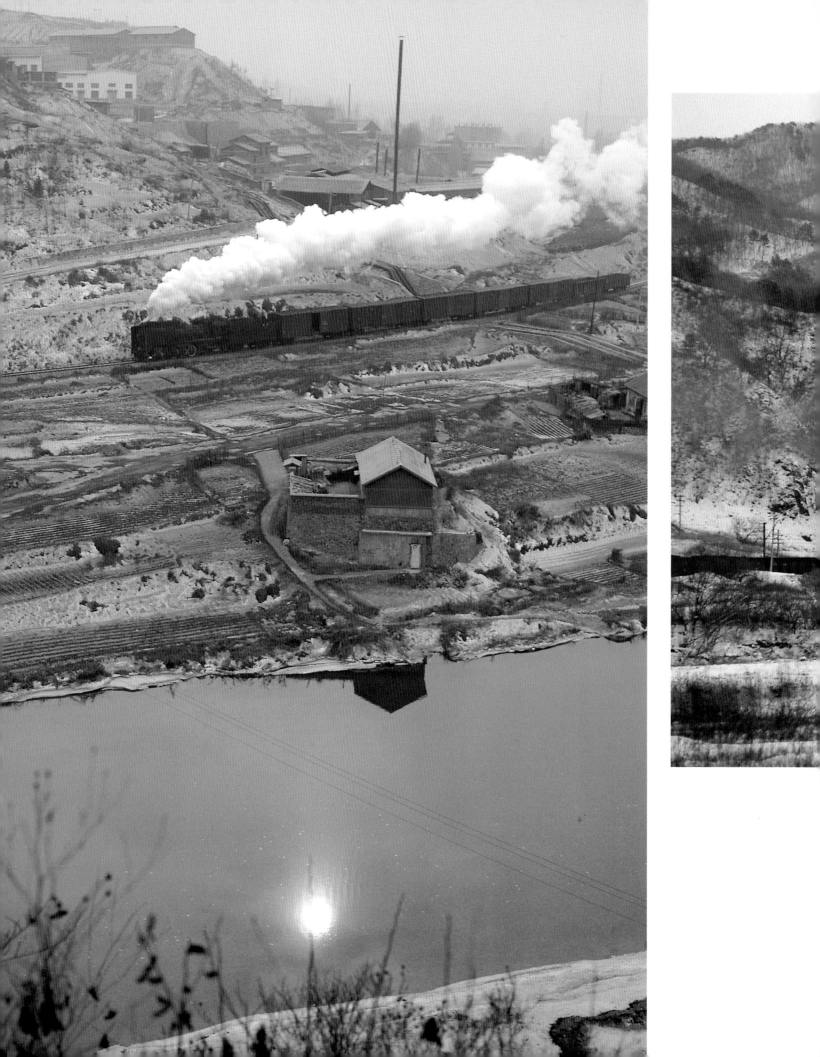

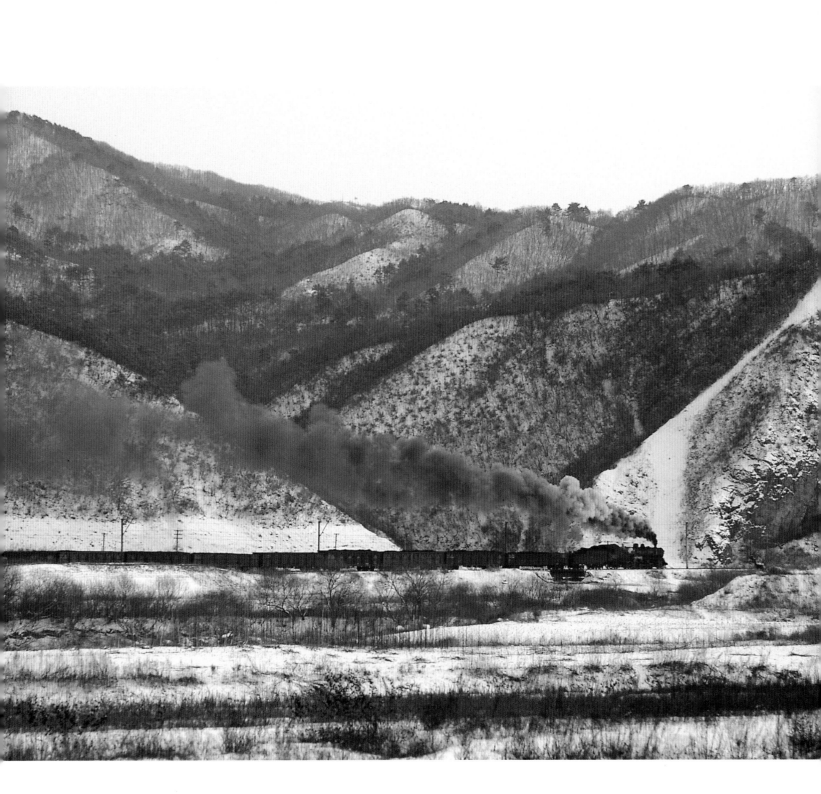

A rare glimpse of a forbidden land. Though taken from China, this shot features a North Korean JF 2-8-2 just across the border, on the other side of the Tumen River, threading through snowbound hillsides as it heads south from Namyang on a freight run. Steam enthusiasts have surmised that there *may* be some remaining steam in North Korea, but given that the country is virtually impossible to visit due to the ultra-paranoid Stalinist regime still prevailing there, no one has been able to ascertain anything for sure. Until the country opens up, there is no way of knowing just how much steam remains, or what can be found where. (March 1, 1995)

With the late-afternoon sun reflected on the Hunjiang River, a China Rail JS 2-8-2 trundles down the Dalizi branch on a short freight run from Hunjiang (now Baishan). (Feb. 1995)

Steam on the Main Line

To stand by a double-tracked main line and watch a steady procession of steam trains flash past in quick succession, the receding beat of one merging into the gathering approach of another, was heady stuff indeed. Sadly, the number of such places where this kind of high-density action could be experienced—few enough in the early 1970s—steadily decreased.

The Rheine–Emden route in West Germany was a very busy main line, able on good days to offer some sixty steam-hauled freights, with steam on expresses too. Until September 1977, the Berlin–Dresden main line in East Germany hosted prewar pacifics pushed to top-notch performance on schedules averaging a mile a minute—the last truly high-speed steam-hauled trains in the world. Until the late 1980s, the De Aar–Kimberley line in South Africa was a celebrated steam racetrack, with giant 4-8-4s rumbling through the Karroo Desert on heavy freights both day and night.

In the early 1980s, China still abounded with densely trafficked steam-worked main lines, such as the Harbin–Shenyang route, the major traffic spine of Manchuria. Changchun, set roughly midway along the route, featured an enormous volume of steam operations, both passenger and freight, with steam trains passing at a headway of every few minutes. From the mid-1980s on, however, steam began to be displaced onto less densely trafficked secondary, cross-country routes.

Still, it was just about possible to experience the thrill of a big steam main line up until the late 1990s, the very last surviving example having been the double-tracked Linfen–Yuci section of the Taiyuan–Mengyuan route (itself part of the Beijing–Xi'an main line), which featured a high volume of 100 percent steam-worked freight. Until diesels were drafted to displace steam in 1997, steam lovers traveling north from Linfen could delight in a window-seat view of a steady procession of QJs rattling past in the opposite direction at the head of long coal trains, with sprawling marshaling yards at intermediate stations such as Jiexiu chockablock with steam freights awaiting access to the main line.

► Delhi, India, was the last capital city in the world to host regular main-line steam passenger operations. In this shot, WG 9982 gets under way out of Delhi with a Moradabad passenger train. (Oct. 1992)

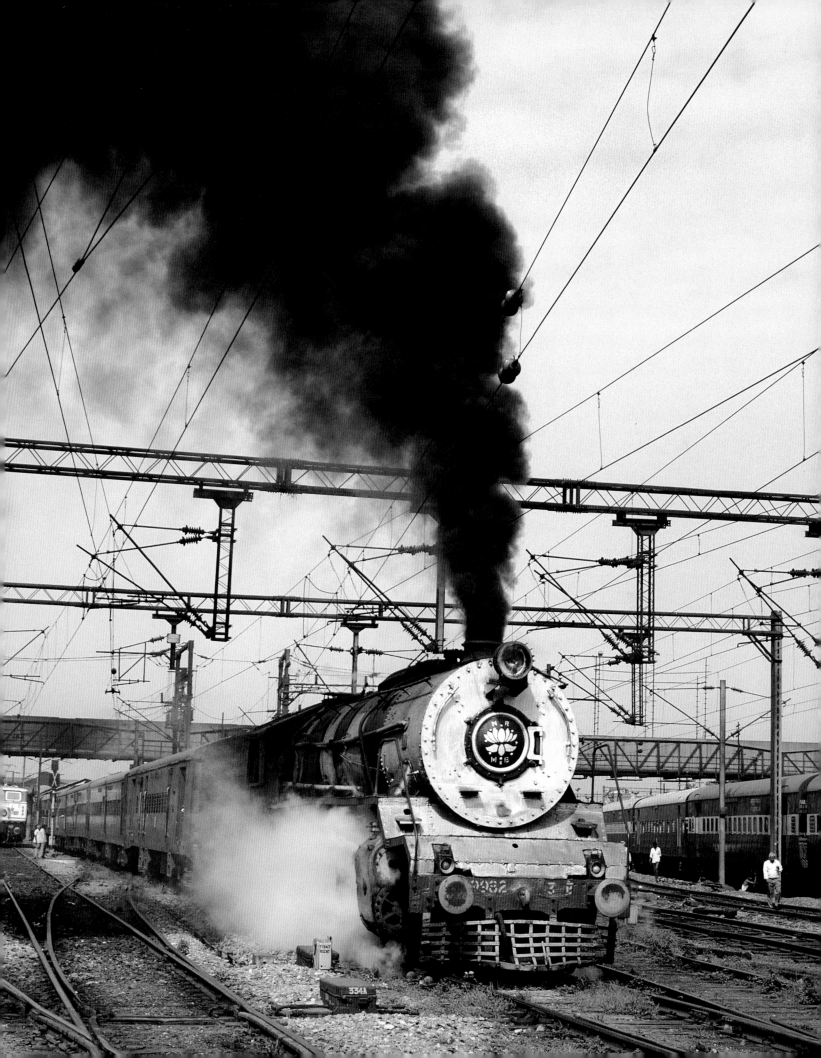

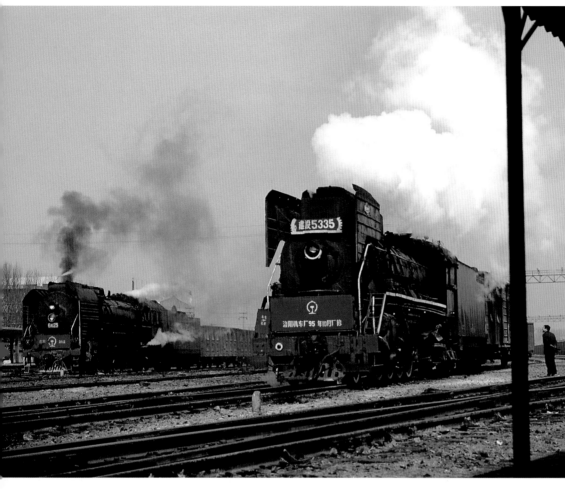

▲ The big city of Linfen, Shanxi Province, on the Yuci–Mengyuan route, was one of the last locations in China where steam traction could be experienced in the context of really intensive main-line opera- tions. With heavy freight traffic (100 percent of it steam-hauled), and steam engines constantly on the move in the station environs—yard shunters bustling to and fro, double-headed freights arriving as others primed to depart, locomotives running into and out of the shed—there was rarely a dull moment at Linfen. Most of the JS-class 2-8-2s were latterly to be found on shunt/pilot duties rather than out on open-line work. In this shot, JS 5335 (in the foreground) shunts while QJ 6425 (behind it) awaits 2329's clearance of the section to follow on a Mengyuan-bound freight. (March 10, 1996)

► China Rail targeted heavily trafficked main lines for rapid dieselization in the 1990s. When the author visited Harbin in 1995, steam predominated over diesel on freight operations on the main line north- west to Daqing by a ratio of nearly two-to-one. By the time he caught this QJ a year later, approaching Harbin on an oil freight from Daqing, the ratio was four-to-one diesel; by the end of that year, steam operations at Harbin had ceased. The photographer was actually standing on the frozen surface of the Songhua River when he took this shot. (Feb. 19, 1996)

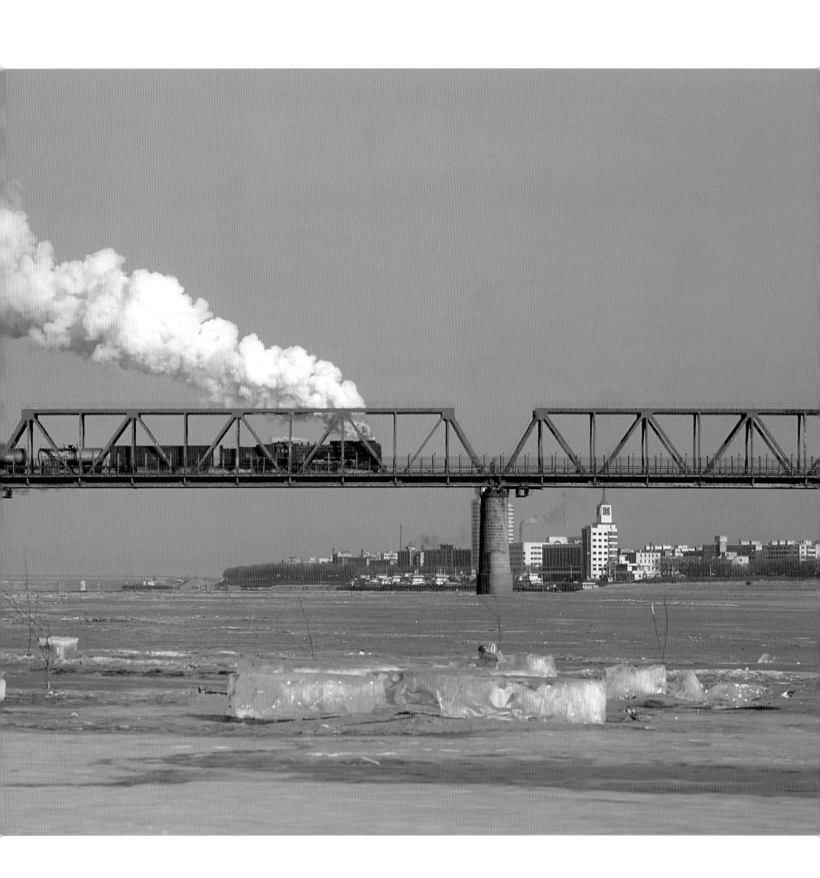

Cross-Country Routes

STEAM WAS MORE COMMONLY FOUND IN ITS waning days on secondary, cross-country routes, which had less traffic. By the early 1980s, most Polish steam operations were on cross-country passenger runs, radiating out from centers such as Szczecinek, Białogard, Lublin, Kłodzko, and Olsztyn, and featuring the elegant Pt47 2-8-2s.

In Turkey, with sparse train service and most of its 5,160-mile system just single track, even rail routes connecting major population centers had a cross-country feel. Most longer-distance trains ran as Mixeds (a combination, that is, of passenger and freight stock), more often than not lumbering leisurely along with scant regard to the official timetable, losing hours en route while wagons were shunted on and off the train at wayside stations.

In Pakistan, where steam had long vanished from the main lines, it was still possible to travel some considerable distance by steam on cross-country routes, the longest haul being Train 191 between Peshawar and Multan, a 375-mile journey scheduled to take nearly twenty-four hours, all of it—until 1987—behind steam.

▶ Even when connecting major population centers, service on many of Turkey's rail routes tended to be scant, featuring only a handful of trains per day. The bus was the locally favored mode of public transport for passenger journeys, with freight haulage the main agenda of the railroads. A popular type of train was the Mixed, whereby one or two passenger coaches would be attached to an otherwise all-freight formation. With so few trains available in Turkey, photographers would generally chase steam trains out into the countryside by car, sometimes staying with the same train all day, instead of linesiding. The İzmir–Ödemiş Mixed was a popular train with photographers, especially when rostered for Stephenson 2-8-2 46105, the sole survivor of its class when seen here between Çatal and Ödemiş. (April 1985)

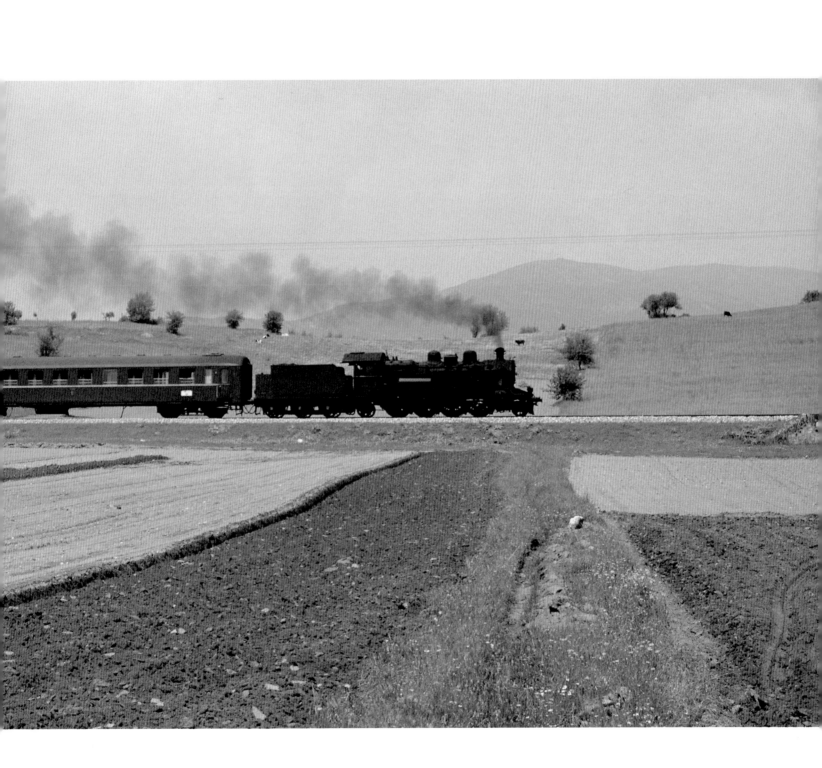

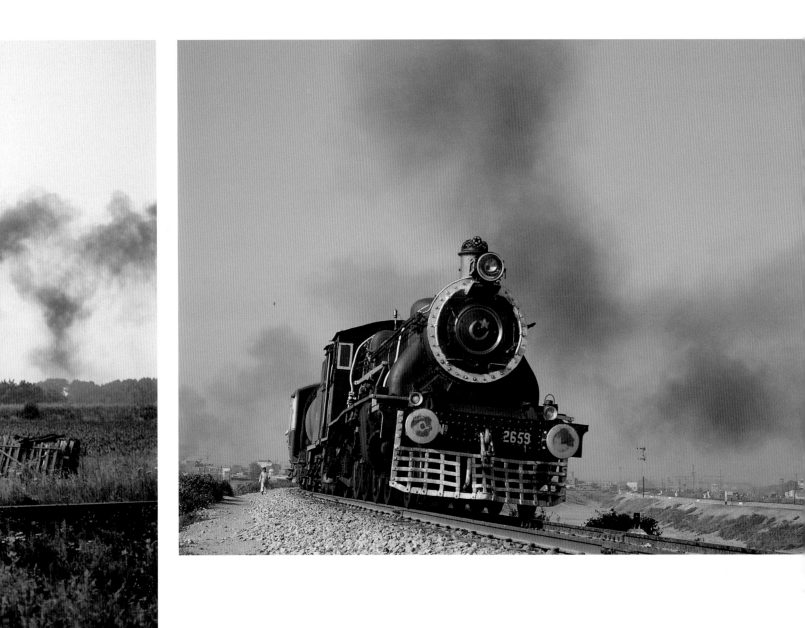

In Pakistan, twelve XA pacifics were shedded at Kotri, a junction near Hyderabad, for working out into the dusty Sindhi countryside on the routes to Mirpur Khas and Badin. The Karachi–Lahore main line is visible to the right of XA 2659, pulling out of Hyderabad on the 7:55 A.M. Kotri–Mirpur Khas run in this shot. The dense smoke in the distance, to its left, is from another XA, simultaneously heading a passenger train out of town down the sixty-mile Badin branch. (March 1985)

Regular steam passenger operations can still be experienced in Europe today in the Wolsztyn area of Poland, where steam's life span has been artificially extended. The 2-10-0 Ty45-379 has but a paltry two coaches behind it as it makes its way out of Wolsztyn on the 3:50 P.M. to Grodzisk. (Summer 1991)

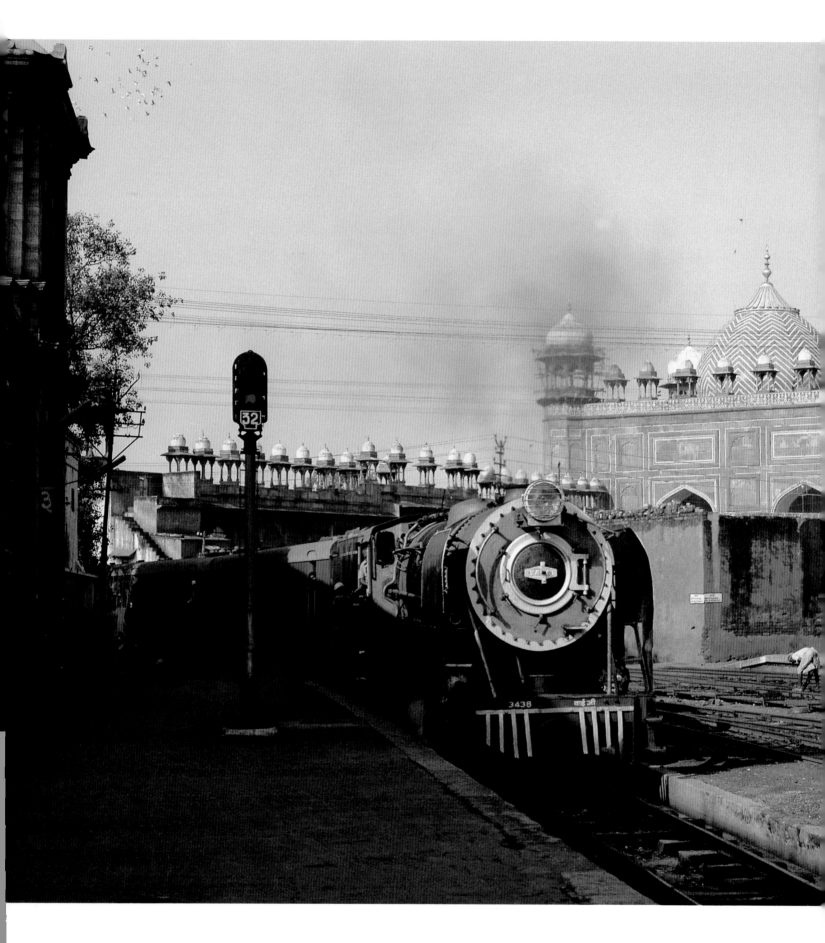

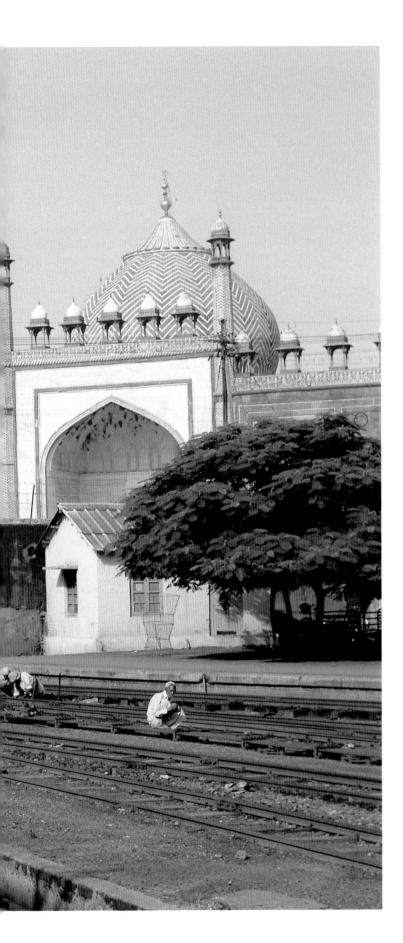

Stations

LARGE STATIONS ALSO OFFERED ABUNDANT photographic possibilities. In contrast to linesiding, in which much of the time was spent waiting, something was nearly always happening in stations to keep photographers on their toes: trains arriving and departing, and engines brewing up at the platforms prior to departure, running to and from the loco shed, or just bustling about on shunting duties. However, photographers often had to exercise caution. Unlike linesiding, in which a discreet profile could be maintained, around a big station they were very much in the public eye, and they could often attract unwelcome police attention.

During the Cold War, showing up at a big station in Eastern Europe and photographing without permission practically guaranteed arrest. Sometimes just showing up sufficed. Station photography without a permit could be tricky even in ostensibly democratic countries such as India. Very often, photographers attracted attention simply because what they were doing was so alien to prevailing local concepts of normal behavior. In some Third World countries, photographers could also quickly attract large, rubbernecking crowds, significantly hampering any attempts to undertake serious photographic work.

◀ Few stations can enjoy as majestic a setting as India's Agra Fort, hemmed in on one side by Agra's imposing Mogul fort and on the other by the exquisite Jami Masjid, built by Shah Jahan in 1648. Here, the Jami Masjid provides the perfect backdrop for this early-morning scene of a meter-gauge YG 2-8-2 rolling in on an overnight express from Ahmadabad. (Sept. 5, 1984)

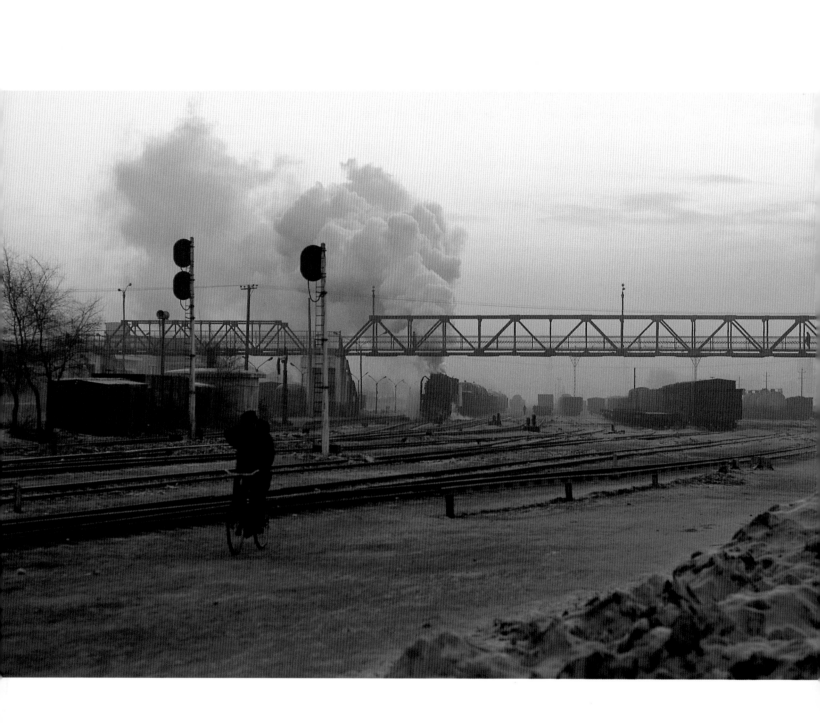

▲ The cyclist at left clapping a hand to his ear gives some indication of the bitter subzero bite to the air as a QJ 2-10-2 gets under way from Bei'an at dawn on a freight to Fuyu. Although freight work was 100 percent steam at Bei'an when this shot was taken, by November of the same year Bei'an was yet another location—by then one of the last few remaining—from which steam traction had been eradicated. By 2001, other than the local government Ji-Tong line between Jining and Tongliao (traversing the spectacular Jingpeng Pass), regular steam-line operations in China could be found at only a handful of locations, such as Yebaishou, Fuxin, Tonghua, and Da'an. (Feb. 1999)

▶ Freight bales abound on the platform as WP 7688 restarts an Ambala–New Delhi passenger train from Saharanpur, its headlight blazing into the gathering twilight gloom. (Sept. 22, 1992)

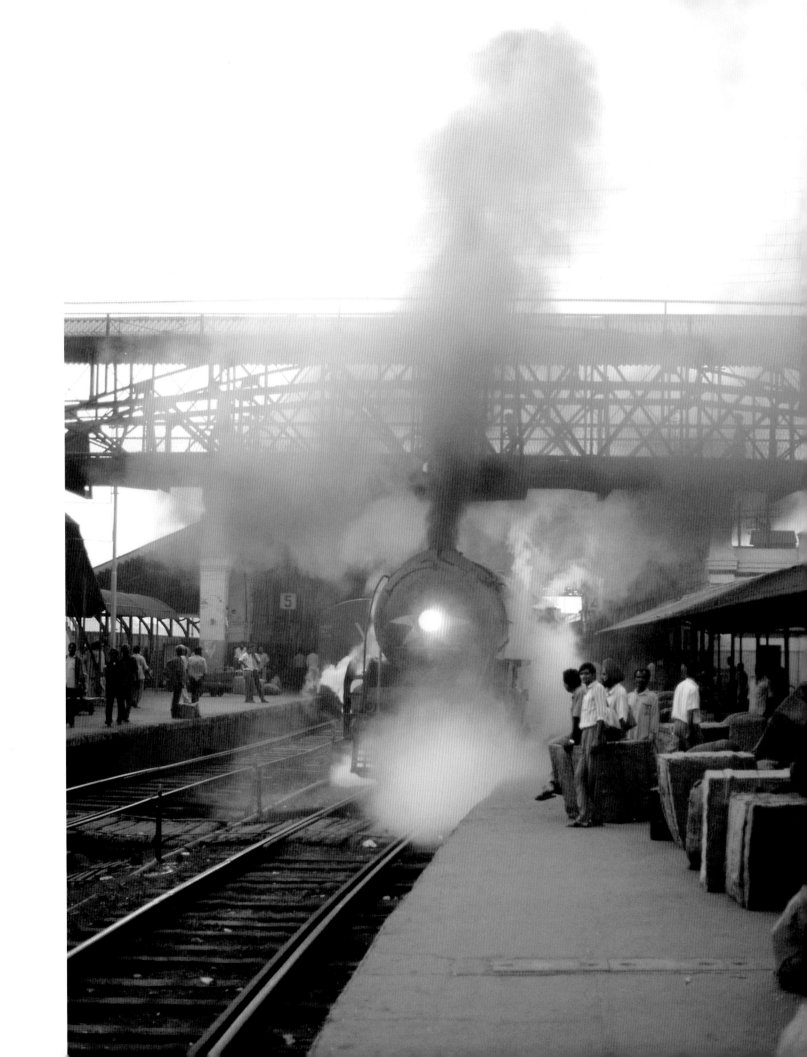

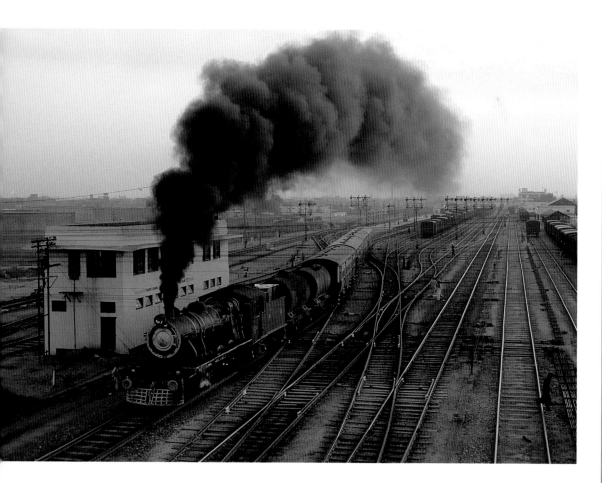

▲ Hyderabad, in Pakistan's Sind Province, was a big junction offering
 excellent photographic opportunities. In this elevated view, taken from
 a footbridge, XA pacific 2704 snakes out of the station at twilight on
 the 6:00 P.M. Hyderabad–Badin run. (March 1985)

► Big stations can feature many photogenic props that can be used to the photographer's advantage,
 such as these two semaphore signal gantries seen looming very impressively over Pakistan Railways XA
 pacific 2693 as it speeds out of Hyderabad on the 7:55 A.M. Kotri–Mirpur Khas run. (March 1985)

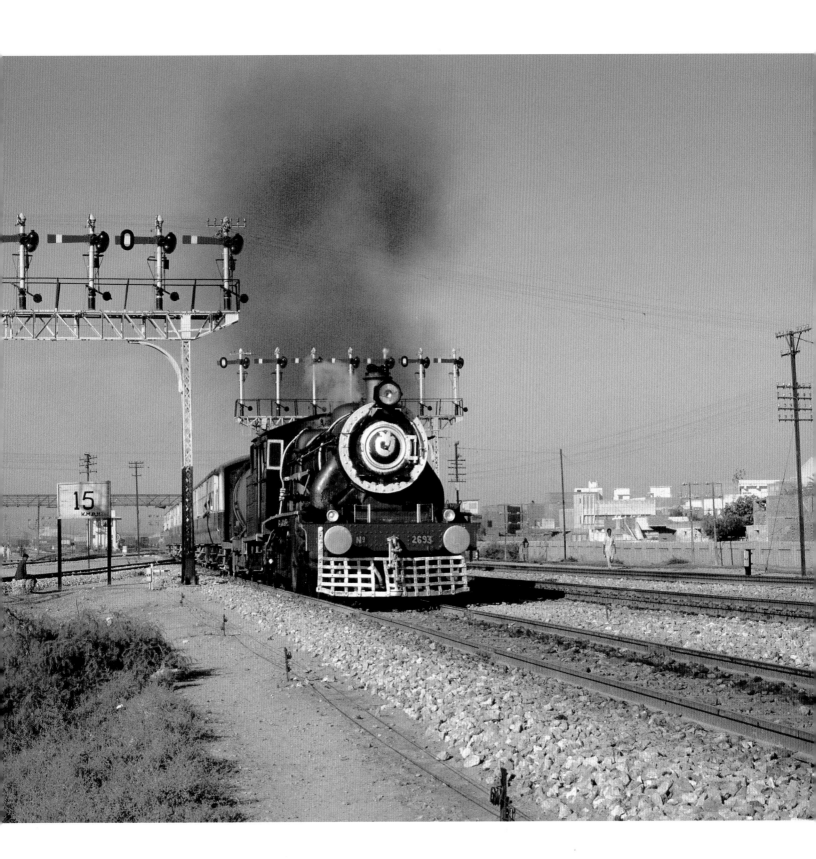

Loco Sheds

THE LOCO SHED WAS THE STEAM LOCOMOTIVE'S home base, the place to which it periodically returned between working trains to be serviced and just sit, simmering, awaiting its next call to duty. It was standard international railroad operating practice for locomotives to be allocated to particular depots, which in turn decided which engines worked what trains, as well as servicing incoming locomotives from other depots.

At loco sheds, more than anywhere else on the railroads, it was all too plain to see why operating staff so often welcomed the clean, shiny new diesels. In contrast to the soot-begrimed, labor-intensive steam locomotives (which had to undergo elaborate, time-consuming servicing rituals), a diesel could just be conveniently turned off and left by its crew. Steam loco sheds, moreover, could scarcely be conceived of as ideal workplace environments: almost invariably mucky and messy in the extreme, featuring a veritable detritus of ash (both heaped up in mounds and scattered asunder everywhere), oily puddles, strewn-about coal chunks—all in all, a surfeit of grit and grime.

To steam lovers, however, big engine sheds were probably the closest earthly equivalent to the Garden of Eden. With so many engines crammed into one constricted space, with the air vibrant with the hiss of simmering steam and pervaded by a heady, sulfurous aroma, and with activity everywhere—locomotives being coaled, watered, turned, fussed over by fitters, and received and dispatched around the clock—the atmosphere at a big main-line steam shed was truly something else.

Photography within shed limits could, however, be tricky. In many countries, locomotive depots were perceived as prime strategic installations, strictly off-limits to the public. Controlled access was permitted to organized tour groups of enthusiasts, however, even in Communist countries. To the individual traveler going it alone, successful shed photography was very much a matter of potluck.

By the mid-1980s, only India and China could offer steam sheds with really big allocations (upwards of 100 or more locomotives). The Public Relations Department of Indian Railways operated a commendable system whereby photographers could apply for a photography permit stipulating the specific sheds where they wanted to take pictures. With the magic permit, they would be accorded every hospitality. Without it, they could be arrested, detained, and subject to confiscation of film. In China, where no such system operated, photographers just had to take their chances, in some cases successfully managing to photograph without interference, in others being arrested and evicted.

► Visiting loco sheds in the former Warsaw Pact countries was a hazardous affair during the Cold War, and often all but impossible to accomplish except under the auspices of an organized tour group. In this view taken at the Celldömölk loco shed in Hungary, a 324-class 2-6-2 faces one of the handsome 424 4-8-0s, its smokebox adorned with the Red Star—standard practice throughout the erstwhile Communist bloc. (Sept. 1980)

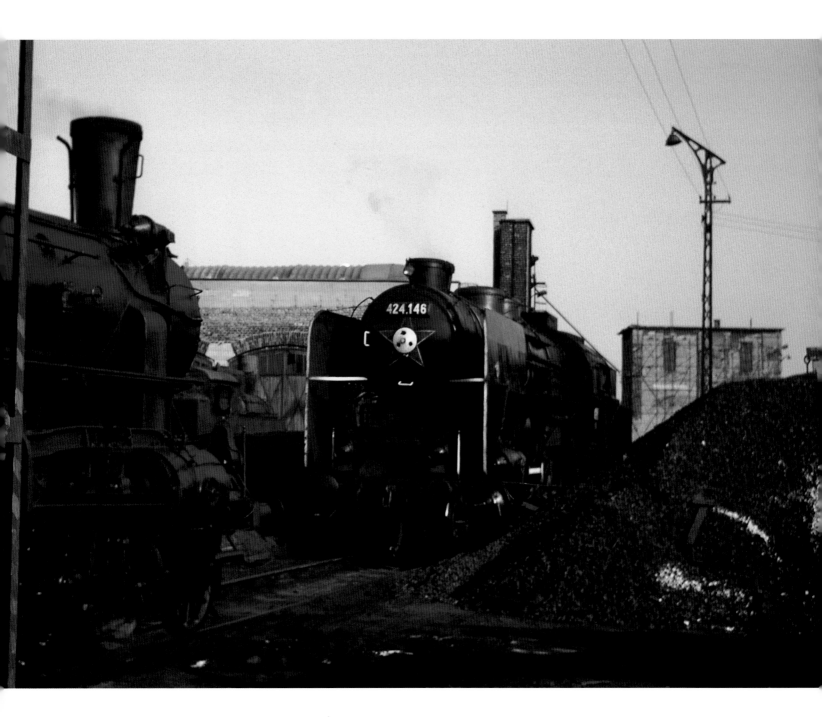

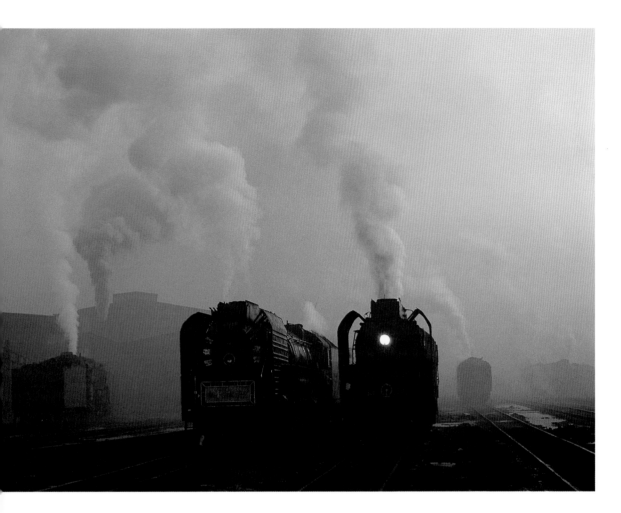

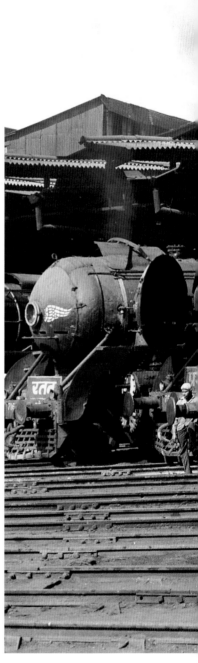

▲ With so many locomotives crammed into one constricted space
and air vibrant with the hiss of simmering steam, the atmosphere
at a big main-line steam shed was truly something else. One can
almost smell the heady sulfurous aroma pervading the air in this
scene of a group of QJ-class 2-10-2s brewing up in the loco shed
yard at Jiamusi, China. (March 1995)

▶ Moradabad was the most impressive and photogenic engine shed in India, a giant forty-three-
stall roundhouse with eighty-one locomotives allocated when this shot was taken of a group of
WPs and WGs resting around the depot turntable. The bullet-nosed smokeboxes of the WPs are
adorned with the home depot's distinctive eagle's wings motif, which always identified Moradabad
WPs, however far afield they traveled on the Northern Railway system. (Feb. 1985)

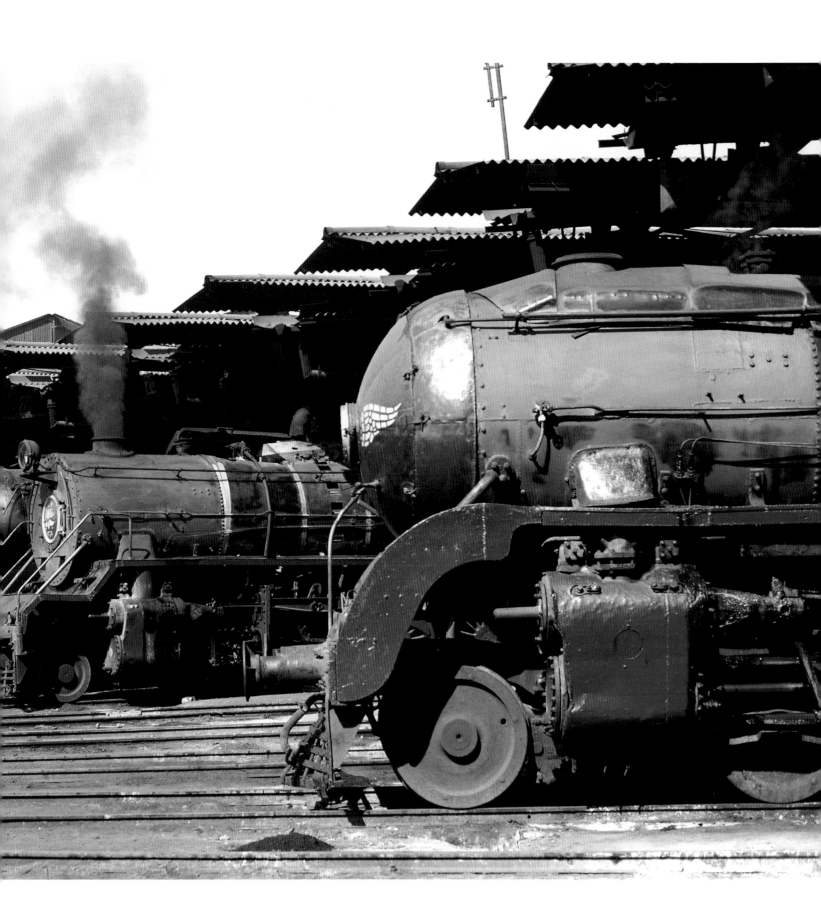

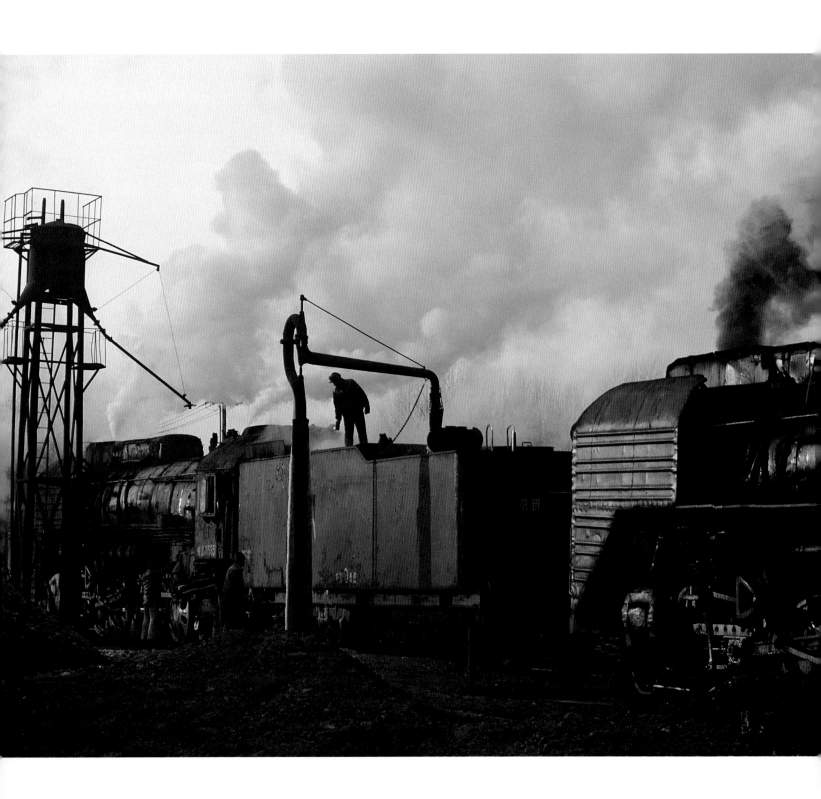

▲ A rear three-quarters close-up of two QJs being serviced at the Bei'an
loco shed after arrival on a freight from Suihua. (Feb. 6, 1999)

► Although a steam locomotive is not the main subject here, this is an image that powerfully evokes the
unique atmosphere of a big main-line steam shed. The setting sun peeks through the pall of heavy
smoke hanging over the loco shed yard in Harbin, China, silhouetting a water crane. (Jan. 1996)

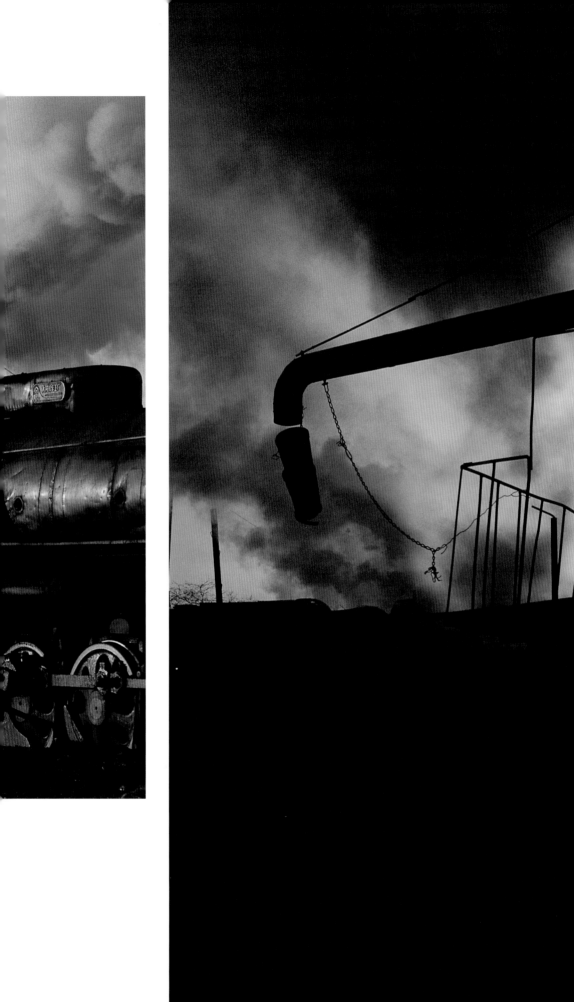

Ancient and Modern

A FASCINATING COMBINATION OF VETERAN and modern locomotive types survived together into the twilight of the Steam Age (with anything built after World War II to be considered modern in steam-engine terms). In a high-tech era, some remarkable survivors of former eras continued in everyday use, long after the times that had produced them had vanished. Right up to the late 1970s, some of East Germany's top intercity expresses out of Berlin were rostered for engines dating from the time of the Third Reich. Until the late 1980s, a fascinating array of pre–World War I types proliferated on the Indian narrow gauge, with veteran Prussian designs likewise steaming on in Turkey, and British-built veterans remaining in service in Pakistan into the 1990s.

Even into the new millennium, elderly engines can still be found at work. In India, the Saraya Sugar Mill's famous 0-4-0 "Tweed," built way back in 1873—the oldest steam locomotive in regular working service anywhere in the world—is in its third century of service and shows no signs of retiring. Meanwhile, every Zafra (sugarcane harvest), Cuba presses a wonderful variety of American old-timers into service for the first four months or so of the year.

Many countries continued to build steam locomotives during the 1950s. In Europe, the epitome of latter-day steam design was probably attained in Czechoslovakia, which produced engines that were not only ultra-proficient performers, but also of exceptional aesthetic appeal. By the end of the decade, however, fresh steam construction was coming to a close as country after country made the transition to diesel. West Germany built its last steam locomotive in 1959, East Germany and Britain in 1960, and Spain in 1961. Farther east, Third World countries retained their allegiance to steam a little longer. India built more than 2,000 steam locomotives during the 1960s, but even there the pressure toward diesel eventually became irresistible, with the last steam locomotive being turned out for the broad gauge in 1970 and the meter gauge in 1972.

China, a country rich in coal resources, was the only country to defy the international trend, continuing to build main-line steam engines long after the rest of the world had switched to diesel. By the time the last QJ 2-10-2 rolled out of the Datong Locomotive Works in December 1988, a staggering 4,708 of that class had been built. Steam construction continued until the late 1990s at the Tangshan and Changchun production plants, where a handful of SY-class 2-8-2s were built each year for industrial service. To steam aficionados accustomed to witnessing their beloved machines in a no-future context of constant decline, it was somewhat surreal at such a late stage to come upon brand-new steam locomotives fresh from the production plant.

▶ Two standard classes, the WP pacifics and WG 2-8-2s, massively predominated in the latter-day Indian broad-gauge steam scene. The final WP pacific was built in 1967, the class being the last big steam express passenger design in production anywhere in the world. The WPs were originally conceived as a design for top-link expresses. Not long after production ceased, however, they were progressively displaced from star turns to more mundane duties, such as this stopping passenger run to Waltair, India, seen heading out of Vijayawada in glorious mauve morning light. (Dec. 1984)

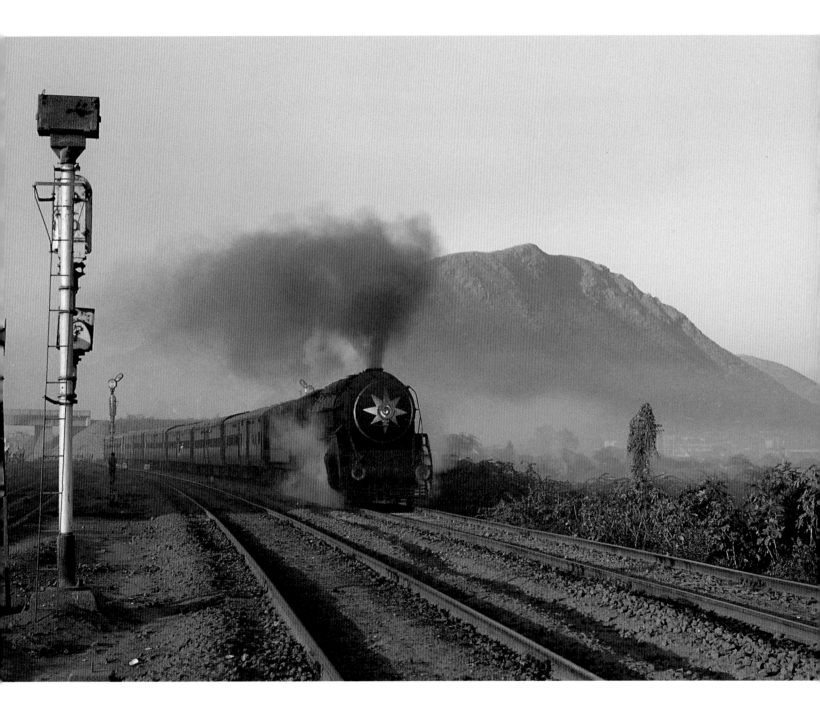

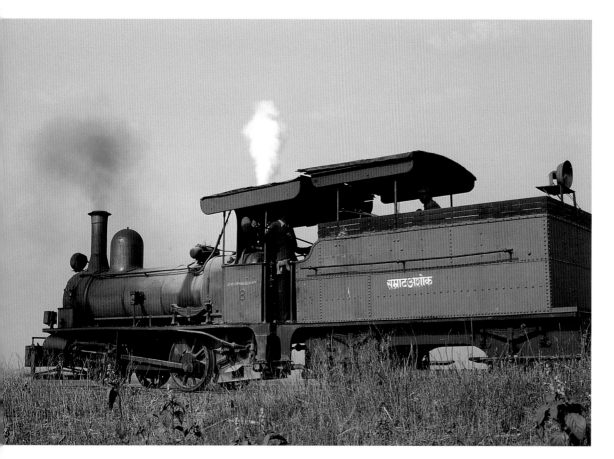

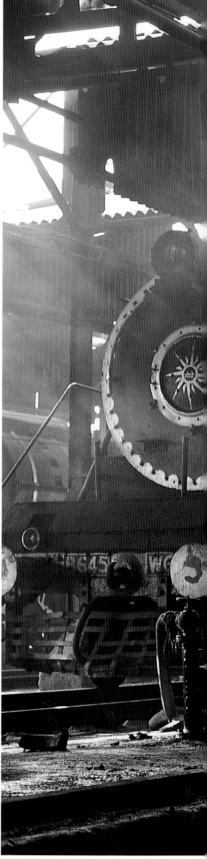

▲ For quite some time now, the oldest steam locomotive in regular, revenue-earning service in the world has been this meter-gauge 0-4-0 "Tweed," seasonally employed at the Saraya Sugar Mill, Sardarnagar, near Gorakhpur, India. Built by Sharp Stewart & Co. Ltd. of Manchester and Glasgow in 1873, "Tweed" still, incredibly, showed no sign of retiring at the start of the twenty-first century. This rear three-quarters shot strikingly presents its antediluvian profile. It is strange to think that the railroads themselves had arrived in India only about twenty years before. (Feb. 5, 1985)

▶ Just a short distance from the Saraya Sugar Mill, WG 2-8-2s built almost a century later could be seen working passenger trains on the Gorakhpur–Bhatni line. The WGs were the final broad-gauge steam locomotives to be built in India, with the last one rolling out of the production plant at Chittaranjan, West Bengal, in 1970. Here, a pair of WGs rest side by side at Gomoh. (Feb. 1985)

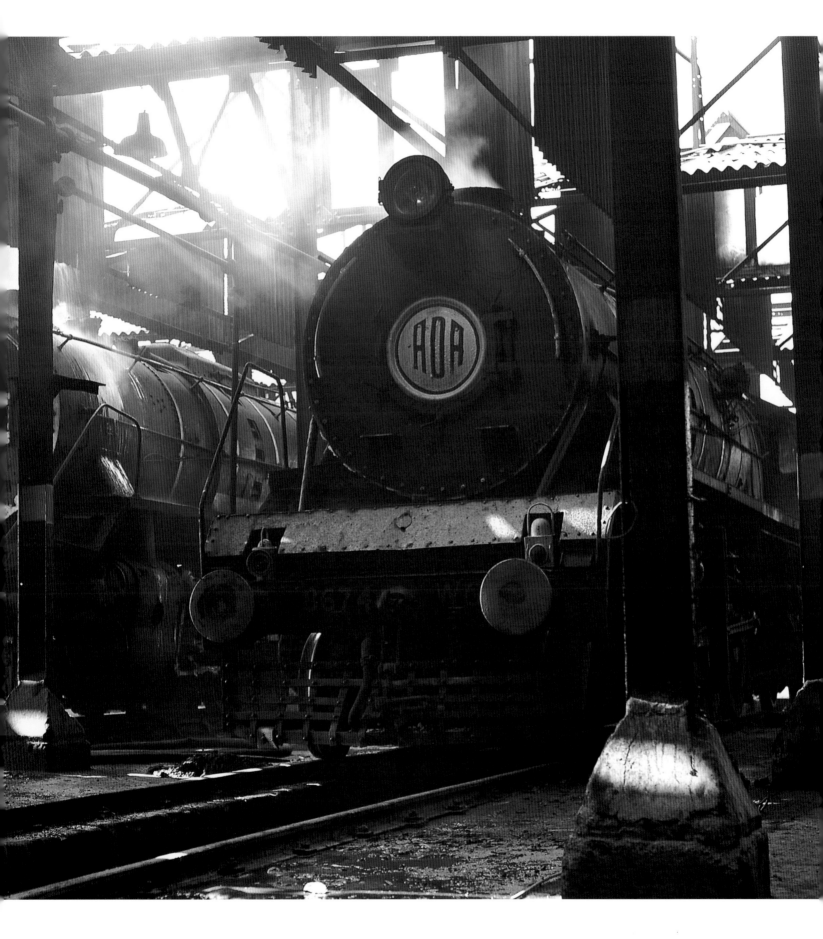

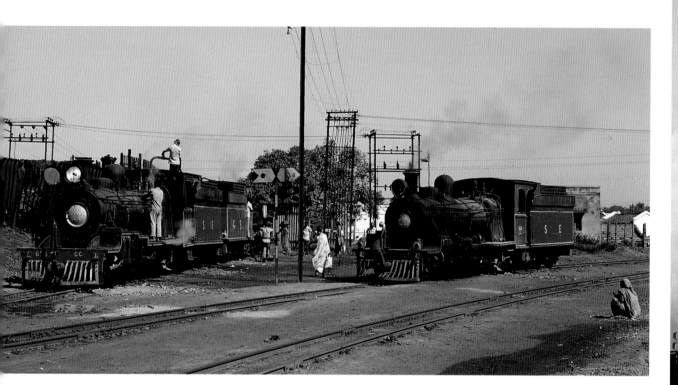

▲ The CC pacifics were probably the handsomest of all India's narrow-gauge locomotives, with none more fetching than those based on the Raipur system, which sported an attractive bright red livery. Here, with space at a premium at the cramped loco shed, a batch of CCs stable at the station between duties. CC nos. 676 and 664, in the foreground, date from 1907 and 1908, respectively, both having been built by the North British Locomotive Co. Ltd. of Glasgow. (Oct. 30, 1984)

▶ The last main-line steam-engine type in regular production anywhere in the world was the Chinese QJ 2-10-2, mass-produced to some 4,708 between 1956 and 1988. To the far left of this shot, taken at Lutan, near Nancha, the last wagons of a Nancha-bound freight can be seen about to disappear, clearing just in time to let the photographer snap the pristine QJ 6900 romping through on a freight for Jiamusi. (March 1996)

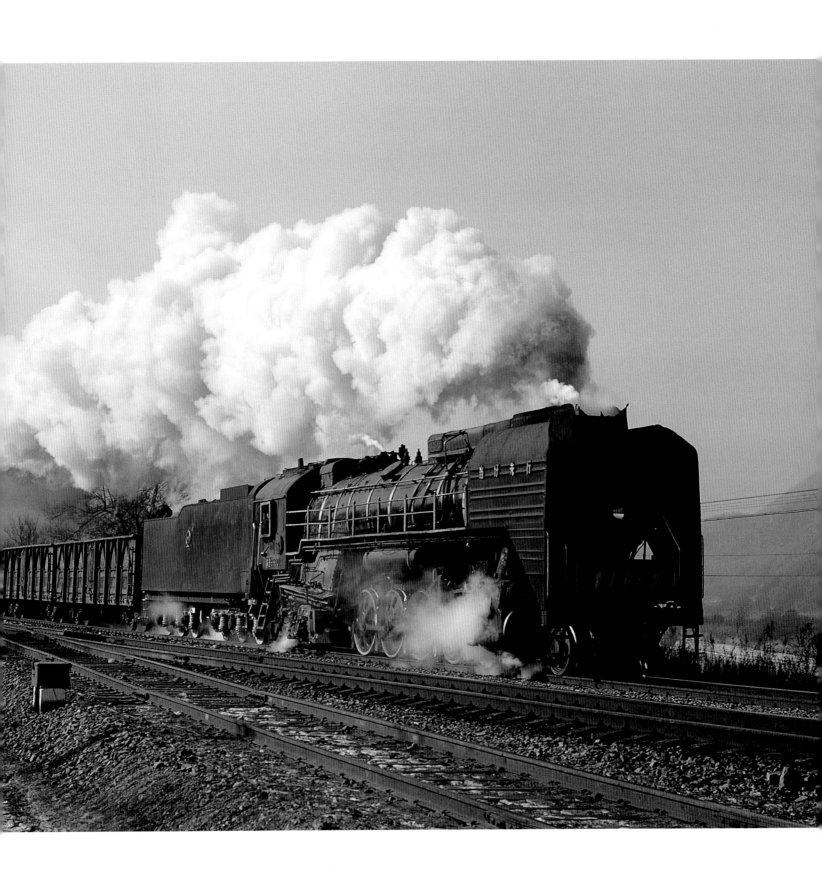

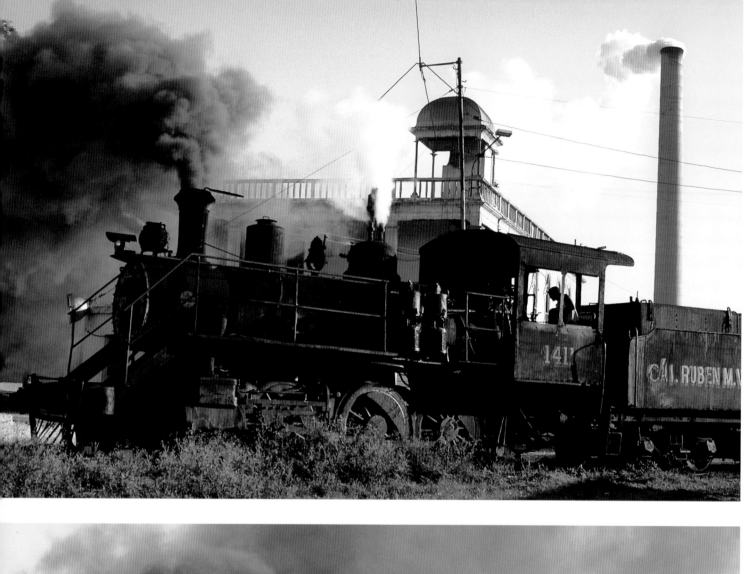

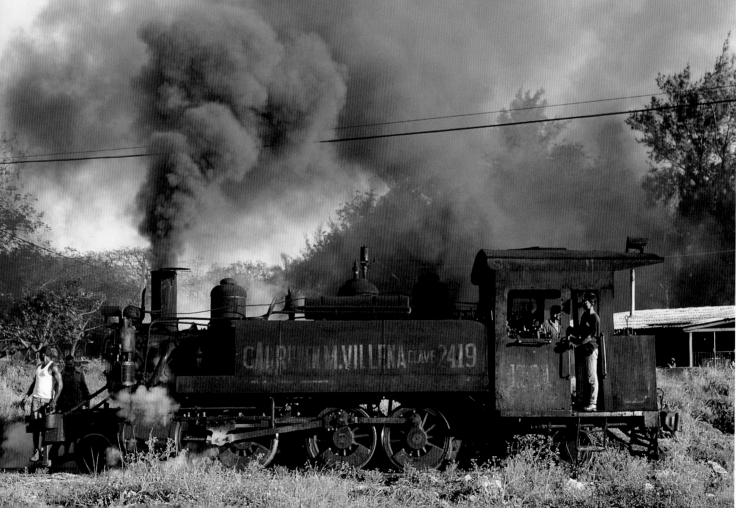

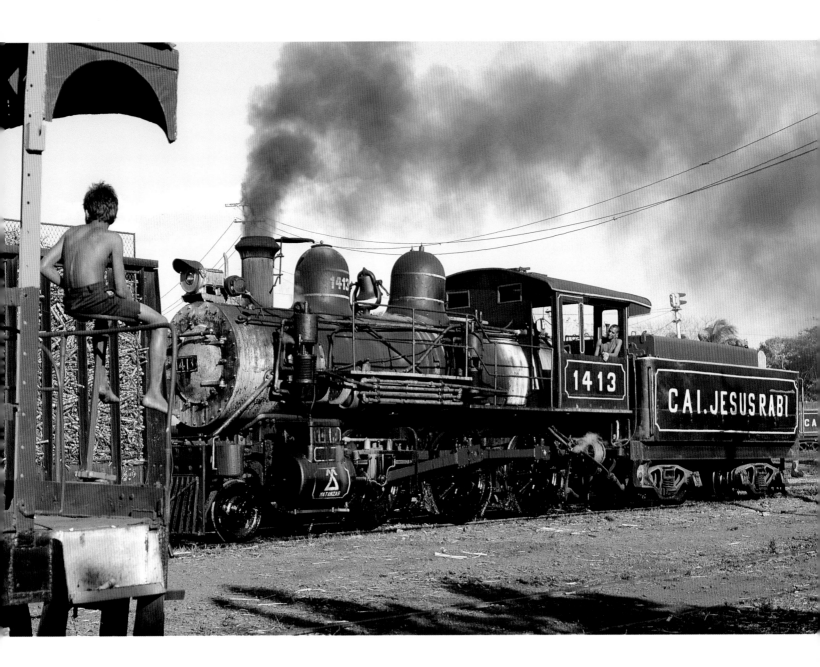

▲ Still in service a full 110 years after its construction by Cooke in 1891, 2-6-0 1413 cuts a fine sight in the soft late-afternoon light as it shunts the yard at Jesús Rabí mill, Cuba, overseen by a young boy perched at the back of a caboose. (March 6, 2001)

◄ Steam operations on Cuba's sugar-mill rail systems can be highly unpredictable, prey to a whole host of factors. When the photographer showed up at the Rubén Martínez Villena mill in the morning, following a period of heavy rains, there was nothing doing, with the mill temporarily out of commission and no steam to be seen. A return visit in the late afternoon, however, found an entirely different situation, the mill chimney having meanwhile been lit up again and begun smoking healthily away; now three steam engines were bustling about the yard, including veteran 2-6-0 no. 1411, depicted here, a Baldwin product of 1916. (March 3, 1998)

◄ Every year, Cuba's Sugar Ministry (MINAZ) fields a marvelous array of American ancients for the duration of the sugarcane-harvesting season. The oldest serviceable locomotive on the island is the 1878 Baldwin-built 0-4-2T no. 1112, based at the Rubén Martínez Villena mill. On this particular occasion, 1112 was not working, so the photographer had to make do with 2-6-2T 2419—a mere youngster by comparison, having been built by Baldwin of Philadelphia in 1904. Here, it brews up a fine head of steam in the evening sun. (March 3, 1998)

Elegance and Style

With regard to steam locomotives, as with any area of aesthetics, beauty is very much in the eye of the beholder. Steam enthusiasts, though, could be notoriously xenophobic; many English, German, and American steam fans were inveterate home birds, able to relate only to the locomotive designs of their respective countries. Those chasing steam worldwide generally had a more open-minded, adaptable attitude regarding unfamiliar types. Looks undoubtedly mattered, however, and it always upped the excitement level to be photographing good-looking engines. My own particular preference was for Eastern European classes such as the Polish Pt47s, Romanian 142s, and Hungarian 424s—but basically, if it was steam, it could do the trick and cast the magic spell.

With top-link expresses generally the first targets of dieselization, glamorous express engines were often early casualties. In the waning days of steam, when maintenance standards could often plummet to dire levels, it was always heartening to come across well-kept machines that showed signs of care amid the decline. In cases in which engines were always allocated to the same crew rather than pooled, engines could sport various colorful decorative adornments. In India, a so-called Black Beauty competition was held annually in which different depots would compete, each sprucing up one of its WP pacifics to "super-shine" condition, often adorned with elaborate

▶ Steam enthusiasts can be widely divided on the question of locomotive aesthetics. Most concur, however, about the striking good looks of the Pakistani SPS-class 4-4-0s, amply evident in this portrait of SPS 2981 nearing Wazirabad on a morning passenger run from Faisalabad, passing a tethered water buffalo at left. (May 1984)

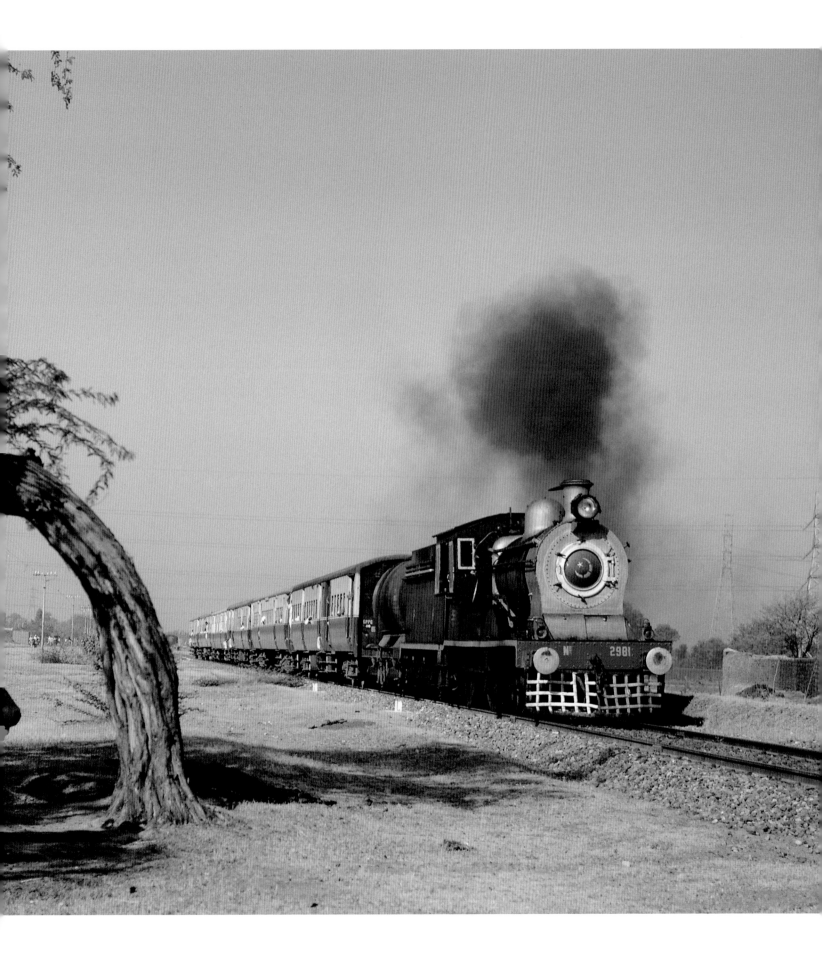

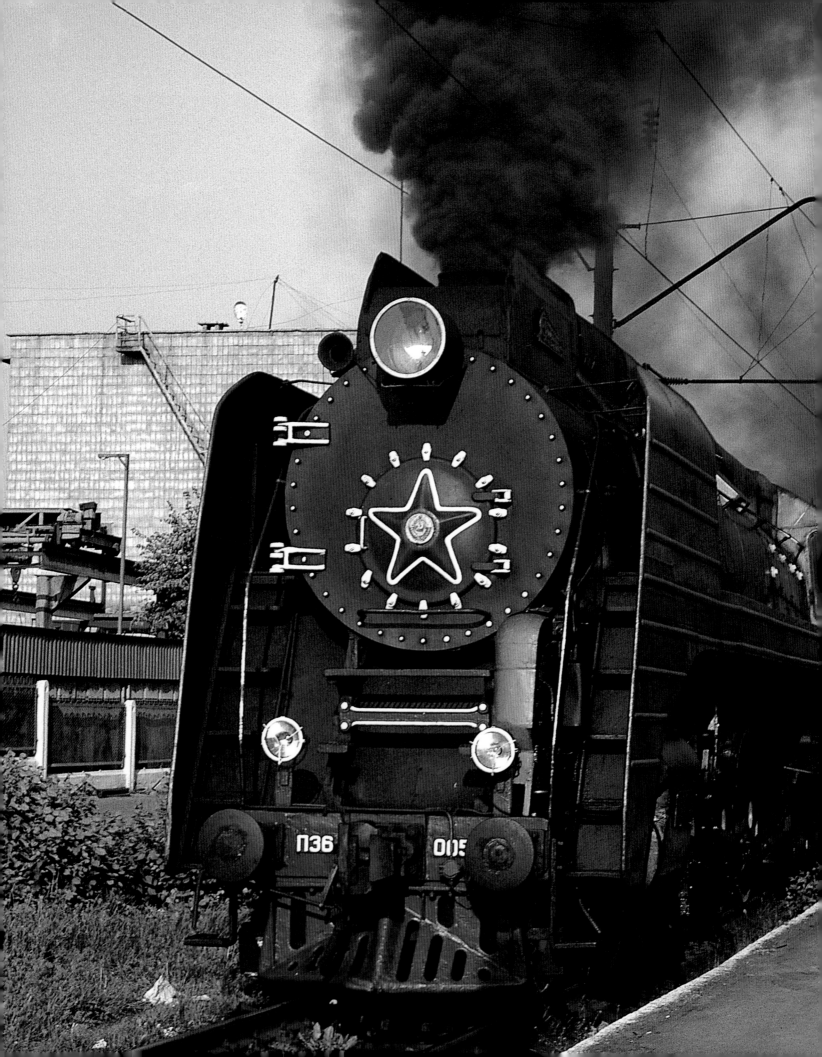

gold and silver embellishments, then submitting it against the other competitors, the prize being awarded to the most pristine and fetchingly prettified WP.

China was another country where locomotives could be "bulled up" into "ex-works" condition, with Jiamusi probably its most noteworthy latter-day location for "super-shine" specimens. Many of its locomotives were customized by crews, sporting colorful Chinese character boards and polished to perfection.

▲ With their bullet-nosed, semi-streamlined front end, the Indian WP pacifics had a stylish and unmistakable profile, always enhanced when the locomotives were well maintained and—as in this shot of two immaculate WPs inside the machine shop of the Bhusawal loco shed—prettified by smokebox adornments, such as the silver starburst radiating out from the locomotive headlight. (Oct. 1984)

◄ The Soviet P 36 4-8-4s represented the epitome of steam-engine development in the former Soviet Union. They had a fabulously glamorous appearance in their apple green, red-banded livery, but most remained inaccessible to photographers during their days in service. Since the collapse of the Soviet Union, steam tourism has taken off in a big way in some of the former republics, with many rail tours being run behind steam for the benefit of foreigners paying hard currency. In this view, P 36 0050 is caught in attractive evening light at Shepetivka, Ukraine. (Summer 1993)

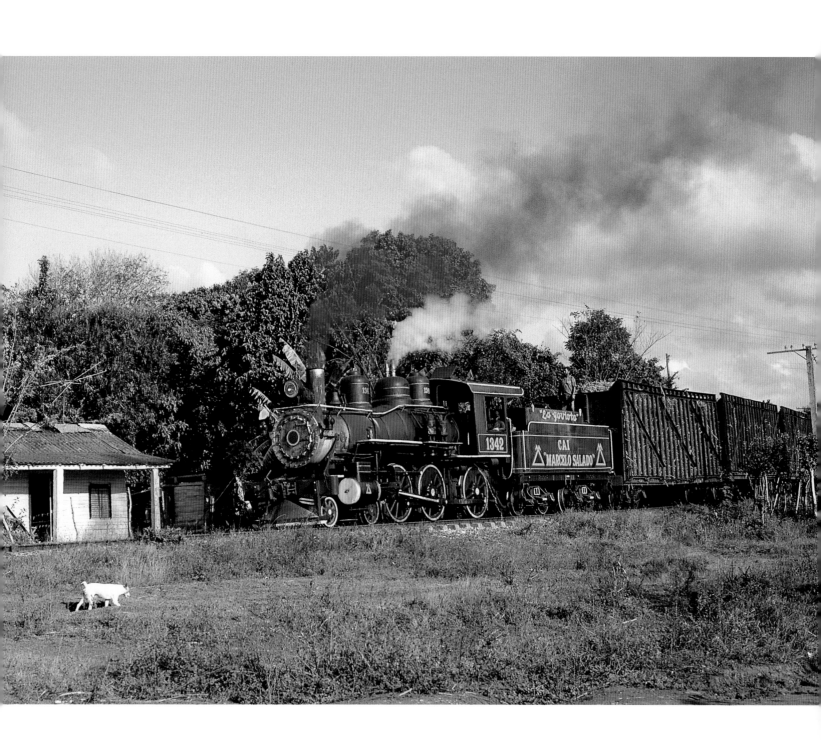

With its high, roomy cab and narrow, tapered boiler, Marcelo Salado 4-6-0 1342, a 1911 Baldwin product, sports classic Wild West looks, and is renowned as one of Cuba's most "glam"-looking locomotives. Here, 1342 is seen curving into Carolina on an inter-mill working from Marcelo Salado to Batala de Santa Clara. (Feb. 23, 2001)

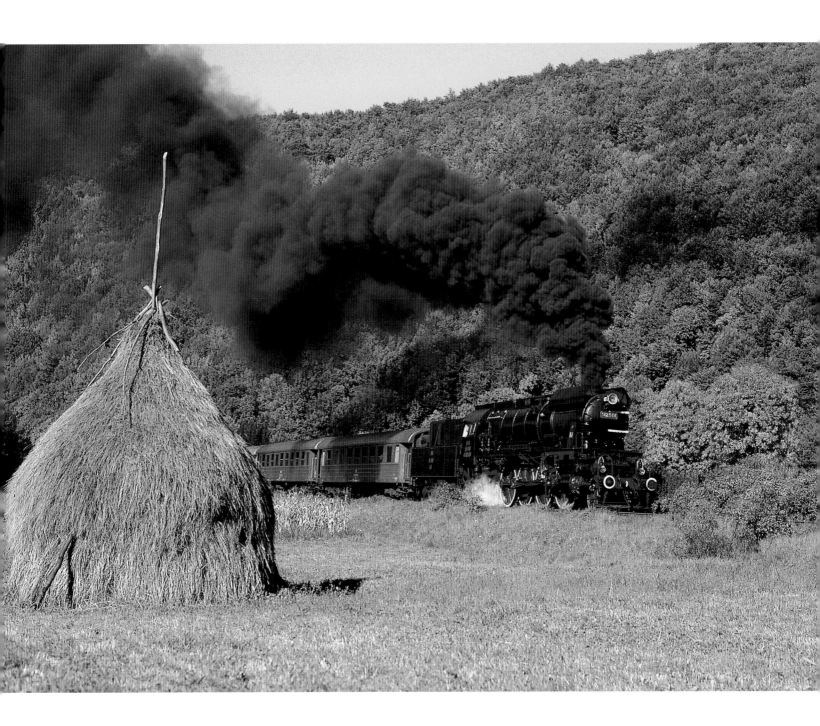

▲ The Romanian 142-class 2-8-4s—straight copies of an original Austrian design—were renowned as one of the most elegant types of steam locomotive in Europe. Their last regular duties were on express workings connecting Arad, Timișoara, and Oradea in 1974. No. 142-044, however, has since been restored to working order and is seen here performing on a staged run outside Ciucea on the Oradea–Cluj line. (Oct. 5, 1997)

Rare Birds

In the latter days of steam, the generally prevailing trend on railroads using steam traction was standardization around a limited number of locomotive classes—a practice that might not have been popular with steam fans, but that undoubtedly made sense from an operational point of view (greatly simplifying, for example, the perennial problem of spare-parts provision and interchangeability).

The Prussian State Railways set an early precedent for serial production of standard types (such as the P8 4-6-os and G10 o-10-os) in enormous quantities, a practice continued in the Third Reich, where some 8,000 of the austerity-era Kriegsloks were mass-produced. The Soviet Union was another nation favoring mass production; some 13,000 of the Russian E-class o-10-os were constructed over a forty-year period (1912–52)—the largest number of any type of steam locomotive ever built. The world's last two major steam-using nations, India and China, likewise favored mass production of proven standard designs, the Indian WG 2-8-2 and Chinese QJ 2-10-2 being constructed to totals of some 2,450 and 4,708, respectively.

It was always a pleasure, therefore, to come across rare and unexpected survivors. To the steam photographer, each design has its own unique character, and the joy experienced in encountering a rare bird is much akin to that of a naturalist stumbling upon a nearly extinct species that has somehow managed to survive against the odds. Turkey was a country where distinctive and rare designs proliferated (hailing from such diverse parts as the United States, United Kingdom, Germany, Sweden, Czechoslovakia, and France), and it was happy to continue fielding many locomotive classes down to just a few survivors each. The Indian narrow gauge, too, offered a wide variety of rare types. All this is history, but in Cuba, for the time being, the Sugar Ministry (MINAZ) presses a motley array of veterans into service for the sugar season between January and April each year.

▶ Not only is Cuba a haven for rare locomotive types, but it is also able to offer constant surprises as to just what will show up in traffic next, and where. For years, former main-line 2-8-2 no. 1910—built by the Brooks Works of the American Locomotive Company in 1925—languished out of use in the eastern province of Holguín, before being suddenly and unexpectedly transferred halfway across the island to the Ifrain Alfonso sugar mill, near Santa Clara, in 1991. Along with fellow Ifrain engine 2-8-2 1850, built in 1925, it is by far the biggest steam locomotive operating in Cuba, and the only one of its particular type. In this shot, 1910 is seen framed between trees, working a loaded cane train upgrade on the approach to the mill. (March 1998)

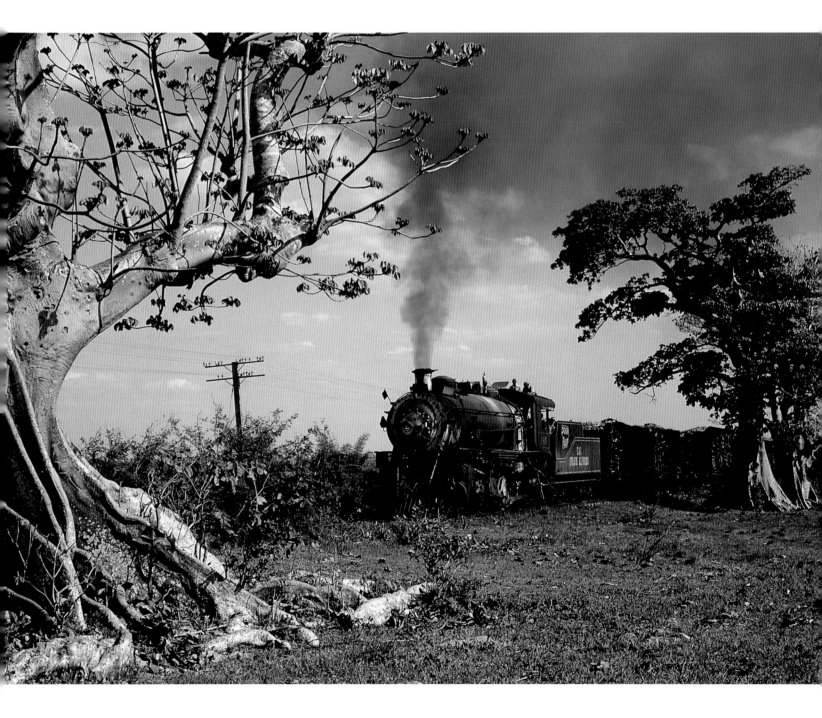

▲ Until an extensive dieselization program was launched in the late 1980s, the Indian narrow gauge proliferated with maverick designs. The three 2-8-4Ts pictured in this scene, taken at Dhaulpur during a monsoon deluge, were not only specific to the Dhaulpur system but of different classifications; left to right: ZA/4 736, built by Hunslett of Leeds in 1951; ZA/3 735, by Kerr Stuart of Stoke in 1921; and ZA/5 810, by Hunslett in 1959. (Sept. 1984)

▶ India formerly fielded a fascinating variety of rare locomotive types, but by the early 1980s, both the broad and meter gauges had become very standardized. There were, however, exceptions. On the meter gauge, the X-class 0-8-2Ts were unique to the Nilgiri Railway, between Mettuppalaiyam and Ootacamund. Fitted for rack-and-adhesion operation, the Xs were supplied by SLM of Winterthur, Switzerland, in different batches between 1914 and 1952. During the English colonial era, Ootacamund (or 'Ooty, as it was more commonly known) was a renowned hill station resort. With the stone church and cemetery overlooking the lake, there is very tangibly a "Little England" feel to this scene of an X 0-8-2T departing 'Ooty on the 3:15 P.M. to Mettuppalaiyam. (Dec. 1984)

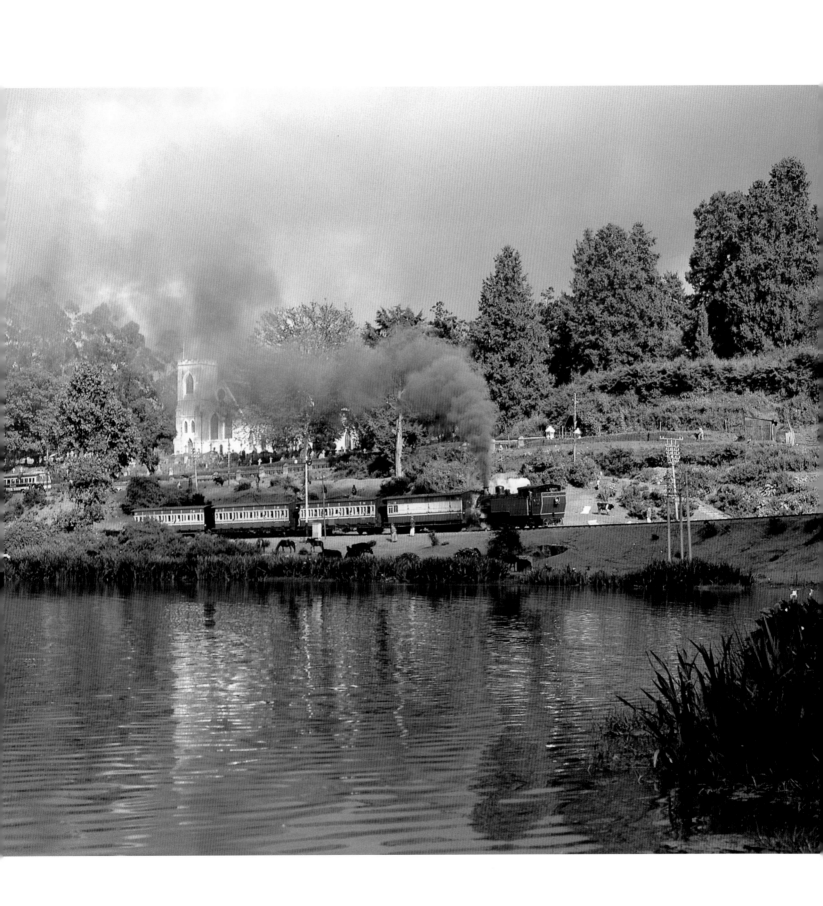

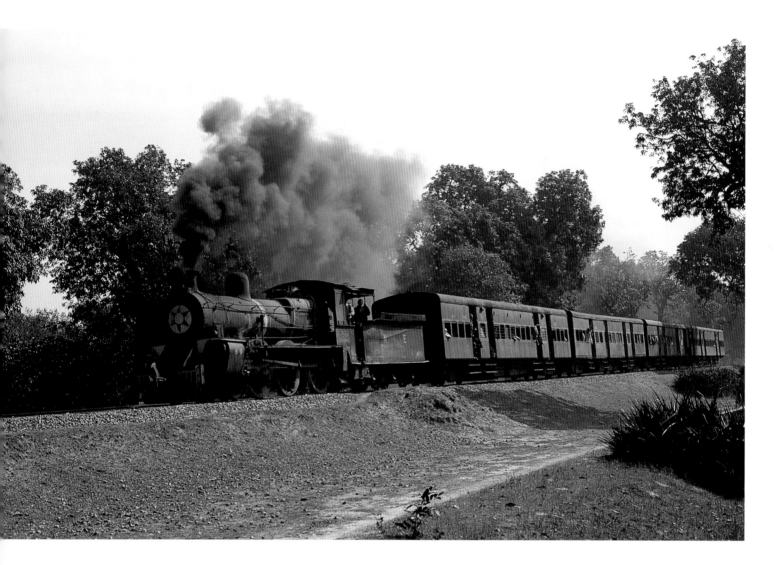

▲ A tip from the shed staff at Gorakhpur led the author to the short Bhagalpur–Barari branch on the North Eastern Railway in Bihar State, where he came upon this delightful rare bird, P-class 4-6-0 31911, seen here nearing Bhagalpur Kacheri on the morning passenger run from Barari. Despite their ancient appearance, the two Ps working on this isolated meter-gauge line were believed to have been cobbled together from bits of other engines lying around Izzatanagar Works, Bareilly, as recently as 1965. (Feb. 1, 1985)

▶ The PL-class 0-6-4Ts were exclusive to the Naupada–Gunupur line on the South Eastern Railway. In this view, PL 698 (built by Hunslett, Leeds, in 1931) departs from Naupada on the 6:45 A.M. to Gunupur, with the Calcutta–Madras main line visible in the foreground. (Jan. 1985)

▶ The hermetically sealed state of North Korea remains very much a mystery as to how much steam remains in operation, with what kind of loco-motives, and where. If major political changes were ever to occur and tourist access to the country became possible, it is a safe bet that steam enthusiasts would be among the first foreigners there. As in so many other countries, they would doubtless scour the country up and down to establish what was available and to search for rare birds—including, perhaps, some familiar old Soviet-bloc designs such as the Hungarian 424-class 4-8-0s and Czech 475 4-8-2s, both known to have been exported to North Korea. For the time being, however, only rare, tantalizing glimpses of North Korean locomotives can be had on cross-border operations into China. Here, a pristine North Korean JF-class 2-8-2 works an interna-tional freight between Tumen (China) and Namyang (North Korea) over the Tumen River, which effectively constitutes the border. (Feb. 1995)

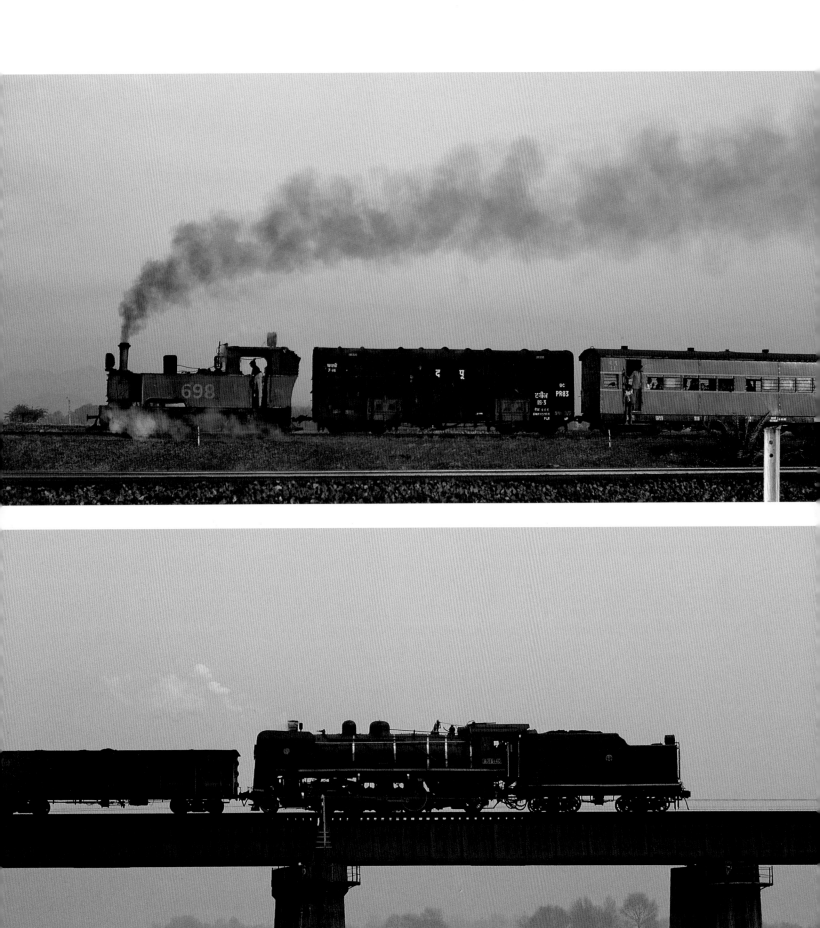

Drama and Mood

THE STEAM LOCOMOTIVE IS AN OFTEN difficult and invariably unpredictable photographic subject, always performing differently at each stage of its journey along the line. Lineside steam photography is a pastime not far removed from the fisherman waiting for a bite, for no matter how much planning there has been, the steam loco-motive—the elusive, ever-unpredictable x factor—is what ultimately determines whether the shot is a hit or a miss.

One vital element facilitating drama in a picture is smoke, preferably spectacular sky-high columns. Success in getting this, however, always depends on how the loco-motive is working when it comes along, a timely application of coal by the crew often making all the difference between a first-class and a merely ordinary result. This is undeniably part of the kick behind the habit, for when everything comes together just right, a good shot is truly a lucky catch, as much down to the sheer fluke of being in the right place at the right time as any photographic skills.

Photographers traveling abroad for steam soon came to realize that much more could be done with their cameras than straightforward historical documentation. While a rear guard of traditionalists continued to favor the standard sun-behind-the-shoulders, three-quarters-approach

► Drama and mood combine in this twilight shot—taken at about ten o'clock on a midsummer evening—of the former Soviet FD 2-10-2 and SO 2-10-0 double-heading an enthusiasts' special over the Dniester River, Ukraine, south of Kam'yanets'-Podil's'kyy, not far from the Moldovan and Romanian borders. In typically Soviet style, the locomotive classifications are derived from erstwhile Soviet luminaries, the FDs named after the infamous secret-police chief Felix Dzerzhinsky and the SOs after Georgian general Grigory Ordzhonikidze. (June 3, 1993)

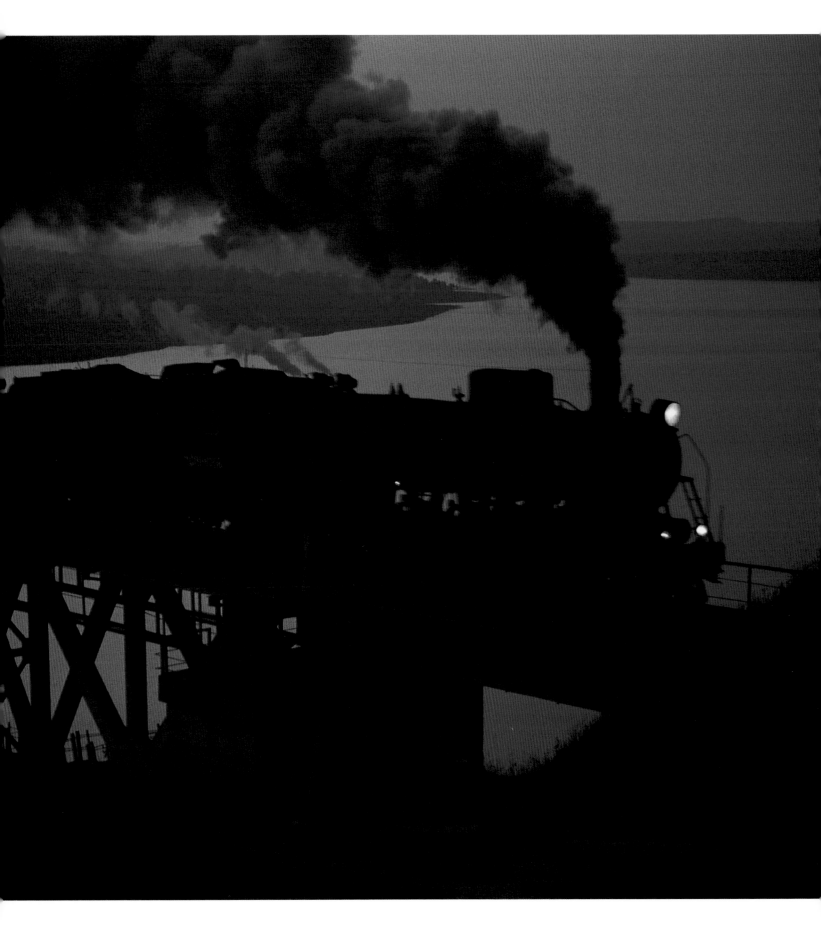

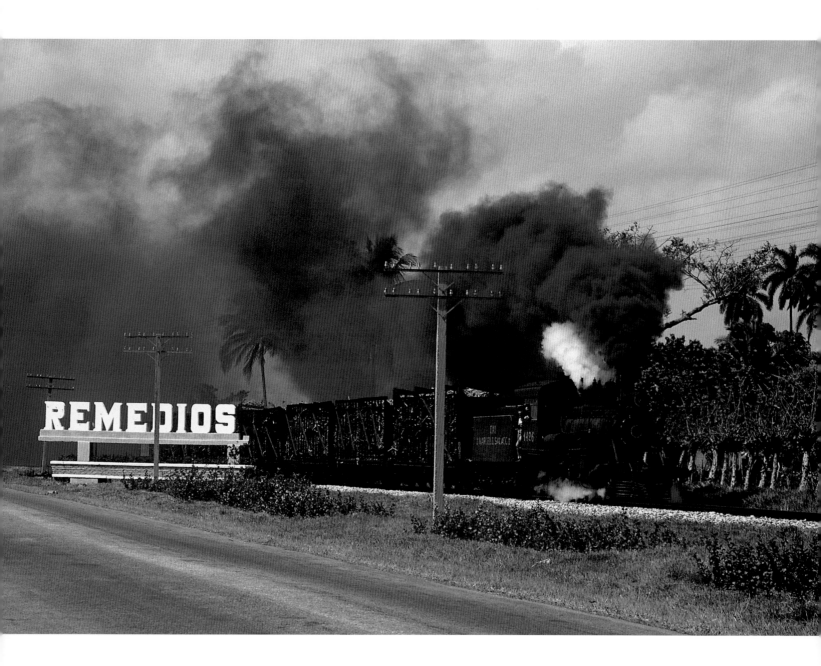

shot, others increasingly inclined toward a more imaginative and creative style of photographic interpretation, endeavoring to capture such elusive qualities as drama and mood. To those motivated by this more artistic type of aesthetic, the object of the exercise was not simply photographing steam locomotives per se, but in circumstances where the machine would be at its most photogenic, the pictorial quality of the image as important as the historical reality it (simultaneously) recorded.

The visual drama of the steam locomotive was always best brought out working upgrade, when spec-

tacular smoke effects would generally be the order of the day. Mood was an altogether more intangible, will-o'-the-wisp thing, in most cases rendered by ethereal lighting conditions enabling atmospheric interplay of steam, light, and shadow.

▲ A fine smoke display, from Cuban 2-8-0 1426 (built by Baldwin in 1920) dragging an oily black net of smoke behind it as it runs roadside out of Remedios en route to the Marcelo Salado sugar mill with a loaded cane train. (March 17, 1998)

▶ A pair of China Rail QJ 2-10-2s send vapor trails high into the dawn sky at Chengde. (Feb. 27, 1996)

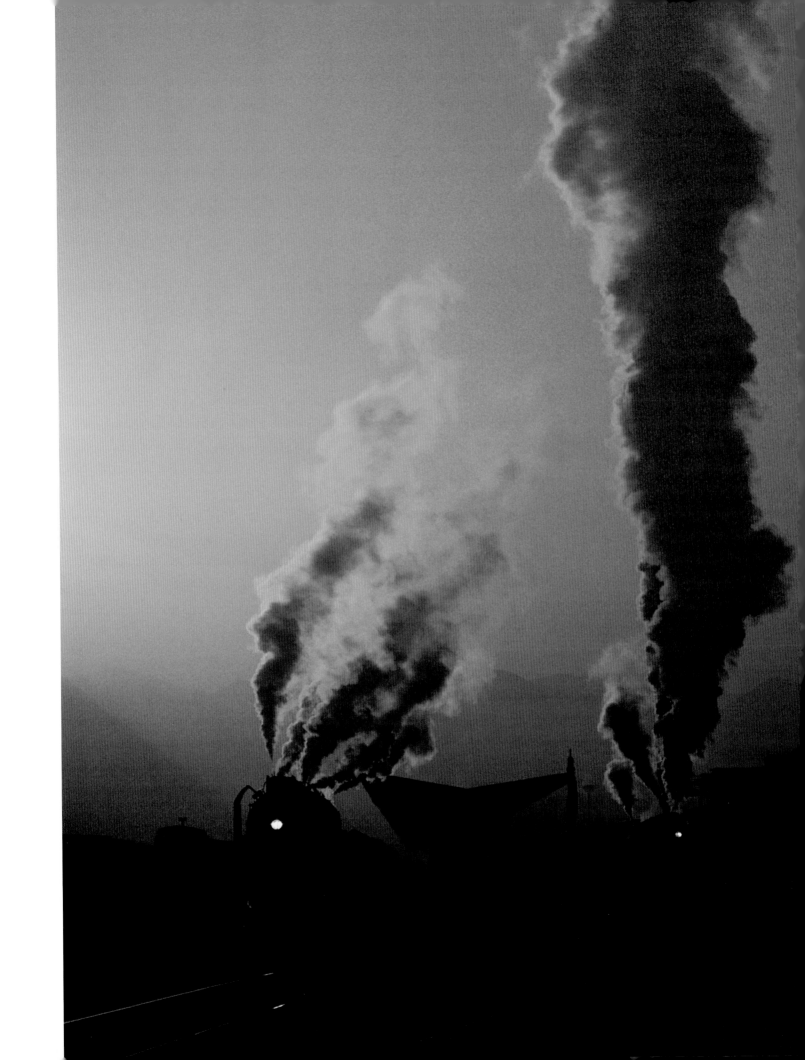

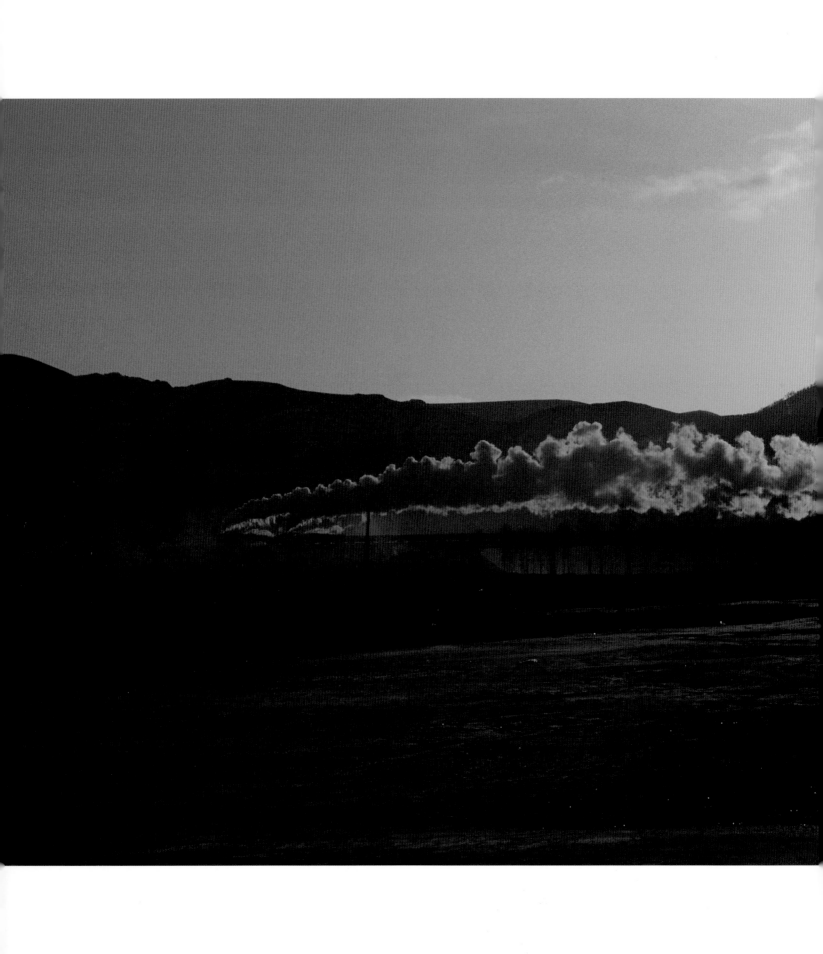

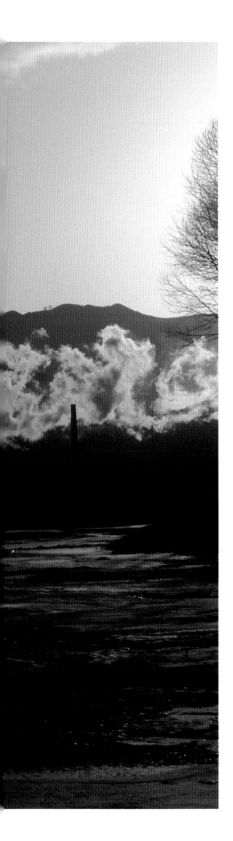

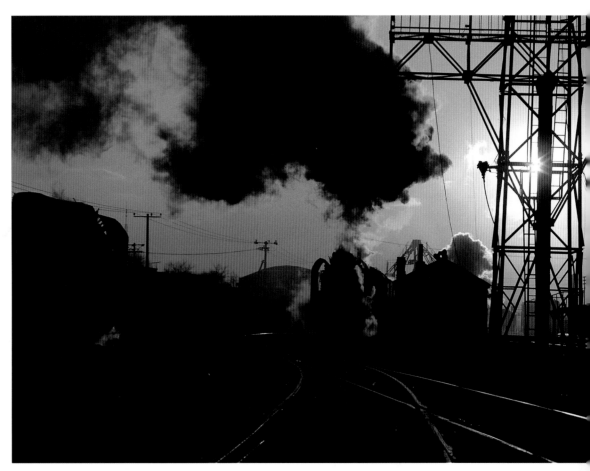

Steam allocation in Jiamusi, China, was down to just twenty dowdily maintained specimens by early 1999. As a location, however, it still offered excellent potential for atmospheric low-light photography, with the sun setting in a direct line with the loco shed every evening, and rarely any cloud in the cold, clear winter skies to obscure its descent. Here, a pair of QJs stand face-to-face in the depot yard, the setting sun spangling off the floodlight gantry and backlighting steam clouds from another QJ farther up the yard. (Feb. 20, 1999)

In this view at the brickworks viaduct between Xiakengzi and Shangdian, one of the most distinctive features of the western side of the Jingpeng Pass, the morning sun has just shown its face over the hills to backlight two QJs en route with a Daban-bound freight. (March 2, 1999)

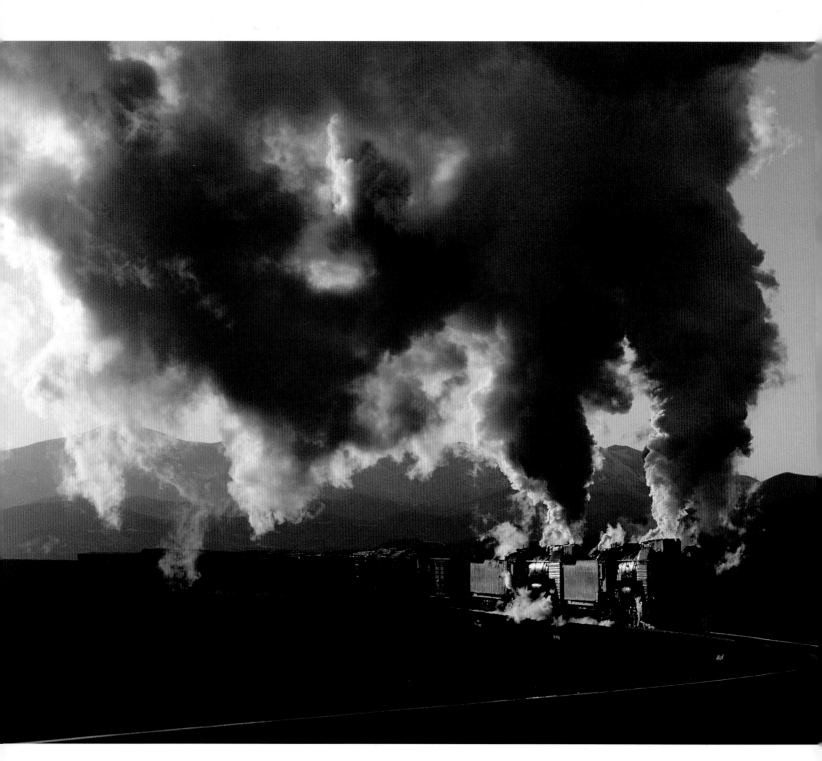

▲ Two QJs heading a westbound freight through the Jingpeng Pass catch the glint of the setting sun as they take the long, looping ascent from Reshui to Liudigou and thence to the summit at Shangdian, before descending sharply toward Jingpeng. (Feb. 27, 1999)

► Good smoke effects have always been one of the most vital contributing factors to a dramatic steam shot, there certainly being no shortage of that here: two veritable volcanic eruptions spewed skyward by this pair of QJs rasping upgrade through the Jingpeng Pass, near Xiakengzi, on a Daban-bound freight. (Feb. 1, 1999)

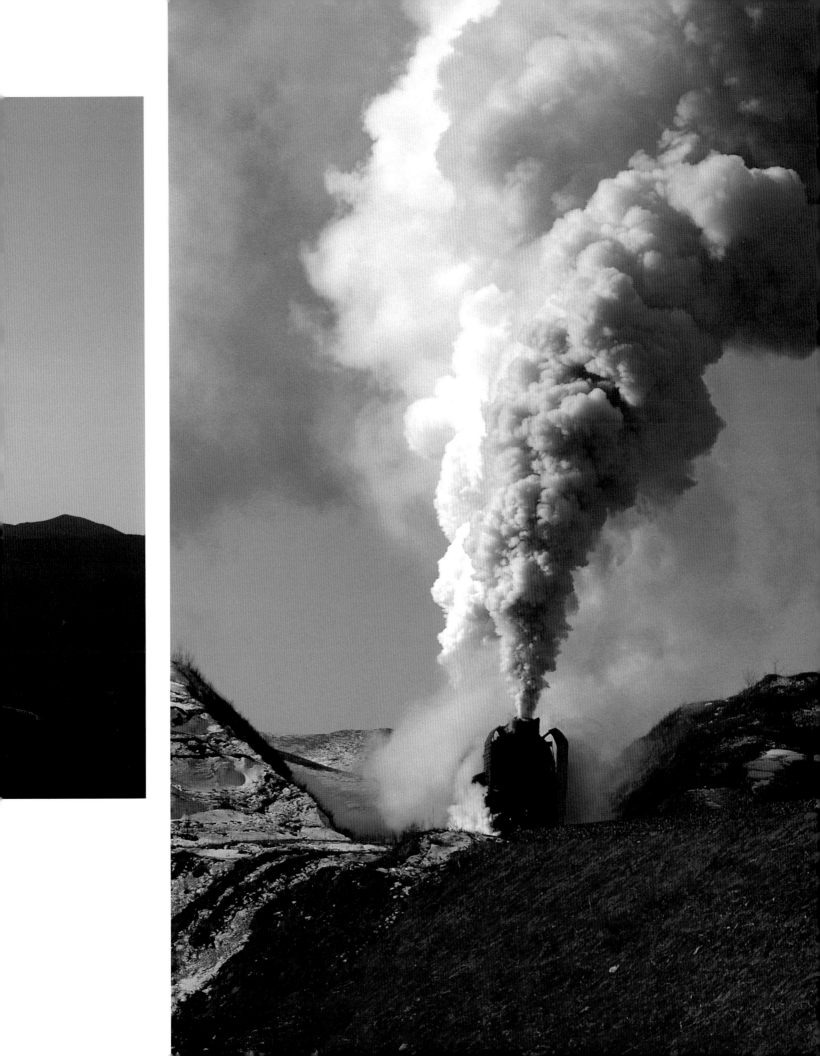

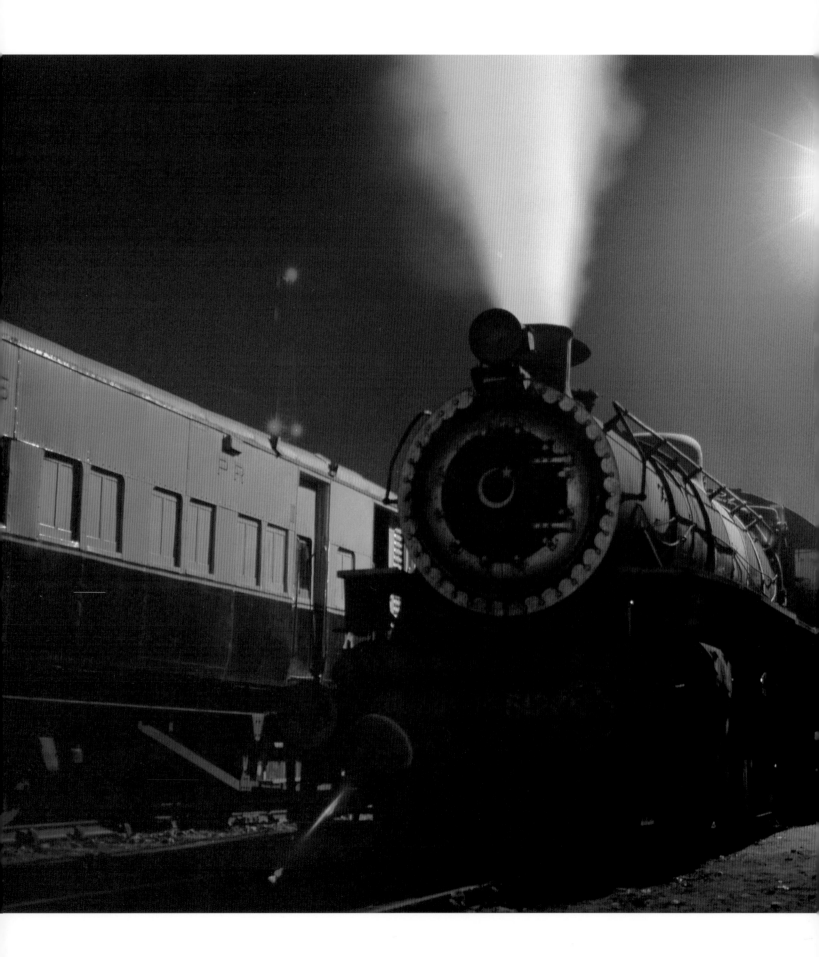

Low Light and Night

ALONG WITH ABUNDANT SMOKE EFFECTS, another vital component of a striking steam image is quality of light. Any aspiring steam photographer witnessing just once how dramatically lighting can enhance the already dramatic subject matter generally learns to seek out such circumstances again and again. In low light especially, when interesting lighting conditions are often complemented by a vibrant range of sky tones, the photographer can sometimes achieve results seemingly more akin to paintings than to photographs.

Whereas most photographers recording the endgame of steam in the United States and United Kingdom had been working in black and white, color was the predominant medium for those pursuing steam in its latter years, meaning that photographers intent on optimum image quality had to think in terms not only of composition, but also the impressionistic impact of color balance and tone. Many countries on the steam trail featured lighting conditions radically different from those prevailing back home, a difference impossible to ignore out on location, and inevitably exercising a strong influence on adopted photographic style.

The super-sharp quality of South African winter light, for example, was legendary. On the Indian subcontinent, it always paid to be out on location before dawn. Day after day, the sun could rise in a spectacular orb, its gathering rays shredding the atmospheric haze with a marvelous range of tones, from red to orange, then pink to peach.

◀ CWD (Canadian War Department) 2-8-2 5122 waits at the head of a northbound night freight at Multan, Pakistan. (March 13, 1985)

Even in the frozen wastelands of northeastern China, where the temperature could plummet to twenty degrees below zero, the sun would usually be riding high in stunning azure skies, casting a superbly crisp wintry light down on the steam action below.

One timely development that coincided with the end of the Steam Age was the radical improvement in the quality of color transparency film, as the all-too-often anemic 1960s films were superseded by a new generation of films capable of rendering color in dense saturation and with superb definition. This opened up a whole new range of possibilities, enabling portrayal of the steam locomotive at times—dawn, dusk, and night—hitherto beyond the range of most photographers working in color.

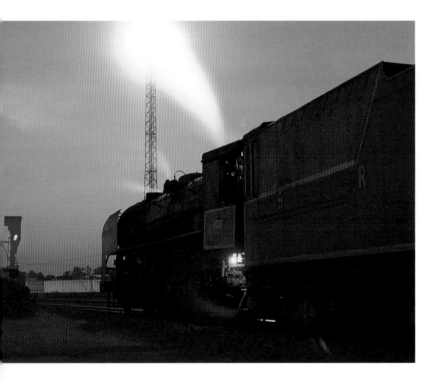

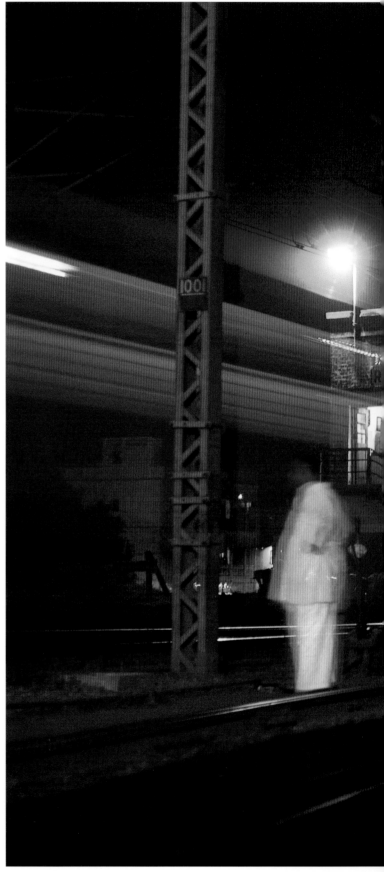

▲ At Mysore station in India, a YG 2-8-2 faces a color light signal, catching its reflection on its smoke deflectors. Steam production for the meter gauge in India continued until 1972, the last locomotive produced being a YG 2-8-2. (Dec. 1984)

▶ This long exposure of Indian South Eastern Railway XD 2-8-2 22337, resting between pilot duties at Raipur, India, has yielded an unusual effect, picking up the light trajectory of a diesel-hauled express that was pulling out while the exposure was being made, and giving the Indian citizen awaiting its passage a ghostlike appearance. (Oct. 29, 1984)

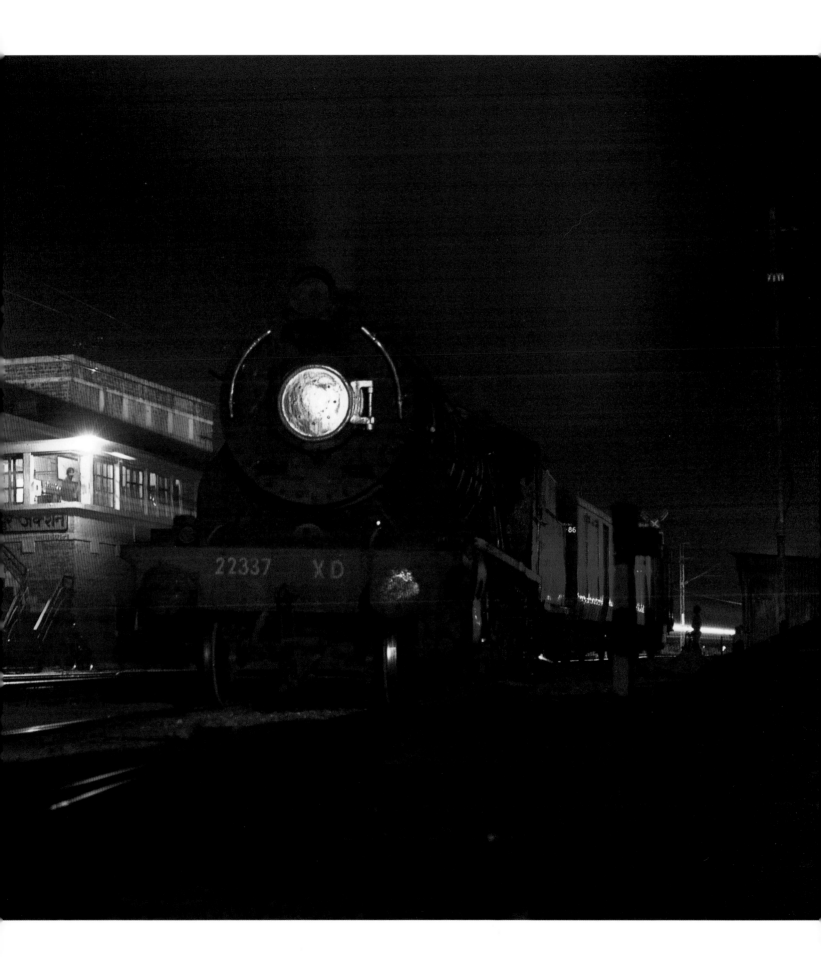

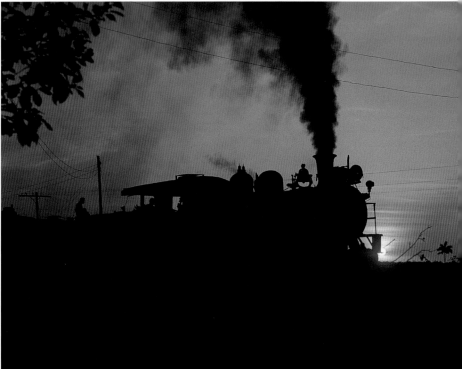

This is my own favorite kind of steam photography. When the sun begins to dip low enough to shoot against it without incurring lens flare, its waning rays granting excellent glint and backlighting possibilities, I have always felt extra-energized, knowing there is a good chance of achieving some interesting and unusual results. Admittedly, this is not a style of photography to appeal to those who prefer nuts-and-bolts definition. In terms of conveying the poetic mood and atmosphere of the steam locomotive, however, there is probably none better.

▲ With steam operations generally not getting under way until well after sunrise, and the sun dying all too rapidly in the evening, Cuba is not especially renowned for offering many possibilities for low-light photography. There can be exceptions, however, as in this particular instance at Murga on the Australia system, where the photographer was luckily in the right place at the right time to silhouette the veteran ten-wheeler 1515 against the setting sun on its way out into the cane fields. (March 6, 1998)

► A WP pacific brewing up at Amritsar, India, poised to depart on the overnight passenger run to Haridwar, is silhouetted against the crimson dusk sky. (Oct. 1992)

▲ A dramatic sunrise shot at the Vijayawada loco shed in India, with the crew of a WG-class 2-8-2 strikingly silhouetted in the cab. (Dec. 1984)

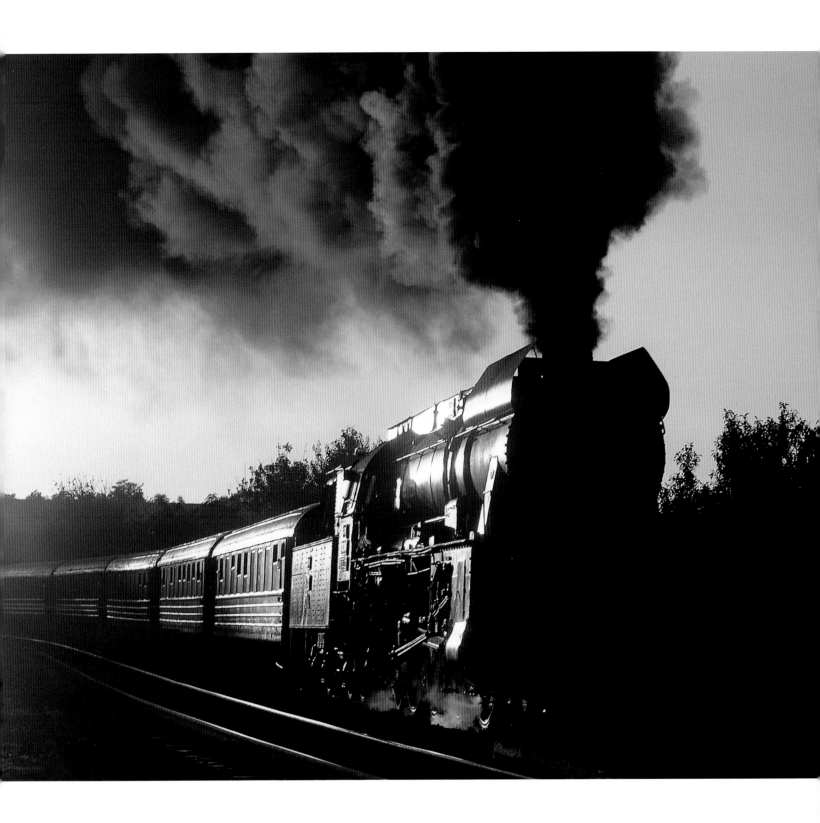

▲ Romanian 142-class 2-8-4 044 catches the full flush of the setting sun at Stana, east of Huedin (Oradea–Cluj line), on a rail-tour special. (Oct. 1997)

◄ The rising sun highlights the rail patterns at Bhusawal, India, as a WG yard pilot (running tender first) shunts a long line of freight wagons. (Oct. 17, 1984)

3 The Latter Days of Steam

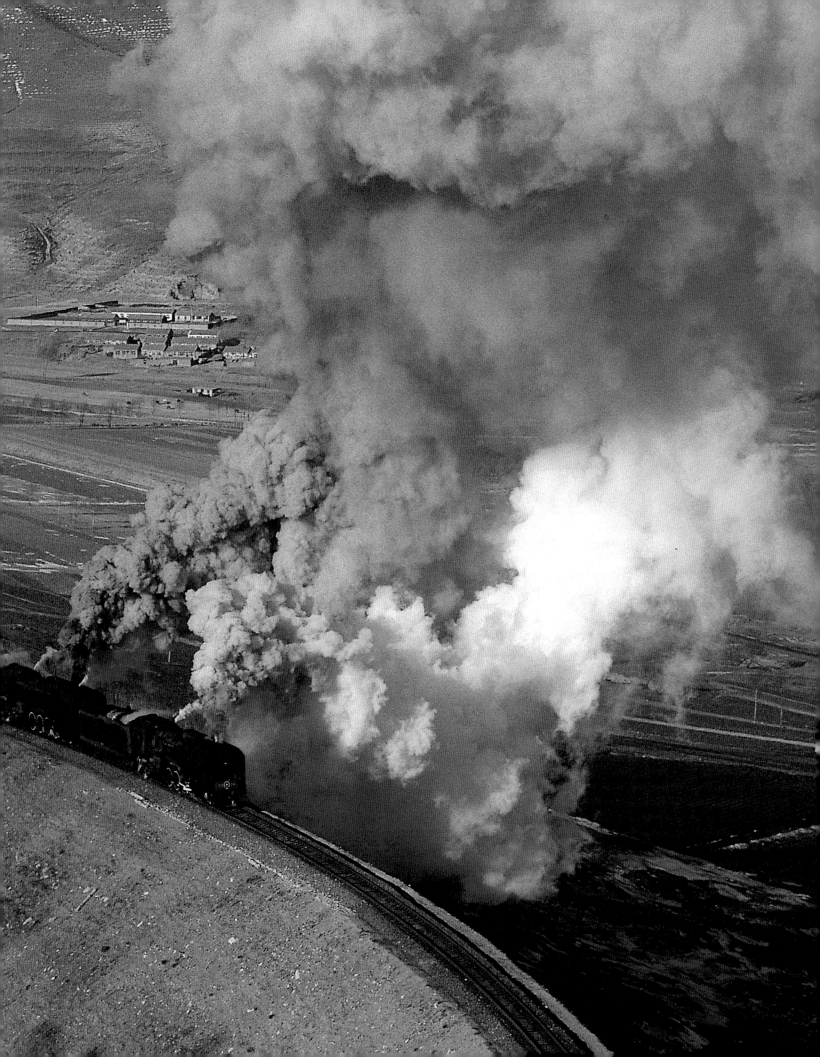

India: Steam on Four Gauges

INDIA WAS THE WORLD'S SECOND-BIGGEST latter-day user of steam power after China, featuring steam operations on the broad (five-foot-six-inch), meter, and two narrow (two-foot and two-foot-six-inch) gauges. In 1981, when some 7,525 steam locomotives remained in service throughout its giant system (divided for administrative and operational purposes into nine different regional railroads, the locomotives of each sporting distinctive regional liveries), a relatively wide variety of locomotive types still operated on both broad and meter gauges. Thereafter, however, a ruthless culling of older and nonstandard types took place, with any locomotives with boilers more than forty years old being automatically consigned to scrap.

Unlike China, where steam eked out its endgame on freight, in India steam bowed out on passenger trains. Even a full fifteen years before Indian broad-gauge steam operations came to an end in 1995, apart from the odd exception, there was precious little in the way of steam-hauled main-line freight, which (along with express passenger service) was the first priority of Indian Railways' relatively slow yet inexorable dieselization program.

By late 1983, only five types remained in service on the broad gauge. The ubiquitous WG 2-8-2s (2,450 built between 1950 and 1970) and WP 4-6-2s (755 built between 1947 and 1967) predominated at most locations. Most of the WL-class light pacifics (104 built between 1955 and 1968) were concentrated in the Punjab. The XD 2-8-2s (a class originally introduced in 1927, then built in another batch

between 1945 and 1946) could be seen at just a few locations on the South Eastern Railway and, along with the A/CWD 2-8-2s (more than 700 of which had been built by the American and Canadian war departments between 1943 and 1949), had disappeared by 1986.

On the meter gauge, the YP pacifics (871 built between 1949 and 1970) and YG 2-8-2s (1,074 built between 1949 and 1972), two types that were virtually indistinguishable save for the wheel arrangement, similarly predominated. By 1984, many older nonstandard types had been withdrawn, though some remained, with YB pacifics roaming the rails in Gujarat and YD 2-8-2s working in Goa. The attractive YL 2-6-2s (264 built between 1952 and 1957) provided additional variety, as did the WD 2-8-0s. In the mid-1980s, steam still significantly predominated over diesel on the meter gauge. In March 1985, for example, 2,349 steam locomotives were in service on the meter gauge, compared with only 541 diesels. Soon after, however, a massive program was launched to convert much of the meter gauge to broad gauge. Although there were still some 1,400 meter-gauge steam locomotives in stock in 1992, that figure had dropped to a mere 136 by 1996.

In contrast to the extreme standardization prevailing on the broad and meter gauges, a delightful variety abounded on the narrow gauge, from 1950s-built 2-8-2s to pacifics dating back to the beginning of the century. Most

▲ Two QJs tackle the long, winding—and windswept—upgrade beyond the Reshui viaduct in the Jingpeng Pass. (Jan. 26, 1999)

► The WG 2-8-2s were originally intended for freight, but by the mid-1980s, diesel hauled virtually all freight on the Indian broad gauge. Instead, WGs were used on stopping passenger trains, on yard shunting, and sometimes even on expresses. In this view at Ambala, a WG 2-8-2 (with a smokebox adorned by the distinctive white starburst motif of the Ghaziabad loco shed) gets the 8:25 A.M. Ambala–Delhi passenger run under way. (Feb. 1985)

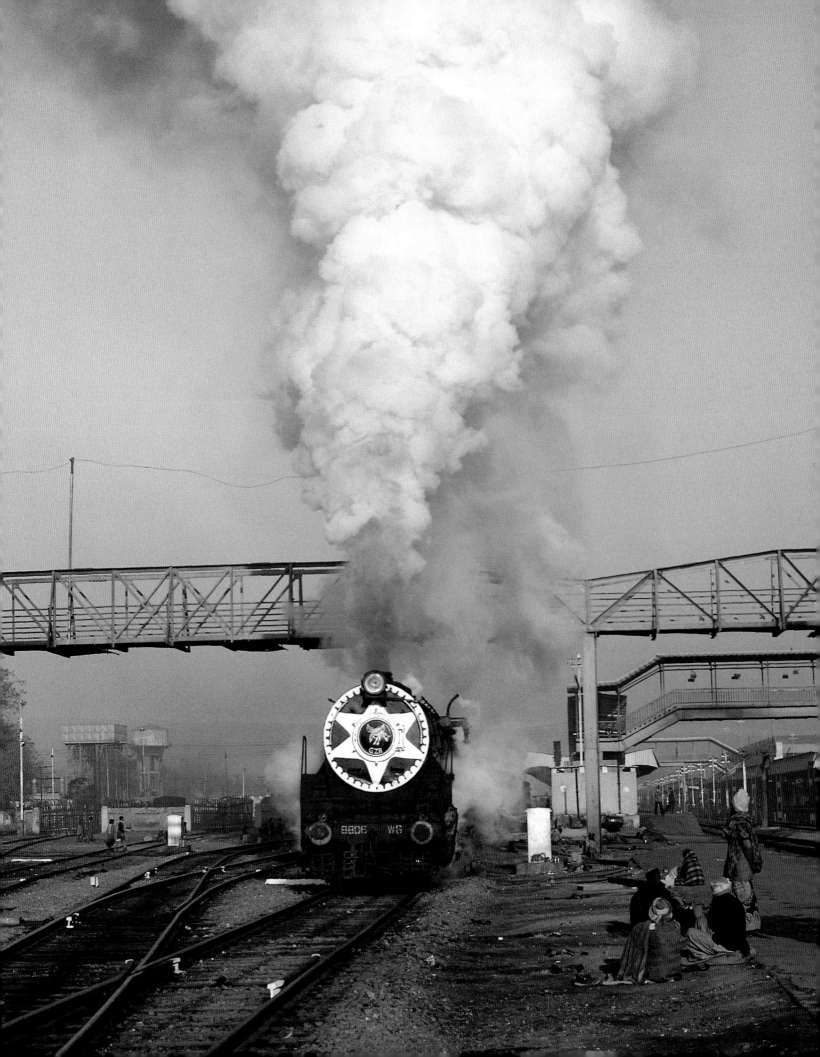

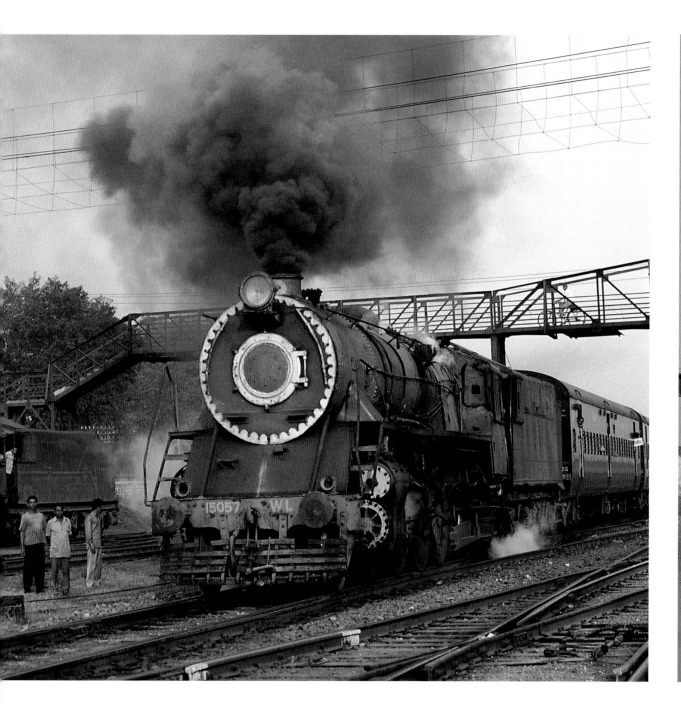

Indian narrow-gauge lines were gauged at two feet six inches, exceptions being the Central Railway's Gwalior system and the celebrated Darjeeling Himalaya Railway, both gauged

▲ In the Punjab, in northwestern India, more than sixty steam-hauled passenger trains were still working in and out of Jalandhar every day in the early 1990s. Here, a distinctly dowdy WL 15057 departs on the 7:50 A.M. to Jaijon Doaba, as classmate WL 15044 backs down to the station from the loco shed. Another WL, 15100, headed India's last steam-hauled broad-gauge service train, the 5:35 P.M. Jalandhar–Firozpur run, on November 23, 1995. (Oct. 1992)

at two feet. In March 1985, before Indian Railways targeted the narrow gauge for extensive dieselization, narrow-gauge steam stock totaled 322, a decrease of only 63 over the preceding ten-year period.

Things, however, soon began to change. From about 1987 on, many of the unremunerative rural routes were closed, and new diesels cascaded onto others. By October 1995, there were only 28 narrow-gauge locomotives left in stock, by which time, with broad-gauge steam at an

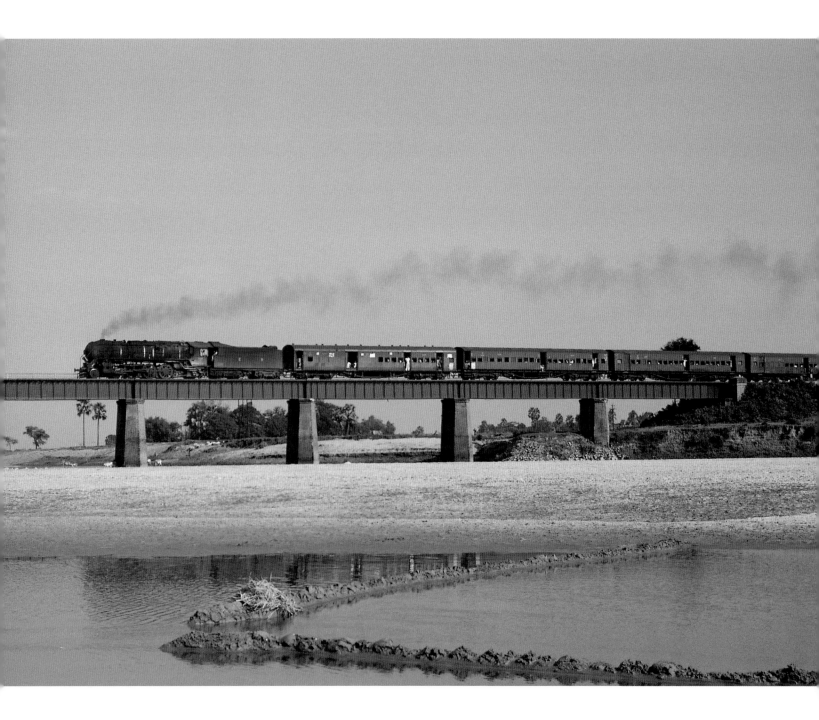

end and meter-gauge steam stock down to a mere 231, the Steam Age itself in India was all but over. The final stomping ground of Indian meter-gauge steam was in the western state of Gujarat, with the very last center, Wankaner, just about hanging on as the century came to a close. From being a country that in the 1980s could offer steam of some description in virtually every nook and cranny of its intensively tracked system, by 2000—other than the odd survivor in industrial service—all that remained active of

India's once rich steam heritage was a couple of exceptions retained as tourist attractions: the narrow-gauge Darjeeling Himalayan line in the far northeast, and the meter-gauge Nilgiri Railway in the southern state of Tamil Nadu.

▲ The first priorities of Indian Railways' broad-gauge dieselization program were long-distance expresses and freight. By the time this shot was taken, at Katwa on the Eastern Railway, most WPs had been displaced from prestigious glamour turns onto more mundane workings such as the 7:35 A.M. Sealdah (Calcutta)–Salar stopping passenger train, seen here crossing the Ajay River. (Nov. 1984)

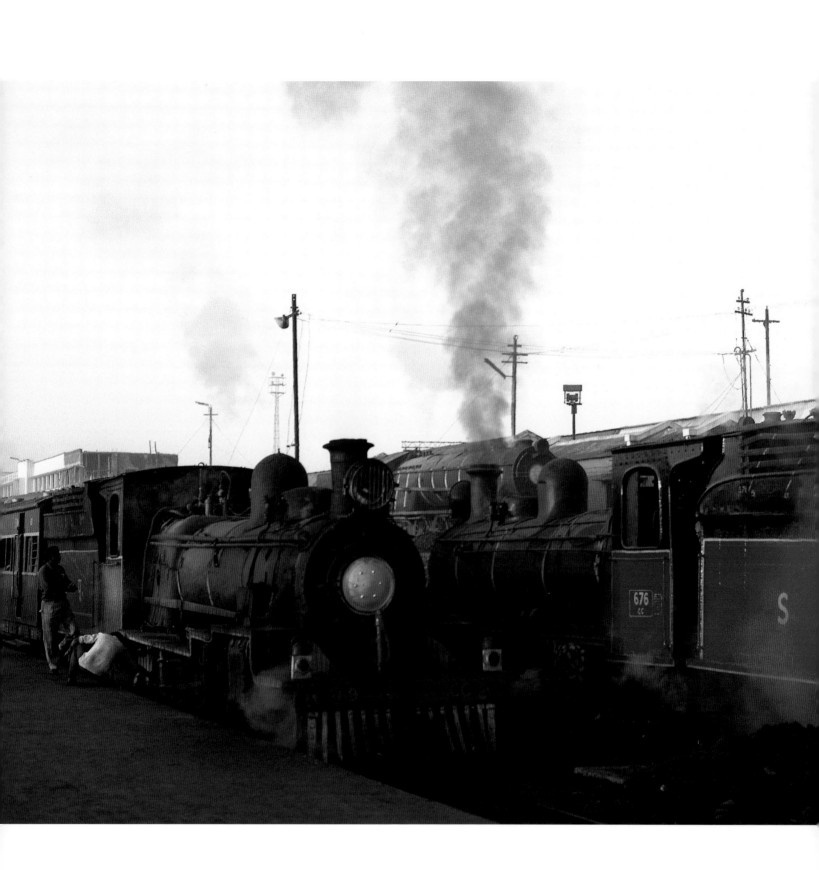

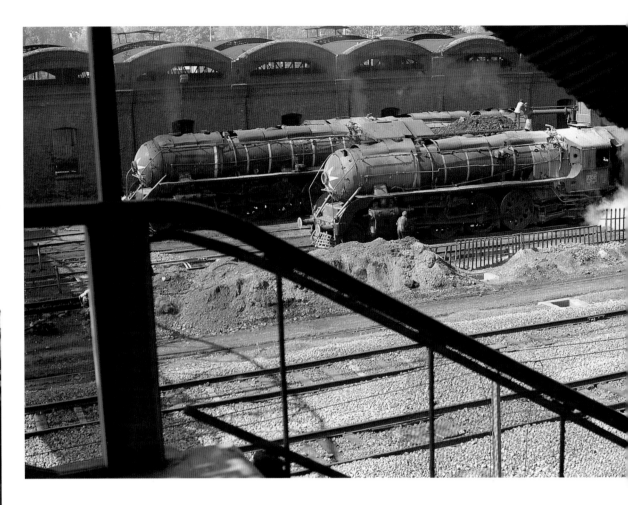

By the early 1990s, steam on the Indian broad gauge was well on the wane, with much of the broad-gauge system entirely steamless, and such steam as remained elsewhere often having been allowed to deteriorate into appalling mechanical and external condition. Typical of the condition in which latter-day Indian broad-gauge steam operated are these two grime-encrusted WPs, resting between duties at the Saharanpur loco shed. (Sept. 22, 1992)

Taken on the day of Indian premier Indira Gandhi's assassination, this shot depicts two broad-gauge XD 2-8-2s looming over a pair of narrow-gauge CC pacifics at Raipur. By the following day, Raipur—like so many towns right across India at this critical time—was in turmoil, with rioting and the burning of Sikh properties culminating in the imposition of a military curfew. (Oct. 31, 1984)

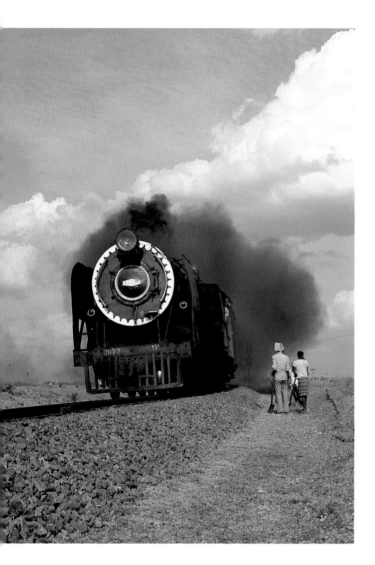

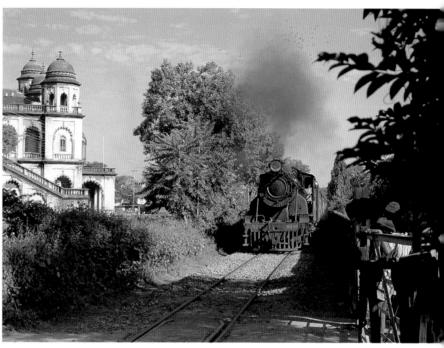

▲ The mainstay of steam-hauled passenger traffic on the meter gauge were the YP pacifics. Here, South Central Railway YP 2672 passes a track-maintenance team on its way into Hubli with a fast passenger train from Solapur, dragging a net of black smoke behind—contrasted strikingly against the puffy white cloud formation above. (Jan. 1985)

► The Indian narrow gauge was renowned for its motley variety of aged, nonstandard types, in addition to the more numerous ZB 2-6-2s and ZE 2-8-2s. In this view at Baripada on the South Eastern Railway, CC pacific 663 is coaled by hand at the depot, with classmate CC 666 in attendance behind. Both locomotives were built by North British of Glasgow in 1906. (Jan. 22, 1985)

▲ There were other locomotive classes besides YPs and YGs to provide some variety on the meter gauge. For example, with their high-pitched boilers, the lightweight YL 2-6-2s (264 manufactured between 1952 and 1957 by various builders: Robert Stephenson, England; Mavag, Hungary; and Henschel, Germany) were visually distinctive machines. The YLs could be seen, among other places, on line work on the Western Railway rural byways of Gujarat. In this view, the Henschel-built YL 5207 approaches a level crossing on its way out of Junagadh with the 8:40 A.M. passenger train to Visavadar, passing the imposing Bahuddin College Building at left. (Oct. 1984)

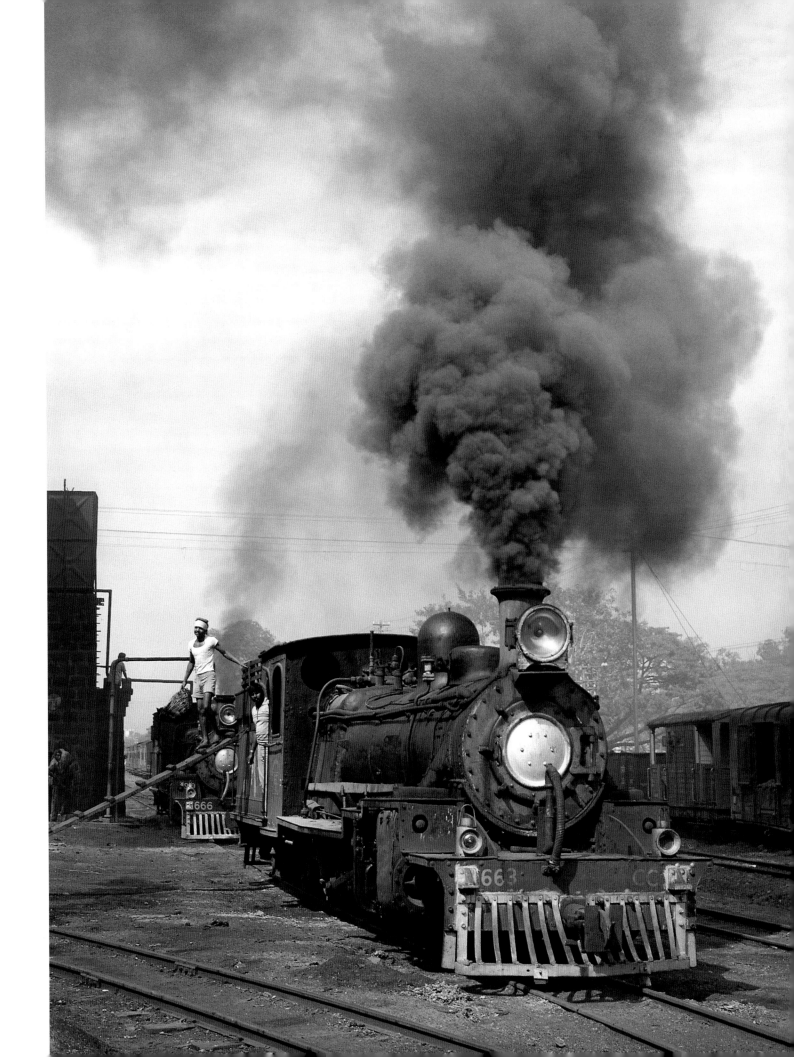

China: End of the Steam Age

As steam's fortunes waned in the 1980s, China was the last big hope, still sticking with steam as a technology, and at one point seemingly intent on further pursuing it. With its vast indigenous coal reserves and cheap labor costs, there did seem a strong case here for retaining steam power. In 1986, British engineer David Wardale was invited to the Datong Locomotive Works as a technical consultant, to work on improving the performance rate of existing QJ-class 2-10-2s and on developing a projected Super QJ—a plan, alas, ultimately abandoned as China, too, opted for full-scale dieselization. Not long after the last QJ had been produced in December 1988, the familiar phasing-out process began to get under way in China too, steam first being ousted from the main trunk routes, then from entire geographic regions, as it became concentrated in ever-contracting pockets.

Most of the steam locomotives latterly operating in China were of relatively recent vintage (the majority built between the mid-1970s and mid-1980s), though the actual designs dated back to the 1950s, with classifications redolent of the era of Socialist Realism. Almost 5,000 of the QJ (for Qianjin, which literally translates as the tautology "Advance Forward"—as if such a feat could be accomplished sideways!) class were mass-produced between 1956 and 1988, with nearly 2,000 of the JS (for Jianshe, meaning "Construction") type built during the same period. Between them, these two accounted for virtually all main-line steam operations, while the 1,800-strong SY (for Shangyou, or

"Aiming High") class similarly predominated at industrial locations such as steelworks, coal mines, and cement plants. Other than several exceptions, such as the JF (for Jiefang, or "Liberation") class, and an odd rarity in industrial service, only the same few highly standardized types were to be found from one end of the country to the other.

What Chinese steam power lacked in variety, however, was to a certain extent compensated by some of the superb landscapes through which it worked, and, of course, the context in which it could be witnessed, that of an authentic, intensively trafficked main-line system. Until 1996, locations such as Yebaishou, Linfen, and Jiamusi provided what by then was the unique spectacle of truly large-scale steam operations.

Steam was not evenly distributed throughout the country. Because of its distance from the coalfields, there was very little in the south, more in the center and northwest, but most of all in the northeastern provinces of Jilin, Liaoning, and Heilongjiang. Traditionally, steam photographers always specifically aimed to cover the northeast during the winter season, when the photographic returns (snow cover, crisp light, stunning azure skies, and spectacular steam effects resulting from the cold) were considered to outweigh any creature comforts forgone.

In Heilongjiang, bordering Siberia, the thermometer could plummet to as low as forty degrees below zero, conditions that precluded even the most fanatic of the lunatic fringe from remaining outdoors for any length of time.

▶ A latter-day stronghold of JS-class engines was at Bei'an in the far northeast, just south of Siberia, where they performed on freights as far as Longzhen on the line continuing north up to the border crossing at Heihe/Blagoveshchensk, as well as on shunt/pilot duties. Here, JS 6554 stands at the head of a line of locomotives in the murky gray of dawn, poised to take on yard shunt duties. (Feb. 8, 1999)

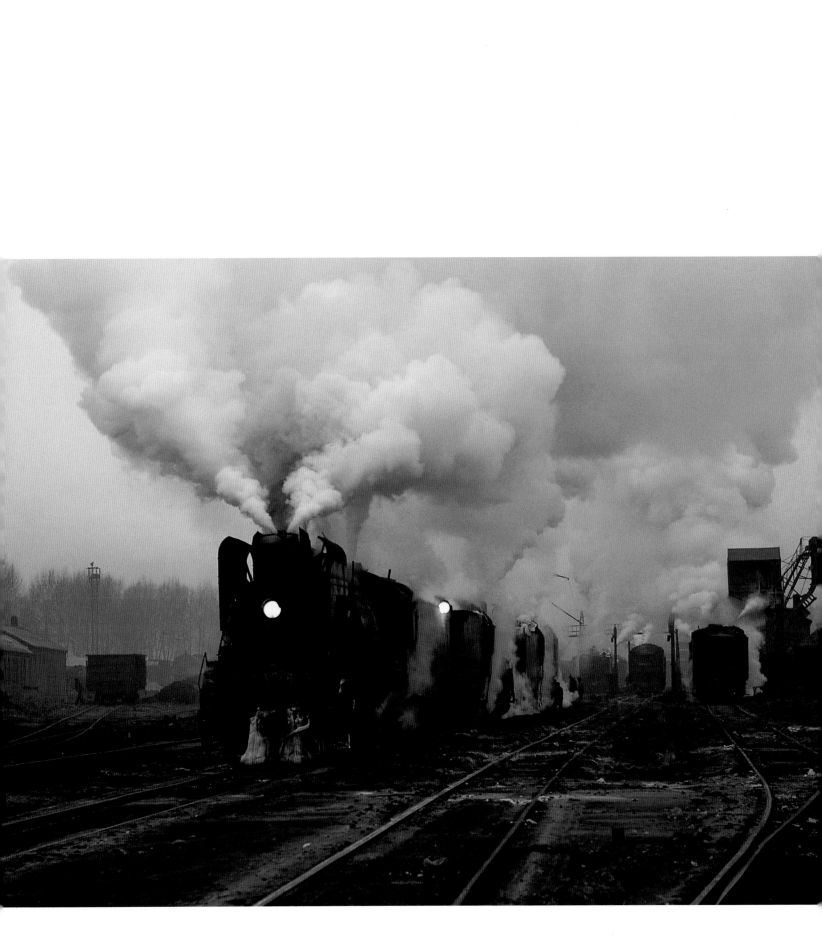

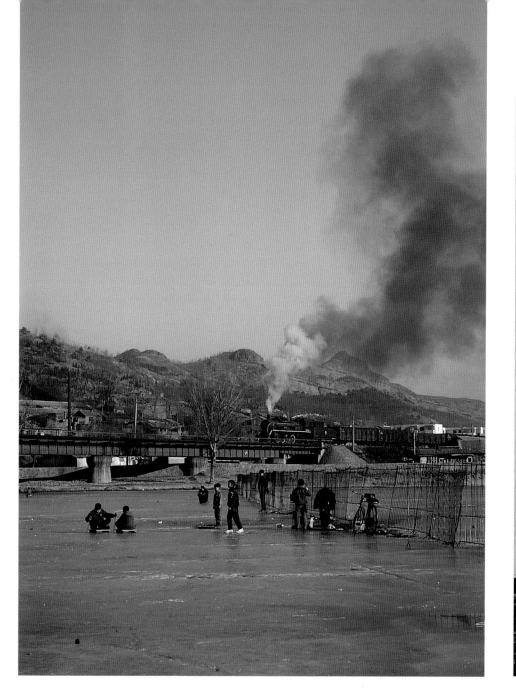

Anything halfway bearable, however, would result in little frozen figures huddling patiently along the lines, taking consolation perhaps from the credo that the more extreme the weather, the more potentially spectacular the shot. And no doubt about it, when the proverbial object of fascination

▲ With steam locomotives still being manufactured for industrial service until the late 1990s, steam has better survival prospects working at coal mines, steelworks, and the like, unlike the decimation of steam on open-line operations. For some time to come, hopefully, it will be possible to witness such sights as this SY 2-8-2 crossing the Wulie River at Chengde at the start of its daunting climb west up the Chengde Steelworks branch, accompanied by young ice-skaters on the river's frozen surface in the foreground. (Feb. 7, 1995)

eventually appeared, with jagged icicles hanging from the front end, and billowing clouds of steam clinging statically to the subzero air, the sheer drama of the spectacle could be so spellbinding as to momentarily eclipse consciousness of all else, numbed extremities notwithstanding.

At the outset of the 1990s, there was still plenty of steam around, with sprawling marshaling yards in major cities such as Harbin and Shenyang chockablock with steam freights. Until 1992, the main Beijing–Ürümqi trunk route, out to the far west, was practically 100 percent steam-worked from Baotou to Wuwei, west of Lanzhou. At this stage, while on the way out, steam was still a major

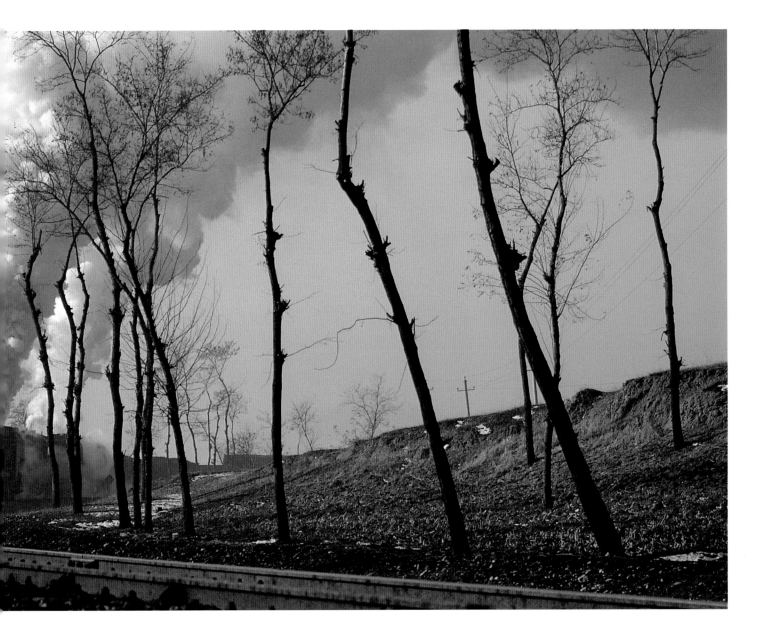

presence. Unlike India, where steam ended its days on passenger runs, in China it was overwhelmingly to be found on freight, with double-heading relatively commonplace due to the heavy tonnage of many freights.

From 1996 on, however, the rate of steam displacement began to radically accelerate, and by 2000, steam could be found in quantity at just a handful of locations on the main CNR system, such as Fuxin, Jixi, and Bei'an. Within industry, though, it remained the predominant traction form. The top industrial operations, such as the Chengde and Anshan steelworks and the Zailanur opencut mine, remained solidly steam, and the main industrial type

of steam locomotive, the SY-class 2-8-2, was still being built—albeit in ever-diminishing numbers—throughout the 1990s at Tangshan and Changchun.

One development that gave steam an extra lease on life in the 1990s was the inauguration of local-government

Yebaishou had a brief life span as one of the world's top steam spots; it was discovered in 1994 but heavily dieselized in 1997 and 1998, with just a few steam workings left by 1999. Here, a pair of China Rail QJ 2-10-2s tackle the stiff, winding gradient between Gongyingzi and Bolouchi with a Yebaishou–Chaoyang freight. During the preceding summer, the spectacle that QJ freights produced toiling uphill was such that the many farmhands working in nearby fields lowered their tools and stood transfixed. (Jan. 1996)

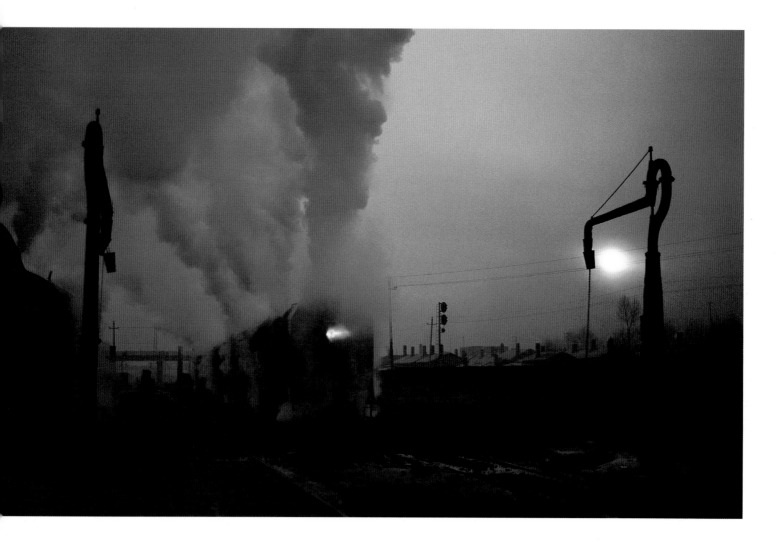

railroads. With most major population centers long since rail-connected elsewhere in the world, the undertaking of major rail construction projects is largely a thing of the past. Not so in China, where the business of developing the country's infrastructure is still ongoing. Thousands of new track miles were brought into commission during the 1990s, both on the main CNR system and on local-government lines. Because of budget restrictions, the local-government lines (so called because they were constructed with local-government finance) had to rely on secondhand steam locomotives pensioned off from the national CNR system.

Among the new steam-worked lines are the Bao–Shen route, between Baotou and Shenmu (in Chinese railroad operational parlance, lines are referred to by abbreviations of the two towns between which they are extended);

the San–Mao, between Sanshui (about two and a half miles from Guangzhou) and Maoming; and, most famous of all, the 586-mile Ji–Tong line, between Jining and Tongliao in Inner Mongolia, featuring the Jingpeng Pass, the super-spectacular stage setting against which the steam locomotive would act out its grand finale.

▲ Bei'an was one of the last locations on China Rail featuring a reasonable level of steam operation on open-line work. Its allocation of some forty locomotives (both QJ and JS class) had 100 percent responsibility for freight traffic on all three lines (to Fuyu, Suihua, and Longzhen) radiating out from the junction when the author visited in February 1999. In this shot (featuring the same scene as on page 133, but looking toward where that photograph was taken), steam wafts up into the headlight beam of a QJ as the rising sun (framed by a water column) struggles to shine through the morning pollution murk. (Feb. 8, 1999)

▶ A fireman trims the coal down on the tender of the lead QJ of a double-headed formation on a westbound freight at Jingpeng. (Jan. 29, 1999)

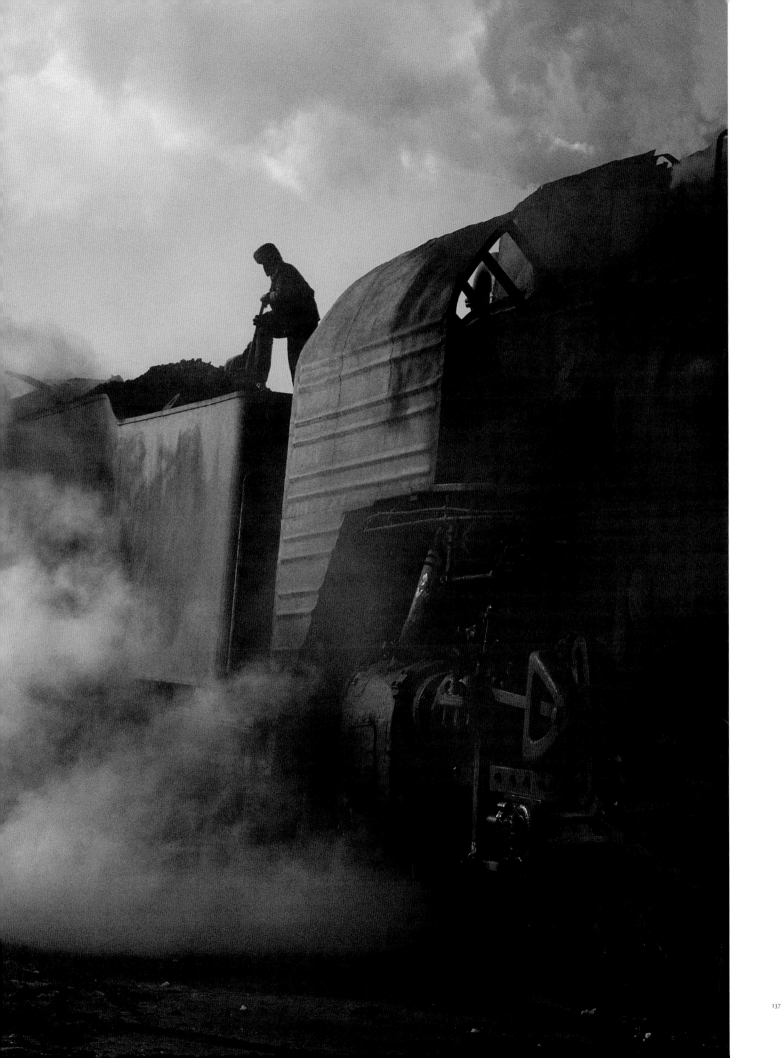

Cuba: Tropical Time Warp

APART FROM CHINA, THE ONLY OTHER sizable concentration of regular working steam left in the world today is in Cuba. Even at that, steam is merely seasonally employed there, for the first four months or so of the year during the Zafra (sugarcane harvest). Steam operations in Cuba are a much more low-key affair than the big main-line action latterly featured on China Rail; the FCC, Cuba's state railroad, fully dieselized as far back as the 1950s. Whatever steam locomotives remain active see service instead with the Sugar Ministry (MINAZ). The engines are dispersed among a fair few—but certainly not all—of its numerous mills dotted right across the country. Each mill system is distinguished by a name derived from the specific mill it serves, sometimes that of a country (Australia, Ecuador, Venezuela), more often that of a historic personality (George Washington, Simon Bolívar).

Steam is especially well represented in the provinces of Villa Clara, Matanzas, and Ciego de Avila. Elsewhere, however, many mill systems are entirely worked by diesels, and east of Ciego de Avila (roughly halfway along the 850-mile-long island) there is very little steam power, other than the scenic Rafael Freyre system in Holguín Province. Each mill system using steam, moreover, keeps only a small number of locomotives, hardly more than a half dozen in most cases, and to find four engines in steam simultaneously on a bigger system such as Australia would be good going indeed.

In contrast to China, where just a few standardized classes could be found, in Cuba a marvelous variety of different types abounds, the vast majority American-built, and all but a few exceptions oil-fired engines. With the youngest having rolled off the production line in 1935, and most of the others dating from the 1910s and 1920s, Cuba offers a unique time-warp experience of vintage American steam power. Builder's plates from the classic American locomotive works of the Steam Age—Baldwin of Philadelphia; Porter, Pittsburgh; and the Vulcan Iron Works, Wilkes-Barre, Pennsylvania—continue to adorn the boilers of locomotives still hard at work decades after the eclipse of steam in their country of origin.

It is not only the sugarcane railroads that seem stuck in a time warp. Enchantingly ancient specimens can be found plying the roads as well, with veteran American saloon cars of the 1940s and 1950s sputtering about in abundance. If one is lucky enough to be in the right place at the right time—at a level crossing, for example—two American road and rail behemoths of yesteryear can be encountered together: a 1920s Baldwin-built steam locomotive, say, looming over a gleaming 1954 Chevrolet or Plymouth.

Unlike China (where a steady flow of regular, time-tabled workings could be depended upon), operations on Cuban sugar-mill systems are much more unpredictable, and prey to a whole host of variables. In basic outline, the general operational pattern at a mill is for a steam locomotive to haul empty wagons out from the mill to the cane fields, drop them off at various loading points en route, and then return sometime later to collect the by-now-loaded wagons and ferry the cane to the mill for processing.

► It is not only Cuba's sugar-mill railroads that seem caught in a time warp. Vintage transport specimens ply the roads too, with American saloon cars of the 1940s and 1950s to be found in abundance. This shot of road and rail relics was taken at the Boris Luis Santa Coloma mill. (March 3, 1998)

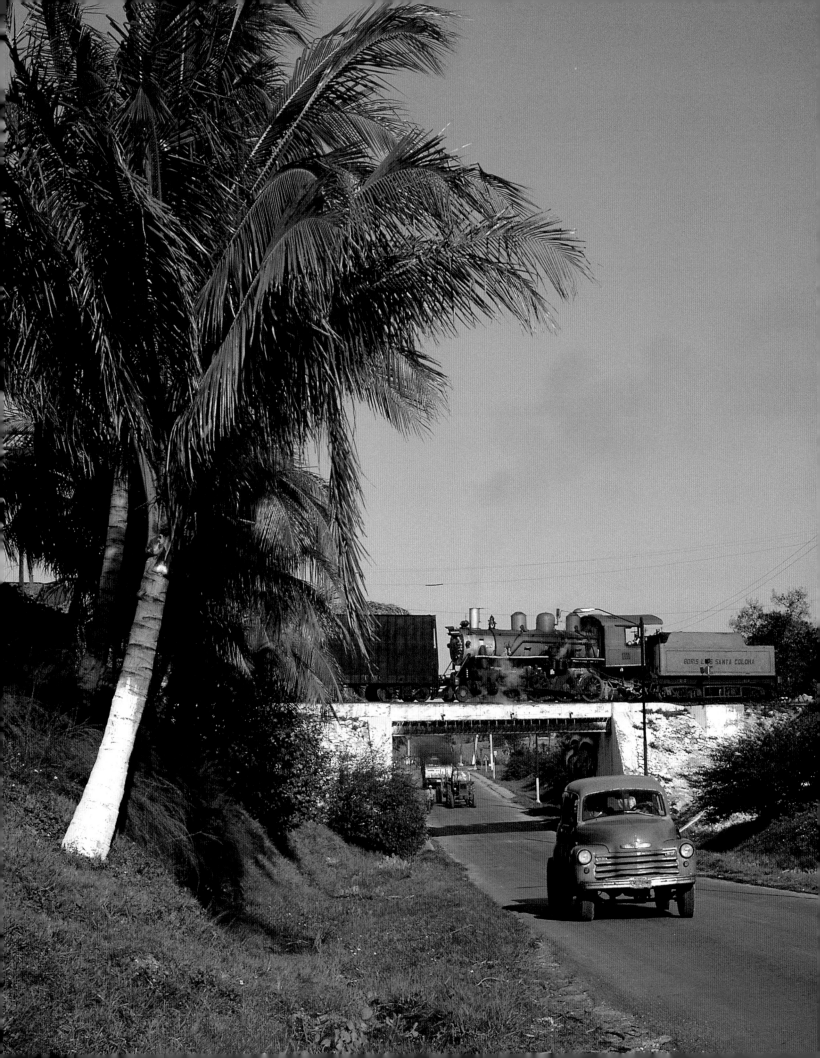

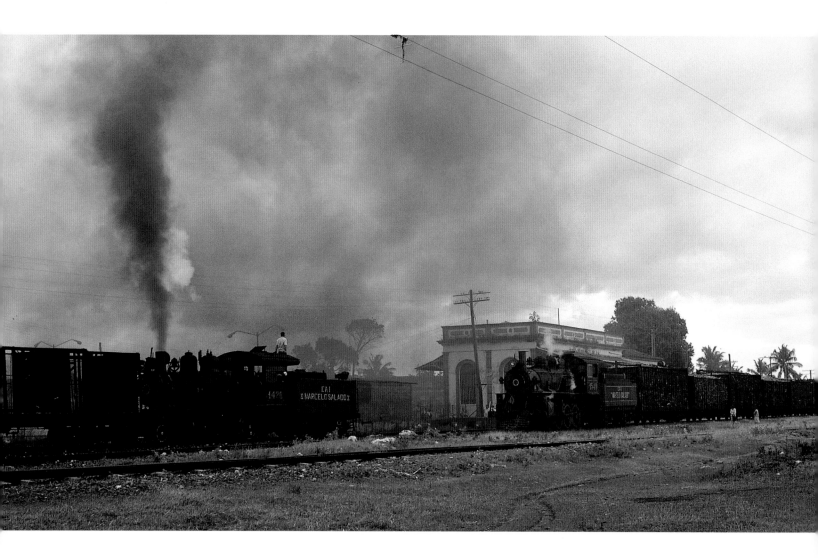

As to just when the trains set out or return, however, and what might intercede in the meantime to jinx their progress, that is entirely another matter.

With the standard of track on some mill systems often abysmal, derailments are not uncommon, and when this happens, traffic paralysis can seize a system for an entire day. The weather can be a major factor too: heavy rain can suspend the cutting of cane in areas where it is cut by machine rather than harvested by hand, and when

▲ The general pattern of traffic operations on sugar-mill rail systems is for locomotives to work out from the mill on empties to *acopios* (loading points) in the cane fields, then go back, ferrying loaded cane to the mill for processing. Here, a pair of trains are seen crossing at Remedios on the Marcelo Salado system, with 2-8-0 1426, at left, arriving in on a train of empties, while 2-8-0 1549, at right, awaits clearance of the single track to haul loaded cane back to the mill. (March 16, 1998)

there is no cane, there are no trains. Mills can close for part or sometimes even all of the season. With trains being so few—a couple of outward and return workings in the morning, then the same again in the afternoon, is about as good as it gets—linesiding is not really a viable option if more than a handful of good action shots are to be secured.

To undertake a successful steam-photography tour in Cuba, a hired car—preferably a good sturdy one capable of withstanding appreciable wear and tear on the rutted dirt tracks—is an essential accessory, enabling photographers to give chase and thereby maximize photographic opportunities. The best policy is probably first to find a train (this often entailing much eye-straining scouring of cane fields for telltale smoke trails), then to stick with it via dirt roads that sometimes run conveniently close to the railroad, and at other times frustratingly diverge. Laboriously researched

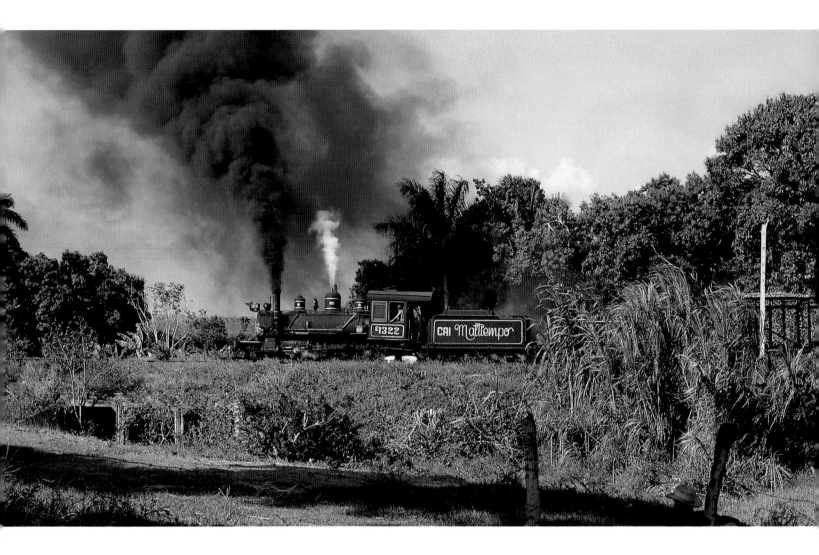

maps published by *World Steam,* detailing how dirt tracks and railroads interrelate, are of invaluable assistance to car-borne chasers. Cuban sugarcane steam, though, is a complicated subject, and rather than setting off on their own, first-time visitors would be better advised joining one of the many organized enthusiast tour groups (such as the U.K.-based outfit Steam in Paradise) visiting the island during the Zafra.

Like the residents of so many other remote and unlikely parts of the world who have witnessed this Western obsession at close hand over the past thirty-odd years, rural Cubans by now are also well used to the zany antics of the vapor worshipers who descend upon their doorsteps for the first four months of each year to enact their cult rituals, tirelessly stalking their photographic prey in the cane fields. During the Zafra, certain parts of the Cuban countryside present a bizarre spectacle, with convoys of rented

cars hurtling pell-mell down dirt tracks, throwing up copious dust clouds as the faithful contingents remain hot in pursuit of the perennial, still-just-about-ongoing agenda, the next shot, to snatch just another before time finally closes in and the last wisp of steam has evaporated forever.

How long this fascinating living museum of vintage American steam power will continue in service depends, of course, on future political developments. Like

▲ Another firm favorite of visiting steam enthusiasts is the narrow-gauge Mal Tiempo system in Villa Clara. The locomotives here are probably the noisiest in Cuba, renowned for the "Mal Tiempo Rumble" produced by their oil burners, which not only ensure that trains are audible for miles, but actually make the earth vibrate. In this view of ninety-five-year-old veteran Baldwin 2-8-0 1322 working uphill, the fierce flickering from below the cab floor shows that the burners are blasting away in classic Mal Tiempo Rumble style. (March 1998)

so many other aspects of the country, Cuba's political system itself can be said to be an anachronism: a Communist regime, more than a decade after the events of 1989. If, upon the death of Fidel Castro, the country goes the way of its erstwhile fellow socialist states, deregulates the economy, and opens up to foreign investment, the survival prospects of its veteran steamers would seem to be slim. For the time being, however, amid a lush, palm-dotted landscape under the hot Caribbean sun, a unique vestige of the past lives on, caught in a tropical time warp.

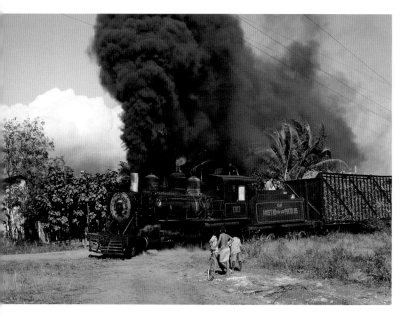

▲ A hired car is an essential accessory to any successful steam-photography trip to Cuba, without which it would be all but impossible to get out into the countryside to snap shots such as this rustic scene. A group of young boys watch 1905 Alco-built 2-6-0 1303 of Amistad mill set off from a distant loading point to work cane back to the mill. (March 9, 2001)

► Every year the Zafra palpably dominates the Cuban countryside, with tractors and trucks plying the roads, leaving discarded cane stalks strewn in their wake, and the skyline smudged by smoke palls from mill chimneys, plus, of course, the odd veteran steamer chugging through the cane fields. Here, at the narrow-gauge Pepito Tey system, 2-8-0 1329 (a Baldwin product of 1919 on loan from Espartaco mill for the season) ferries empties upgrade to a loading point against an appropriate backdrop of a field of as-yet-uncut cane. While the overwhelming majority of cane is now mechanically cut, in this particular area cane was still being hand-harvested, truly hellish, backbreaking work in temperatures—when this midmorning shot was taken—of some eighty degrees. (Feb. 22, 2001)

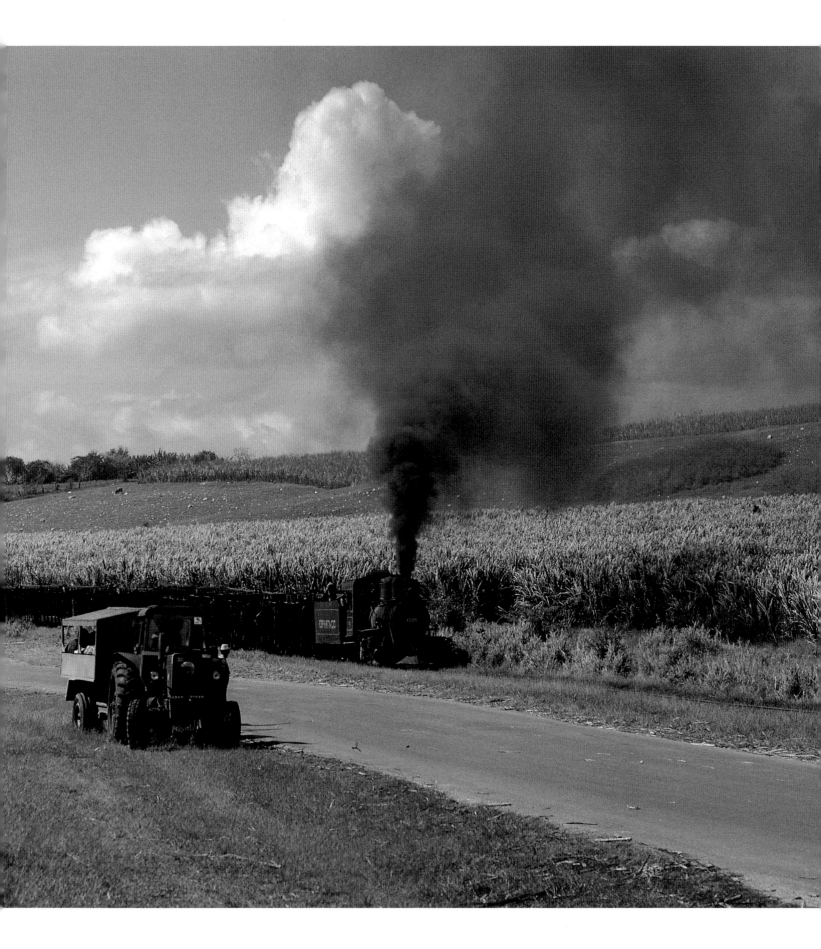

Götterdämmerung: The Jingpeng Pass

To steam lovers worldwide, it seemed scarcely credible that just when the steam situation elsewhere in China was going from bad to worse, along—like some fabulous surprise consolation present for all the losses suffered over the years—came the eleventh-hour wonder of the Jingpeng Pass. If the Steam Age is now finally coming to its very end, some solace at least can be sought from fate having conveniently arranged that in the very place where it is exiting from the stage of history, it is doing so in utterly spectacular style.

For most of its nearly 600 miles, the Ji–Tong line threads through a nondescript wilderness of dust-blown plains. However, along the 30 miles that constitute the Jingpeng Pass (its basic layout, simplified, is one severe grade heading west from Galadesitai to encounter, at the summit at Shangdian, another coming east from Jingpeng) is a breathtakingly engineered section routed through the lunar landscape of the Da Hinggan mountains. As far as the steam photographer is concerned, this is the stuff of dreams.

At points the line runs way above the valley floor along narrow sheer-drop ledges cut out of the rock face, while elsewhere it traverses numerous tunnels and viaducts; yet everywhere it is forced to bore a tortuous passage through the few available folds in a landscape that is otherwise hemmed in by looming brown mountains. Although the Jingpeng side of the pass is probably the more photogenic one (snow cover, for example, tending to linger there longer), the Reshui side offers the more spectacular ascent in purely operational terms. From the base of the climb down at Galadesitai, the line gains ground on the jagged, saw-toothed hillsides overlooking Reshui by means of giant, sweeping loops that force trains to twist, turn, and even change direction over a track layout resembling some madly implausible model-railroad fantasy, before finally describing a curved ledge way above Reshui and disappearing into a tunnel, only to arch right round and change direction yet again immediately afterward.

The area that the Ji–Tong route traverses is very sparsely populated and passenger traffic scant, comprising just one train each way daily. With only a few substantially sized towns en route, the volume of local freight traffic could not have justified undertaking such an ambitious new rail project. The real raison d'être of the line is long-distance through freight. Since it came into commission in December 1995, the Ji–Tong line has conveniently provided an alternative northeast-to-west long-distance freight route avoiding the traditional big-junction traffic bottlenecks of Harbin, Changchun, Shenyang, and Beijing. Some of the freight conveyed over the line originates from way up near the Russian border, to be taken on from Jining by CNR diesels to Baotou and points west.

▶ The spectacular nature of the railroad engineering required to lay the line over the Da Hinggan mountains can clearly be seen in this panoramic shot overlooking Reshui. Way down in the valley, a Jingpeng-bound freight (hauled, unusually, by just a single QJ), having just left Galadesitai and crossed the Reshui viaduct, is poised to come to grips with the long, winding grind upgrade. Some twenty minutes later, having meanwhile described a giant sweeping loop so as to turn back on itself and be facing in the opposite direction, it will pass by the second level track, seen in the foreground. Immediately after passing the tunnel at right, it will sweep right around to change direction yet again, as it continues its onward ascent up to Liudigou, and thenceforth on to the Shangdian summit, after which it will freewheel sharply downgrade to Jingpeng. (Jan. 26, 1999)

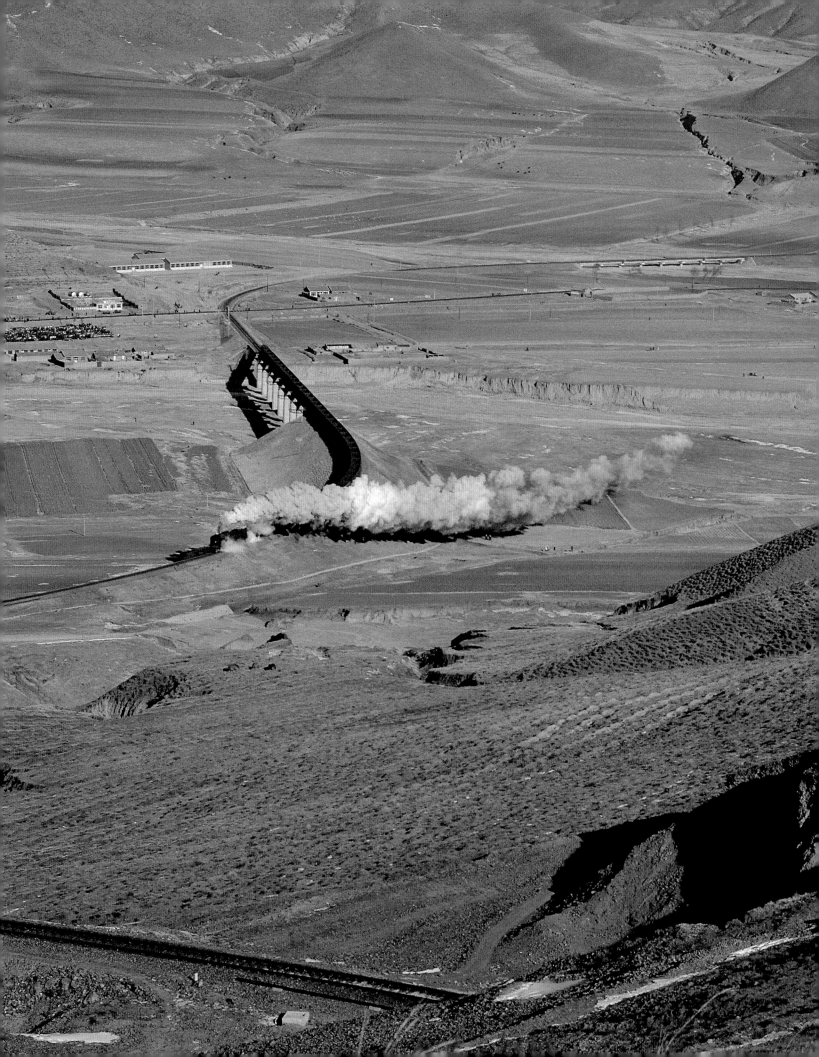

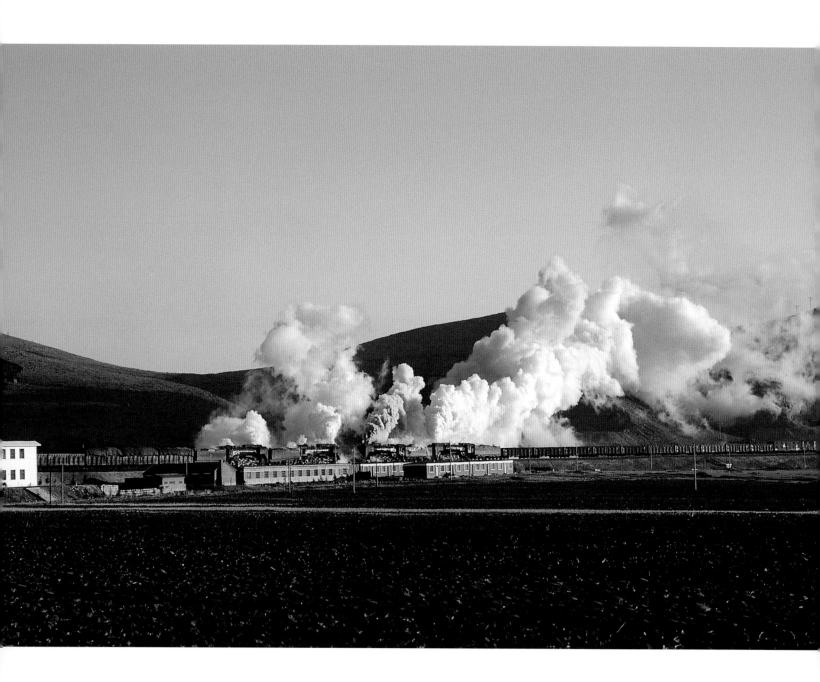

In this sense, perhaps, "local-government railroad" is misleading, conjuring up, as it might, visions of quaint, lightly loaded little trains ambling leisurely along. Though single-tracked, the Ji–Tong line really ought to be conceived of as one of the country's major arterial freight-traffic routes. At times, indeed, it is difficult to perceive any clear distinc-

▲ A double-header crossing at Galadesitai, at the foot of the Jingpeng Pass. The early-morning sun has just appeared over the hills to cast an attractive crisp flush over two QJs, at right, running through on a westbound freight, while two QJs await clearance of the section before proceeding with a Daban-bound freight. (Jan. 29, 1999)

tion between the local-government outfit and China Rail. In terms of appearance, certainly, it is a China Rail operation in all but name, with staff wearing China Rail uniforms, the China Rail logo embossed on the buildings of the little wayside stations, and the 110-odd former China Rail QJs that work the line still marked with their old state railroad running numbers, plus the China Rail logo on the tender.

Daban, where the main loco shed and workshops are located, is the operational hub of the Ji–Tong line. Between there and Haoluku, all but the odd freight (in both directions) is double-headed. It takes westbound freights

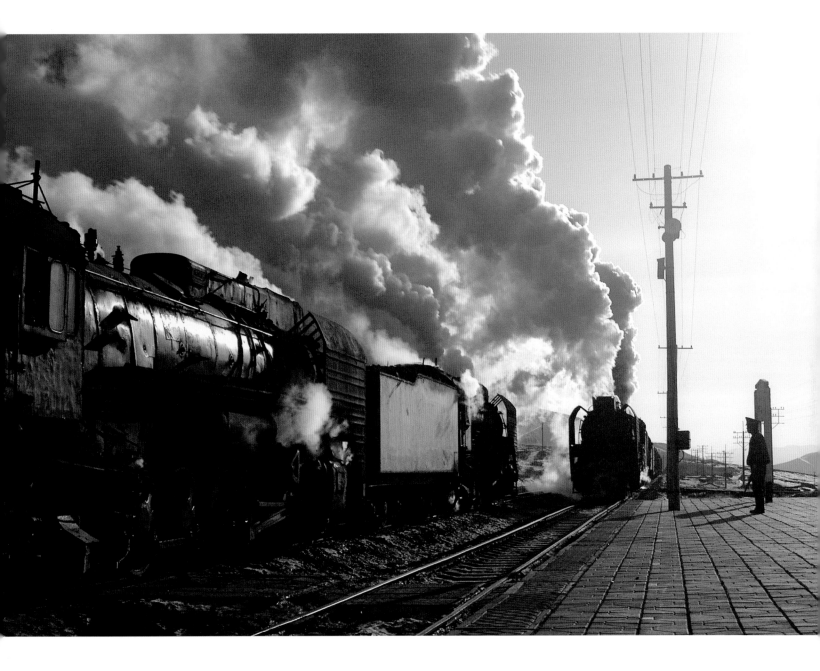

from Daban about two and a half hours to reach Galadesitai, at the base of the Jingpeng Pass, where the world's last remaining spectacle of big main-line steam begins. There is little doubt that the Jingpeng Pass will go down in railroad history as the suitably dramatic setting against which the steam locomotive staged one defiant last stand.

Anyone wishing to experience the show, however, will have to forgo many creature comforts and put up with often extreme weather conditions. In winter, at any rate—undoubtedly the most visually spectacular time to visit—Jingpeng is definitely a location where photographers

have to be prepared to suffer for their art. A hired taxi or minibus may afford some protection from the cold, but many photographic positions—especially those around Reshui—are accessible only by foot. While waiting up on the exposed slopes, taking the full force of Siberian winds

▲ The summit of the Jingpeng Pass is at Shangdian, where severe grades from both east (Galadesitai) and west (Jingpeng) meet for a short level stretch. Here, two double-headed freights cross at Shangdian. The stationmaster surveys two QJs, at right, slogging uphill on the last leg to the summit with a late-afternoon eastbound freight, as two other QJs, at left, await clearance of the single-line section to continue westbound toward Jingpeng. (Jan. 29, 1999)

blowing unimpeded, it can get extremely cold—as an example, a plastic bottle of lemonade brought out on the line will freeze into a solid block of ice in less than an hour.

At this time of year, most locals sensibly stay indoors. Other than the odd hardy shepherd clad in thick Afghan-style sheepskin coats, the only other figures to be seen out and about on the hillsides, braving the elements, are Western steam fans, lumbering about wadded up in high-tech winter gear. To withstand sustained exposure to the subzero conditions, dressing properly is imperative if frostbite is to be averted. This entails togging up in multiple layers of thermal underwear, fleece, and other winter wear, with an insulated flapped cap to cover the ears, arctic gloves to protect the hands, and about three pairs of thick woolen ski socks to keep the feet warm.

Also highly recommended is a jacket with good windproof protection, since the wind at Jingpeng can cut to the bone, transforming tolerable cold into a scarcely bearable, finger-numbing freeze when it whips up all of a sudden out of nowhere. Aside from the excellent steam action, the wind is liable to be the most abiding memory that a first-time visitor takes away from Jingpeng. Sometimes it can gust up to gale force, cutting the electricity supply overnight. Just as abruptly as such weather extremes come, however, they can also go, with the next day dawning perfectly calm, clear, and still.

The Jingpeng Pass may be set in a remote backwater, but fortunately—due to a local summertime tourist trade at nearby thermal springs—a wide range of accommodation is available right in the backyard of the action at the one-street village of Reshui, some forty minutes' walk from Galadesitai station. As for the current wintertime tourist trade, which came into being once the Ji–Tong line opened up, it initially may have surprised locals, especially in an area where foreigners had hardly—if indeed at all—hitherto been seen. As in so many other unlikely places on the steam-chasing trail where the steam locomotive has generated a miniature tourist boom, however, the annual wintertime influx of international visitors is now an accepted part of the cycle of seasons at Reshui, with local hotels, restaurants, and taxi drivers able to depend on an additional source of income for as long as steam lasts.

After the day's photography is done, like desperadoes gathered in the proverbial Last Chance Saloon, steam chasers from diverse countries can be found at local restaurants, tucking into their first decent meal of the day (having been on the go since dawn, with scant time to spare for such secondary considerations while photographic light prevails). Huddled around tables, in the time-honored fashion of their little self-contained world—itself dying along with the steam—they review the day's random run of luck, the shots that got away, or ones that came just right, and then, poring over maps, sketch out a provisional strategy for the next day's hunting. With the drastic contraction of available venues on the worldwide steam-chasing circuit, it is not unusual these days for steam chasers at Reshui to come upon familiar faces last encountered in circumstances far removed, both in time and place—in Turkey, perhaps, in the 1980s, or in another part of China back in the 1990s—yet still, now as then, at the same old game: chasing vanishing steam.

Trade talk inevitably turns to other places and times, as faithful followers relive moments never to be

experienced again—blasting out of Berlin, perhaps, on a scheduled express to Dresden, behind an 01 pacific on a balmy midsummer evening in the mid-1970s; the spectacle of the morning sun shredding the sulfurous haze of legendary loco shed yards such as Moradabad, Bloemfontein, or Jiamusi while dozens of engines simultaneously raise steam; or memories from other latter-day meccas, such as Rheine, Nancha, and Malakwal. More often than not, such wistful reminiscences only more starkly reinforce the reality that of all the great places there used to be to see big main-line steam in action, now only this one remains. An inevitable staple feature of Reshui table talk, accordingly, is fretful speculation as to how long this final fabulous exception to the prevailing steamlessness around it will hold out.

With the investment not only in secondhand steam locomotives but also in operational infrastructure (including workshops, ashpits, water columns, turntables, and the like), steam might reasonably be considered to be able to look forward to a relatively long-term future on the Ji–Tong line, though the recent delivery (in July 2000) of six new diesels to Zhengziangbaiqi depot at the southern end of the line (due to water-provision problems in the area) to work the Baiqi–Benhong section is an ominous portent, even if the relative costs (5 million yuan for a new DF4-class diesel as opposed to just 300,000 yuan for a secondhand ex–China Rail QJ) ought theoretically to mitigate against any likelihood of further dieselization by a cash-strapped local-government authority hard-pressed to find the finance. Inevitably, however, as even the most optimistic aficionado readily concedes, the line's steam locomotives will go the way of all others of their kind at some not too distant point, and that will be that, the final curtain call for the world's last big, live, working steam show.

Various stays of execution are debated, with some suggesting another three to five years, others eight to ten years. As ever, though, no one really knows; the vital decision is up to the inscrutable vagaries of railroad policy planners. The only thing that those making the trek to this last outpost on the steam trail can be sure of, based on bitter experience of how quickly a good thing can go, is that no effort should be spared to see this final big blowout of main-line steam now, while still around.

Even after retiring for the night, the proximity of hotels to the line at Reshui affords enthusiasts the opportunity to follow rail operations as they continue unabated around the clock. It's a strange experience, at the dawn of the twenty-first century, combining both the extraordinary and the everyday, to be able to lie tucked up in bed and catch the strains of another double-header breaking out of the wee small hours as it snorts upgrade, the two disparate exhaust beats resonating crisply over the dense hush of night. If unable to resist the lure from warm bed to window, steam lovers might well be rewarded with the kind of image that sparked this fascination for the first time, way back when.

Out there, saturated by the ghostly metallic sheen of the moonlight, two lumbering phantom leviathans send billowing white columns of smoke up into a sky of startling arctic clarity, flashes of fire from the locomotive cabs flaring episodically out of the amorphous blue-black void, the magic machine as mesmerizing as ever, even as it heads off into the giant dream-fog of eternity. . . .

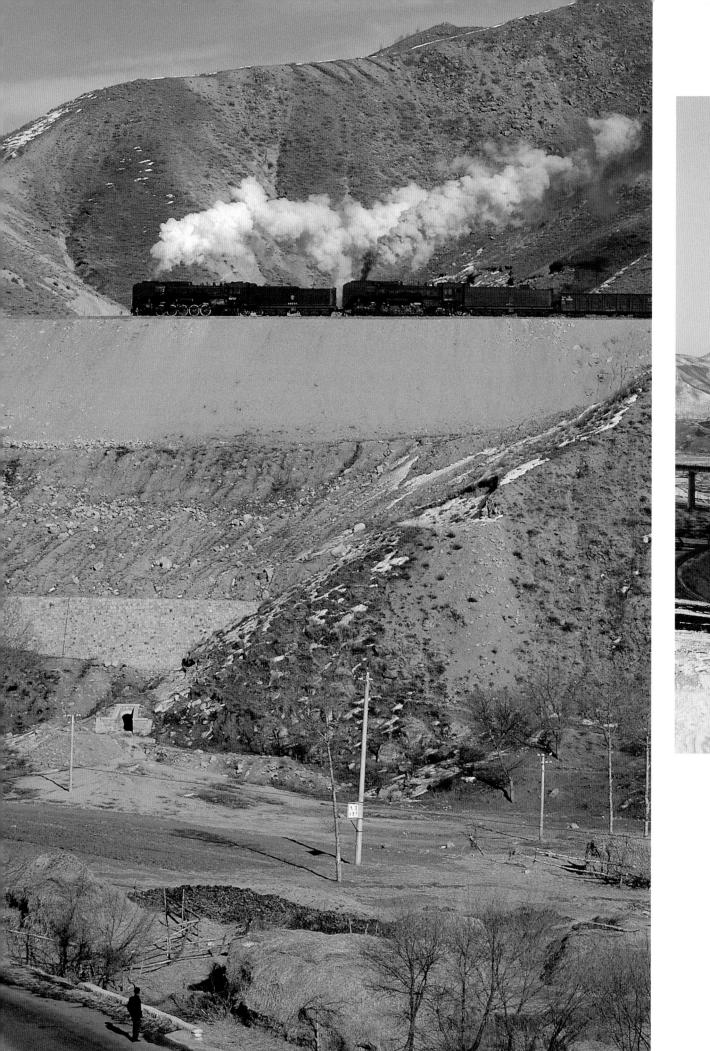
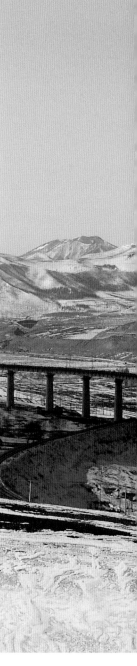

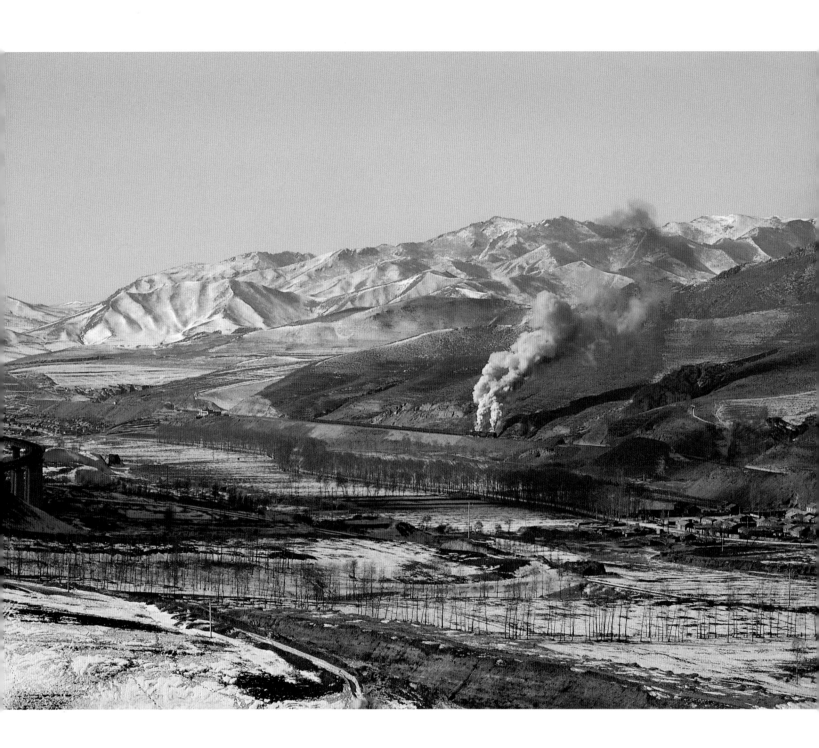

▲ Eastbound trains from Jingpeng face a daunting climb up to Shangdian. In this panoramic view looking down to Xiakengzi, a pair of QJs labor uphill on a morning coal freight. Some twenty minutes later—now facing in the opposite direction—they will cross the curved viaduct at left, after which, having then swung around through a tunnel, they will change direction yet again as they continue to slog onward through the lunar landscape to Shangdian. (Feb. 1, 1999)

◄ On the last eastbound leg to the Shangdian summit, the railroad runs on a high ledge set way above the valley floor. Here, near Dayingzi, QJs 7137 and 6760 are heading the same train featured on pages 54–55, except now (having been chased by car farther up the line) facing the opposite direction. In this broadside view, the villager watching at the bottom of the photograph, by the bridge, conveniently provides a sense of scale. (March 2, 1999)

Afterlife: Steam Beyond the Steam Age

Although the era of the steam locomotive in everyday service is now—apart from a few lingering exceptions—effectively at an end worldwide, strenuous efforts have nonetheless been made to ensure that it enjoys some form of afterlife beyond state rail service. It is as if man can't bear to part with this, his most flamboyant mechanical creation, and—knowing full well that none of its magic will be made manifest by just sitting on cold, static display in a museum, that to be fully appreciated, the machine has to be experienced as a living thing—has so arranged that the spell of steam can still be savored beyond the Steam Age, by both present and future generations.

There can be very few nations indeed where there aren't at least some steam locomotives in full working order, capable of being wheeled out for special excursions. Even in countries where regular steam finished some time ago, such as the Czech Republic, Turkey, Germany, and Romania, fleets of prestige steam locomotives are available for working rail-tour specials. In some instances the locomotives are still owned by the railroads, while in others they have been bought by private individuals or preservation groups.

The most striking example of steam having been extended beyond its natural life span is the cross-country junction of Wolsztyn in western Poland, where the state railroad has consented to use steam on normal scheduled passenger and freight workings. Elsewhere in Poland, steam ended about 1992, but at the "living museum" of Wolsztyn, the Steam Age lingers on, with steam locomotives built in the 1940s and 1950s still puffing in and out, day after day, on regularly scheduled trains. The workings—mostly modestly loaded and patronized passenger trains and local freights—may not be spectacular but are still real steam operations, conveying passengers to and from jobs, with some trains even working into the big industrial city of Poznań.

Another example of steam having been extended beyond the Steam Age is the George–Knysna branch in South Africa, a superlatively scenic route skirting the Indian Ocean and steam-worked three days per week by 19D-class 4-8-2s and 24-class 2-8-4s. The eastern German narrow-gauge lines in the Harz Mountains, still largely steam-worked, and the Nilgiri Railway in southern India, from Mettuppalaiyam up to the old English hill station of 'Ooty, similarly represent a halfway house between the real thing and a museum-style operation, steam having been retained in recognition of its being a guaranteed crowd puller—drawing not just the faithful fanatic hard-core element but a wider public too.

As steam lovers saw their most cherished reality vanish, they became ever more determined to re-create it. A striking initiative to turn back time has been the Plandampf (literally "planned steam") scheme in Germany (and also in the Czech Republic, another noted steam-loving nation), whereby enthusiasts pay the railroads the difference in operating costs to substitute main-line steam locomotives for diesel. In the eastern part of Germany especially, where steam outlasted its western counterpart by more than a decade and much of the servicing infrastructure remained intact, special steam operations were relatively easier to run.

The Plandampf concept has spawned some remarkable occurrences, with steam being substituted not only on minor local trains, but on prestigious international expresses as well. Over the Easter 1994 weekend, for example, the

Plandampf Metropol outfit arranged for five express steam locomotives, with building dates ranging from 1925 to 1961, to substitute on the home legs of prestigious international expresses such as the Warsaw–Berlin and Berlin–Paris runs—much to the surprise of many passengers. In order to keep to company schedules, the steam locomotives—which also have to satisfy rigorous safety criteria—had to perform as in their heyday, or in keeping with current diesel performances, thus giving passengers and spectators the rare treat in the 1990s of seeing German pacifics being thrashed flat out at up to ninety miles per hour.

The Plandampf concept has been increasingly hampered on more major routes, however, by the incompatibility of steam locomotives to a new generation of coaching stock, requiring an electric locomotive to operate many of the onboard services. As time elapses, and the steam locomotive becomes ever more out of sync with the total railroad environment and current operating practices, mounting objections have been raised by railroad health and safety departments, with stringent provisos to be complied with before steam specials can be run over the main lines. Steam may have run in normal company service for decades without such considerations causing undue concern, but now the risk of stray cinders sparking lineside blazes can play havoc with intended itineraries of steam tours during the hot, dry summer months, often resulting in cancellation.

Ambitious though the Plandampf scheme may be, steam-tour operators farther afield were able to give even fuller rein to fantasy, running giant tours lasting up to two weeks in countries such as South Africa, Turkey, and Russia, featuring a rich variety of steam power, during which (with the provision of sleeping- and dining-car facilities) tour participants often lived on the train. At particularly scenic spots, participants would dismount for staged runs, during which the locomotive would reverse, then—often to the incredulity of local onlookers—come blasting past with suitably spectacular smoke effects for the benefit of the assembled gallery of photographers spread out along the line. However crazy this might have been considered locally as a way to spend a vacation, once local entrepreneurs grasped that the steam locomotive could be a moneymaker, organizations came into being to provide a supply of steam to match the copious demand.

With authentic everyday steam operations on the wane worldwide, and requiring often arduous long-haul trips to see them, this type of steam tourism became increasingly popular in the 1990s. The Kiev-based steam locomotive tour company Dzherelo—significantly, one of the very first private business ventures established in Ukraine in the wake of the collapse of Communism—showed astute initiative in buying a small fleet of steam locomotives off the railroads, then running rail tours throughout the year for English, German, Czech, Japanese, and other enthusiasts.

An "anything is possible" spirit has come to characterize the staging of special steam events in the post-steam era, with some of the wildest projects actually being realized. The most audacious steam tour organized to date has been the English G.W. Travel's 1996 Trans-Siberian Express to Vladivostok, entirely steam-hauled (by some seventy-two different locomotives) over the 3,750-mile route—an epic feat made possible by the fact that thousands of decommissioned steam locomotives had been strategically mothballed

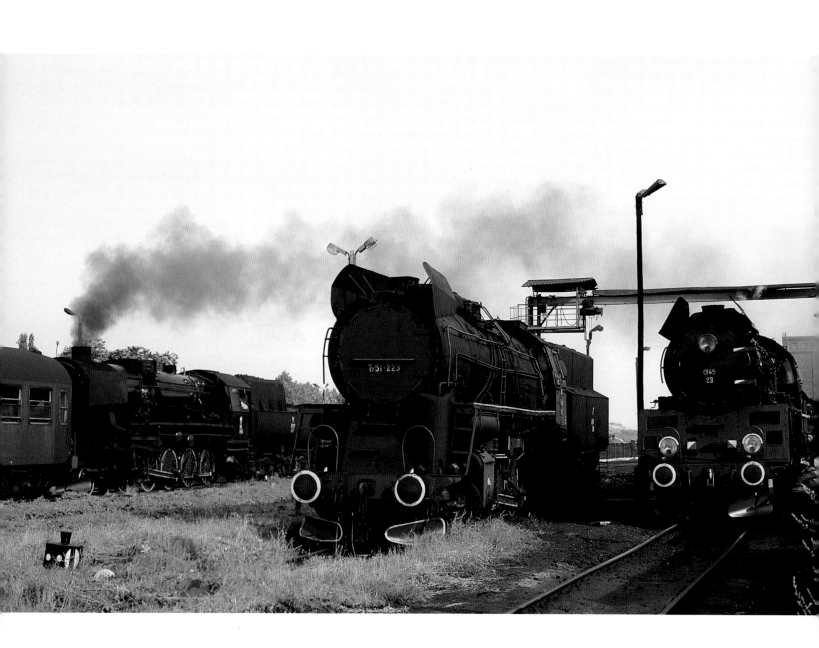

(in full working order) during the Cold War at the behest of the Red Army, and entailing elaborate liaison with the various railroad administrations of the former Soviet Union, to restage a reality that had not taken place for decades.

The United Kingdom is especially renowned for its extensive preservation program, with hundreds of steam engines of all shapes and sizes having evaded the cutter's torch, and many short stretches of branch line dotted right across the country, little time-warp capsules where steam locomotives continue to clank and puff past hedgerows. Although such preservation schemes have to function as viable economic entities within the leisure industry, they can depend on a broad support base of volunteers to provide

free labor (both running the trains and restoring engines and track), as well as donating cash for restoration projects.

British preservationists were uniquely lucky in having access to what effectively amounted to a steam

▲ While the steam situation in most of Poland was going from bad to worse when this photograph—featuring, from left to right, a Ty2-class former German Kriegslok 2-10-0 and postwar Polish designs Ty51 2-10-0 and Ol49 2-6-2—was taken, at Wolsztyn it was improving by bounds. Following its designation as a "living museum," a fascinating variety of vintage locomotives were brought in to Wolsztyn and used on regular-service trains. Although regular steam elsewhere in Poland ended in 1992, at Wolsztyn the Steam Age has been extended beyond its natural life span, its locomotives continuing to perform on regular passenger and freight workings into 2002. (July 1991)

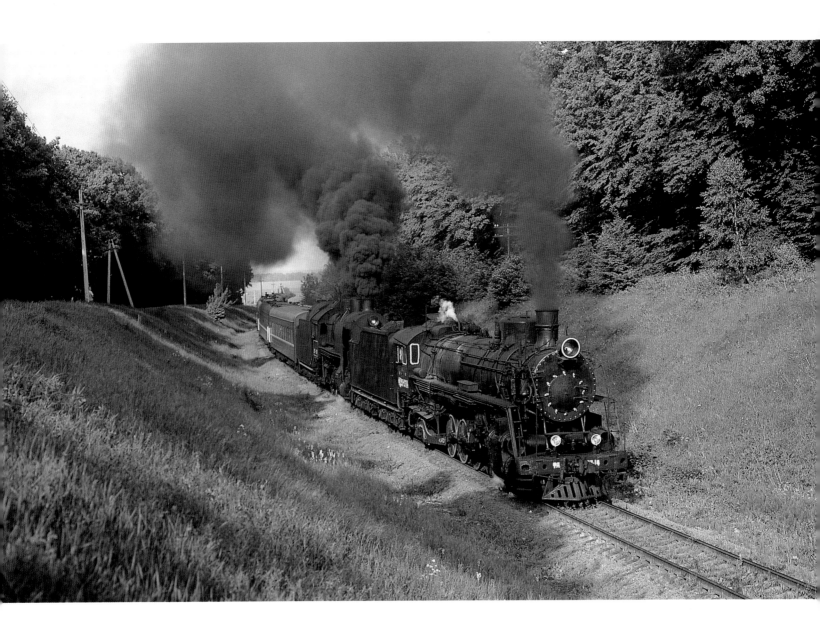

Special enthusiasts' tours may not be the real thing, but in Ukraine, where the steam-engine tour company Dzherelo's locomotives are often left authentically grime-encrusted, they can provide a close enough approximation. In this view, FD-class 2-10-2 2714 double-heads an SO 2-10-0 near Balin on the Grechany–Kam'yanets'-Podil's'kyy line. (June 1993)

supermarket at Woodham's Scrapyard in Barry Island, Wales. When British steam ended in 1968, more than 200 former British Railways steam engines were congregated there, left by the owner, Dai Woodham, to rust in the open throughout the 1970s and 1980s as his company busied itself with scrapping wagons instead, and preservationists meanwhile bought up the engines one by one. By the time the last locomotive left the yard in 1988, all but a few of the locomotives originally gathered there some twenty years earlier had escaped scrap—a rescue of some 213 steam engines, saved to steam another day. Many resurrection miracles have taken place, in which rusty derelicts have been restored from scrapyard condition to gleaming, good-as-new machines.

However, when an even more ambitious group proposed going one step further and actually building a brand-new A1 pacific—a 1940s express passenger design that became extinct back in 1965—from scratch, skeptics considered that this time the dreamers had gone too far, tackling a project that was not only prohibitive financially (more than £1 million, or $1.4 million), but also beyond the bounds of practicality. Yet even this seemingly impossible

dream has triumphed over the odds, with A1 pacific 60163 Tornado—the first main-line steam locomotive to be built in England for some forty years—due to emerge shortly from Darlington.

It remains to be seen whether this remarkable initiative will act as a precedent for the construction of other extinct types of steam locomotives, or even new designs. Past experience within the world of steam preservation seems to indicate that as long as the requisite cash is forthcoming, even the most apparently implausible steam dream can be rendered into reality. Another unlikely project that was recently realized is the 1999 refurbishment—also at a cost of about $1.4 million—of a Third Reich–era Kriegslok, 52.8055, at the Swiss SLM Works Winterthur, featuring many state-of-the-art modifications of the original design.

Despite the overwhelming odds against the realization of any new innovations in steam technology once the traction trend on railroads had tended decisively toward diesel worldwide, there has remained a tenacious "what if?" faction of passionately pro-steam (on grounds of irrational romantic attachment) aficionados such as the Argentine L. D. Porta and Englishman David Wardale (but who also conveniently happened to hail from solidly grounded engineering backgrounds), intrigued by how steam might have fared had its technology been pushed in serious competition against diesel. It is testament to man's ability to doggedly devote himself to all-but-doomed causes that both managed—partially, at any rate—to translate their visions of what could be into reality at such a late stage in the day for steam.

During his time as assistant mechanical engineer (steam) with South African Railways at Pretoria, Wardale

managed to undertake extensive rebuilds of two locomotives, incorporating modifications aimed at improving performance and efficiency in terms of coal combustion and steaming rates, and ultimately at presenting a convincing case for the further retention of steam. The first locomotive to be worked on, in 1979, was 19D-class 4-8-2 no. 2644, fitted with a double Lempor exhaust, gas-producer firebox, and other modifications. This was followed, in 1981, by the reconstruction of a 1950s-built 25NC-class 4-8-4, no. 3450, into a new, visually distinct, and reclassified 26 class, unofficially known as the Red Devil (because of its unusual all-red livery), and officially named L. D. Porta, after the Argentine engineer whose pioneering work on improved component design had inspired the conversion.

Despite impressive performance results from both locomotives, with substantial savings in coal and water consumption as well as increased power capacity, these last-gasp developments came too late to really affect the long-term future of steam overall. In any case, they were accorded an overwhelmingly hostile reception by a railroad management predisposed not to hear any good news about steam. Even after an officially commissioned study by the South African Railways Traction Policy Committee determined steam to be the most economical form of traction on the 146-mile De Aar–Kimberley main line, the railroads proceeded with their program to eliminate steam regardless.

Wardale subsequently took his talents to China and was employed there between 1986 and 1989 as a technical consultant at the Datong Locomotive Works, where for a time it seemed the Steam Age might be prolonged through further development of steam technology. Wardale

fashioned a new prototype QJ2 from an existing QJ, and at one point there was talk that a projected Super QJ might be produced. There too, however, steam was abandoned as a technology. With that, the last significant opportunity to give steam a fighting chance had passed, thus dooming the machine to inevitable imminent extinction.

Porta is another ardent steam activist who has refused to give it up as a lost cause. Ideally, in another time, a man of Porta's engineering vision would have been able to let his imagination run loose designing new steam locomotives—and in fact he has tried his hand at that too, having designed a new LVM-class 0-6-2T, for shunting in Cuba (where it may be manufactured as soon as 2002). He has, however, mostly had to restrict himself to upgrading the capabilities of existing locomotives through what has become known as Porta conversions. The principal hallmarks are the gas-producer firing system and the Lempor exhaust, both of which have achieved significant fuel-consumption savings as well as increased thermal efficiency. Porta conversions have been applied mainly to steam locomotives in South American countries (Argentina, Paraguay, Brazil), but also in Sudan; there, as part of a famine-relief program in 1985–86, six 1950s-built 310-class 2-8-2s, reconditioned by Hugh Philips Engineering of Tredegar, Wales, featured Porta-designed Lempor exhaust systems.

Like the diehard photographers who have followed steam around the globe, Porta too, in his own quixotic way, has remained faithful to the steam locomotive to the very last, a defiantly active steam engineer in a post-steam era. His most recent conversion project, in 1998, is Cuban 2-8-0 no. 1816, a veteran Alco product of 1919 that, after conversion, has—like Wardale's South African 26-class Red Devil—emerged looking like quite a different machine externally, quite apart from internal modifications.

These rearguard actions, fought on behalf of a doomed technology, may have failed to secure an extra lease of life for steam within the context of commercial main-line service on a state rail system. Still, the lessons learned from the endeavors of Porta and Wardale can be incorporated into any new steam locomotive that—following the inspirational example of English A1 pacific 60163 Tornado—might be built for use within the leisure industry.

Plandampfs, special steam tours, privately preserved steam-worked railroads, the continued development of a doomed technology for no other reason than an intrinsic fascination with the machine itself, and now even brand-new steam locomotives—none of these projects could have survived were there not a susceptible market of enthusiasts eager to part with cash in exchange for steam. The market does exist, however. It may be that an element of artificiality inevitably attaches to museum-style steam operations—their unnaturally spotless engines somehow never quite managing to re-create the elusive atmosphere of real working steam—and that nothing in the world will ever bring back the unique magic and gritty realism of a big steam shed, the hustle and bustle of a major main-line junction, steam trains arriving and departing at a dizzying rate, or the awesome drama of a double-header being thrashed flat out upgrade on a 3,000-ton freight load. This magnificent, much-loved machine will nevertheless enjoy at least some kind of afterlife, steaming on beyond the Steam Age.

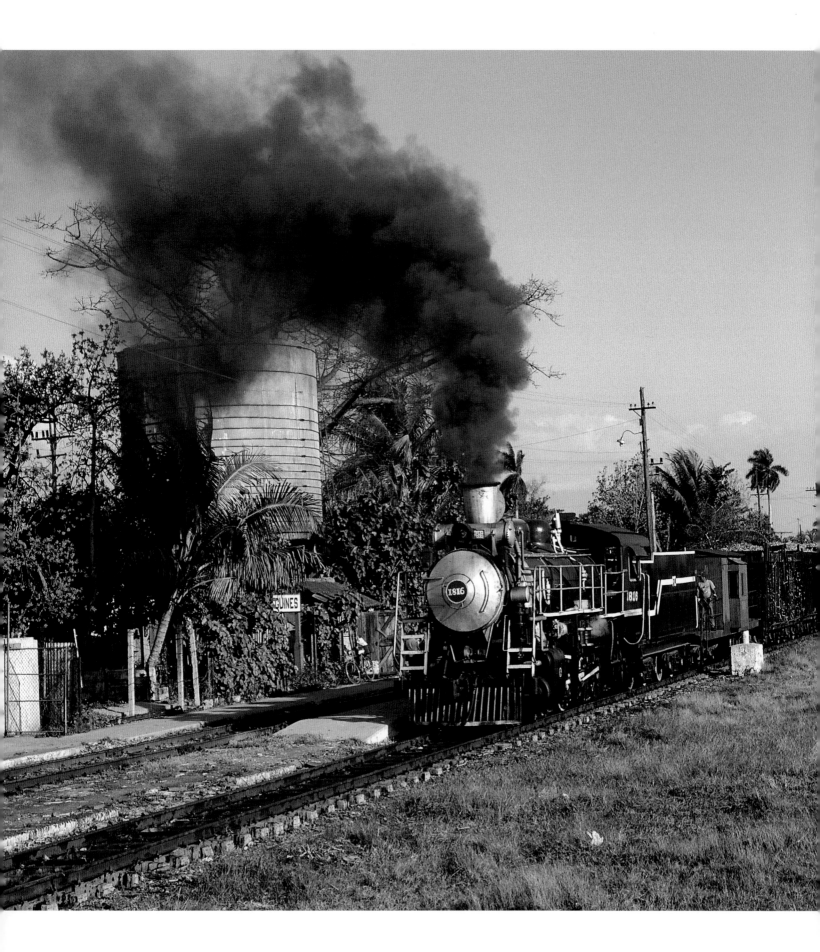

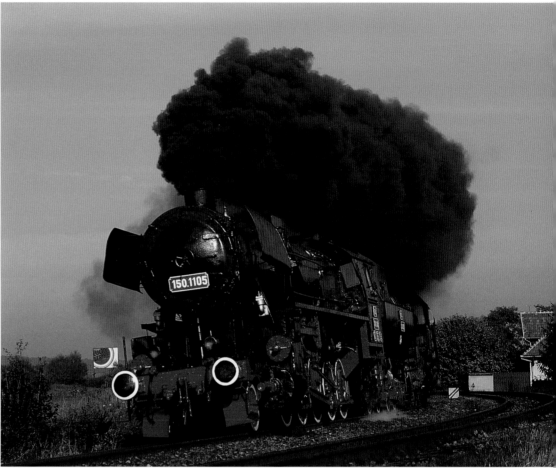

A gleaming double-headed German combination on rail-tour service in Romania, with Kriegslok 2-10-0 150.1105 leading the former Prussian P8-class 4-6-0 230.224, leaning to the curve between Vestern and Tălmaciu on the Sibiu–Braşov line. The Lucky Strike billboard advertisement in the background testifies to the seismic political and economical changes that have taken place since these two locomotive types would have last worked on normal line service, back in the "Socialist Realism" days of the 1970s. (Oct. 1997)

Though refashioned from a locomotive originally built in 1919, Porta Gas-Producer 1816 has the sleek, racy aura of a brand-new, state-of-the-art machine. Having chased the train by car on an early-evening inter-mill working to Héctor Molina mill, the photographer was just about able to keep ahead and catch 1816 rolling into Güines FCC station. Unlike the so many clapped-out relics come upon in Cuba just about struggling to keep their loads on the move, 1816's distinctive choppy exhaust beat exuded supreme confidence in being up to the task of surmounting the stiff grade over FCC metals on its way to Güines. (March 9, 2001)

Ireland, where steam finished normal service in 1970, is just one of many countries where restored steam locomotives can be found working special rail tours. In this night shot at Belfast, V-class 4-4-0 no. 85, Merlin, rests at Central Services Depot after working a rail-tour special up from Dublin. (May 10, 1987)

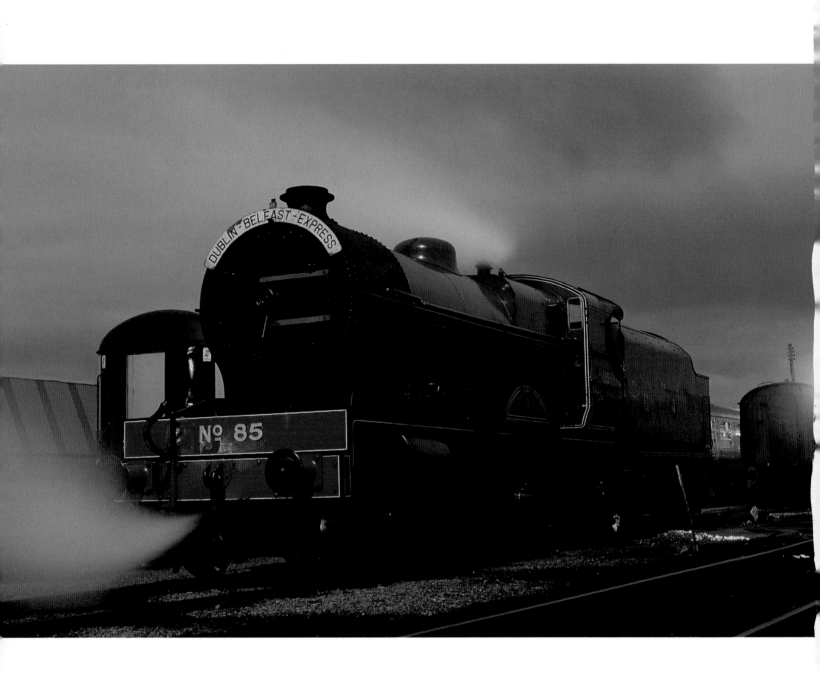

Acknowledgments

WITH SPECIAL THANKS TO

Jonathan Williams, Martin Crawford, Rudi Goldsmith, John O'Farrell, Torsten Sewing, Thorge Bockhart, Hilda Heger, Peggy Langhammer, Sue Randle, Paddy Donnelly, Frankie Quinn, the Steam in Paradise Cuban travel tour team (Ron Lingley, Andrew Clark, and John Bennet), and David Thornhill (*World Steam*).